IMAGES
of America

PONTIAC

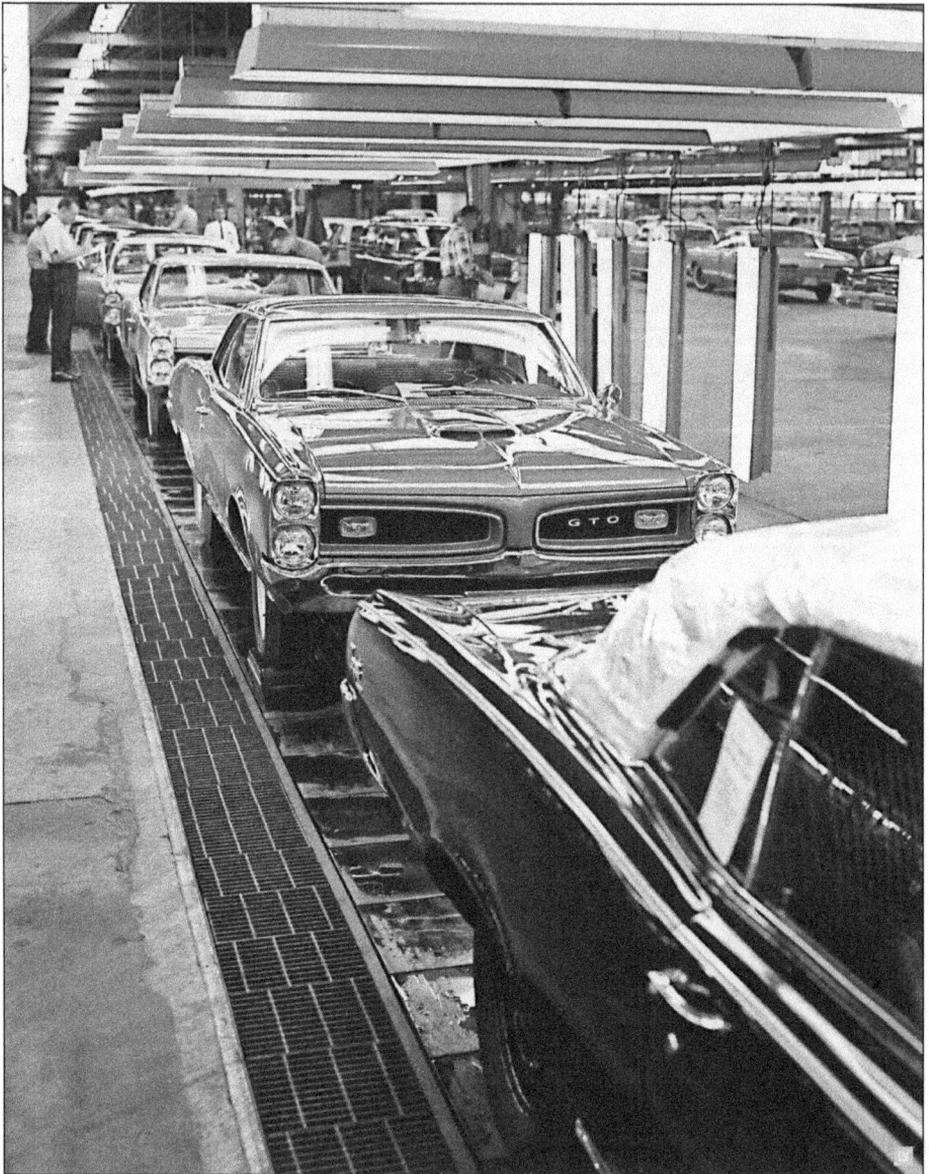

GENERAL MOTORS, PONTIAC AUTOMOBILE, 1926–2009. WHAT A RIDE! The Pontiac Motors assembly line, located in Pontiac, Michigan, is building GTO, Tempest, and LeMans models. GTO stands for Gran Turismo Omologato. It was produced from 1964 to 1974 and again from 2004 to 2006. Its conception is attributed to Russell Gee, Bill Collins, and John DeLorean. The 1966 and 1967 models were virtually identical with some differences in the rear end. (©2010 GM Corporation, used with permission GM Media Archive.)

ON THE COVER: This American beauty, a Flanders Electric, took first prize in the electrical division of the Fiesta San Jacinto on April 15, 1912, in San Antonio. Named for the company's director, Walter Flanders, less than 100 Flanders and Tiffany electric automobiles were made. Electricity stored in batteries was thought to be a viable method of propelling automobiles that proved untrue until recently. There were over 100 makers of electric vehicles prior to World War II, including GMC. (Courtesy of Oakland County Pioneer and Historical Society.)

IMAGES
of America

PONTIAC

Ronald K. Gay with the
Oakland County Pioneer and Historical Society

ARCADIA
PUBLISHING

Published by Arcadia Publishing
Charleston, South Carolina

Library of Congress Control Number: 2009943870

For all general information contact Arcadia Publishing at:
Telephone 843-853-2070
Fax 843-853-0044
E-mail sales@arcadiapublishing.com
For customer service and orders:
Toll-Free 1-888-313-2665

Visit us on the Internet at www.arcadiapublishing.com

*This book is dedicated to Pontiac teachers in public
institutions, private academies, and home schools
and to the memory of the Old Union School.*

CONTENTS

ACKNOWLEDGMENTS

This book has been a community effort that utilized public and private historical archives along with many stories shared orally.

I gratefully acknowledge support from the membership of the Oakland Pioneer and Historical Society that made this project possible. Thanks to the board of directors and specifically Mike Willis, Charlie Martinez, Richard Stamps, Mike West, Brian Golden, and Geoff Brieger.

Others who contributed photographs and research aids include: Annalee Kennedy, Linda Porter, the Pontiac Public Library, the City of Pontiac Cemetery, Oakland County International Airport, Oakland County, the Oakland Press, the Salvation Army Central Territory Museum, Cora Bradshaw, Rodney Gay, Bruce Annett, Tom Shafto and Service Glass, Jim and Jerri Fancher, Rich Sign, Helen Jane Peters, Carmen Martinez, Mark Thomas, Dave and Debbie Parker, Ray Henry, Pontiac Creative Arts Center, Norm Kasavage, Micki King, Geoffrey Holmwood, Joe and Ben Benson and Benson's Building Supply, Fisker Automotive, Jordan Vittitow, SilverStream LLC–Dishmaster Faucet, Kathryn Smith, Ken and Pat Burch, Carol Craven, and Richard Thibadeau. A special thanks goes to James Fassinger, photographer of www.stillscenes.com, for coming to Pontiac to photograph the old coal dock at Canadian National Railroad.

In various other ways, the following people and organizations have contributed to the making of the book: Anna Wilson, Christo Datini, Maj. Gloria Stepke, Jan Odell, Mona Parlove, Cheri Gay, Edmond Richardson, Terry McCormick, Esmo Woods, Marty Padilla, Maria Dana and the Oakland County Research Library staff, William Art Holdsworth and the Oakland County Facilities Management staff, Michelle Stover and the Oakland County International Airport staff, J. David VanderVeen, Glenn Gilbert, Tim Thompson, Guy Duffield, Martha Martinez, Earnest Cleary, Arthur Fowlkes, John Kyros, Elizabeth Clemens, Ashley Koebel, Pablo Cruz, Ken Martin, Len Stesney and Canadian National Railroad, Lisha Fisher, Joe Alessi and Mount Hope Cemetery, Nick Cocciolone, Esther and Lisa Johnson, Wayne Clack, Jeff Lloyd, Robert Oliver, Rod Wilson, Dave Walls, and Fran Anderson.

Special thanks goes to Nancy Thompson, Oakland County Economic Development and Community Affairs, and Ray Henry for their generous assistance.

I looked very hard to find a photograph of Dr. Harold Furlong, a World War I Medal of Honor recipient from Pontiac. With help from Annalee Kennedy, a long search uncovered a picture at Michigan's Own Military and Space Museum, a little known treasure. Thank you Stan Bozich for your support.

The Oakland County Pioneer and Historical Society is abbreviated in courtesy lines as OCPHS; Wayne State University is abbreviated as WSU.

INTRODUCTION

The idea for doing a photographic history book on Pontiac came to me after giving a talk last year at the Grosse Isle Historical Society on how to research an old house. As I was leaving the meeting that night, I was given a book about Grosse Isle in appreciation. The book was written by members of the society and was part of Arcadia Publishing's Images of America series. After 18 years of researching the origins and evolution of my old house in Pontiac, I found out a lot about the first years of this city. My house is closely tied to its founding. I have felt somewhat obligated to share what I have learned, and I needed to put what I had found in writing. Reviewing the Grosse Isle book, I thought a book of that type would serve my purpose. I felt confident I could create a book on Pontiac's history using Arcadia's Images of America series format that would be informative and entertaining.

I attended Pontiac public schools for the first six years of my education. The school policy was to teach local history in the third grade, which included a field trip. I remember leaving the classroom that morning and boarding a school bus. Our driver took us all around Pontiac and some outlying areas. We got out of the bus when visiting the city's first cemetery, an old log cabin, and bronze plaques by the roadside. We took a tour of the local historical museum at Pine Grove, which was once home to Moses Wisner, Michigan's 12th governor. The experience of that trip stayed with me. After purchasing my house, I became a member of the Oakland County Pioneer and Historical Society, located at Pine Grove. The library and archive there was an invaluable resource while researching my house and its owners. When I approached Arcadia Publishing with a book proposal, it included partnering with the society.

From the outset, I approached this book as a community project. While I had a small agenda of sharing some newfound early history about the city, my greater goal was one of telling the story of Pontiac in an interesting and collaborative way. Every citizen has his or her own story of Pontiac, because we see history through our own eyes. Given the shortness of the book's format, I knew it would be a challenge to represent the long and diverse history in a way that everyone might agree with.

I decided to make this book about the city of Pontiac versus greater Pontiac. I wanted to stay within the city limits, with one exception. I feel that the Oakland County International Airport, formerly the City of Pontiac Municipal Airport, has played a large role in our history. Seeing that Pontiac built and owned the airport for 40 years, I felt its inclusion was a must.

I attempted to collect photographs from obscure sources. I handed out flyers, called and visited churches, met with business owners, and asked individuals, friends, and social organizations to share their old photographs or provide names of people they thought could be helpful. I had hoped to find photographs of families in their daily lives, but they were difficult to locate.

Pontiac is an old city. For some reason, Pontiac celebrated its centennial in 1961, yet the town was founded in 1818. In 1861, the town incorporated as a city. I hope from now on we celebrate our founding date, which means our bicentennial is coming in 2018.

In 1818, this area was populated with indigenous people when the United States proceeded to settle the land after decades of skirmishing with the French, British, and Native Americans. Most of Pontiac's first settlers were European, with very few African Americans. Over time, runaway slaves were ferried through Oakland County and Pontiac to Canada by way of the Underground Railroad, away from bounty hunters. During and after the Civil War, African Americans ventured back across the border, some fighting for the Union, ultimately increasing Pontiac's African American population.

We have had our highs and lows. When the Eastern Michigan Asylum was awarded to the city in the 1870s, it was the single most important event ever to impact the lives of Pontiac residents. When it became apparent that cars would take over buggies and that trucks really did outwork wagons and horses, Pontiac exploded with industry and decent jobs as well as modern housing and conveniences. Once the automotive age was in full swing, people from different backgrounds traveled to Pontiac for jobs. For example, people from the South, Italians, Poles, Germans, Jews, Irish, Greeks, Mexicans, and others made their way to Pontiac in varying numbers from the latter 19th century to well into the 20th century. More recently, Asian and other Hispanic immigrants have settled in Pontiac.

When the labor unions came along, they helped to level the equal rights playing field for minorities and women. Women's suffrage was also a good equalizer. Even though Pontiac had a long reputation of fighting for abolition of slavery, and our schools and cemeteries were never legally segregated, the city lived a segregated existence in schools, social events, clubs, and churches. Also, there were deed restrictions that prevented minorities from buying houses in white neighborhoods. The busing ruling of 1971 brought division of immeasurable proportions. The city had already fallen on hard times due to the downtown retailers and businesses fleeing to the suburbs.

The construction of the Pontiac Metropolitan Stadium, or Silverdome as it was later named, was supposed to create new growth on the east side, but barely a spark occurred. In 2009, Pontiac Motors Division went under in the process of General Motors fighting for its life. Though Pontiac Motors hadn't assembled cars here since the Fiero, the city is grieving this major loss. The last assembly plant, the GM pickup plant, also closed that year. The Silverdome was given away in a bad real estate market, and yet, we will be fine.

Take a drive around the city and check out our local history in the wealth of historic houses and buildings. Watch our high school teams during the school year. Come to the Memorial Day Parade or Dream Cruise in August. We have a selection of good and diverse restaurants, a mammoth indoor soccer arena, long established businesses and many new ones, and a rich and inviting heritage.

One

OUT OF DETROIT

Long before the village of Pontiac was born, the British, French, and the new Americans clashed over the right to lay claim to the densely forested lake lands of Lower Michigan—the Northwest Territory of the day. The Ottawa, Ojibwa, and Potawatomi peoples had been fishing, hunting, and gathering here for ages. The city was named for a great Ottawa warrior, Pontiac. He was the most celebrated Native American of his time in this part of the country. He had led a Native American uprising against the British in 1763, becoming immortalized. At one time not too long ago, Chief Pontiac's picture hung in every public school here.

After the War of 1812, the United States sought to expand into the Michigan Territory. Out of Detroit came a group of settlers named the Pontiac Company. Fifteen men and families, who bought eight quarter-sections of land located 25 miles northwest of Detroit, formed the new venture. Solomon Sibley, Detroit's first mayor and a war veteran, was chairman of a committee that was established to assign these tracts of land. He also formed a partnership with Stephen Mack and Shubael Conant. Mack, Conant, and Sibley helped the Pontiac Company begin a town.

The new village had an enterprising start through many long, tough winters. A sawmill was in operation by the second year, 1820, which is the same year the county seat of Oakland was established in Pontiac. When the Erie Canal opened in 1825, it became much easier for those from the Northeast to come to Pontiac, and they did. Notices were printed in the papers extolling the great resources and landscapes. The population grew rapidly in the following years.

In 1826, Stephen Mack, the agent for the Pontiac Company and the man largely responsible for overseeing all of the town's early development, died. With Mack gone, Solomon and Sarah Sibley, who had financed all of the first mills and buildings and overseen the early settlement, took over again and helped the village through the end of the decade.

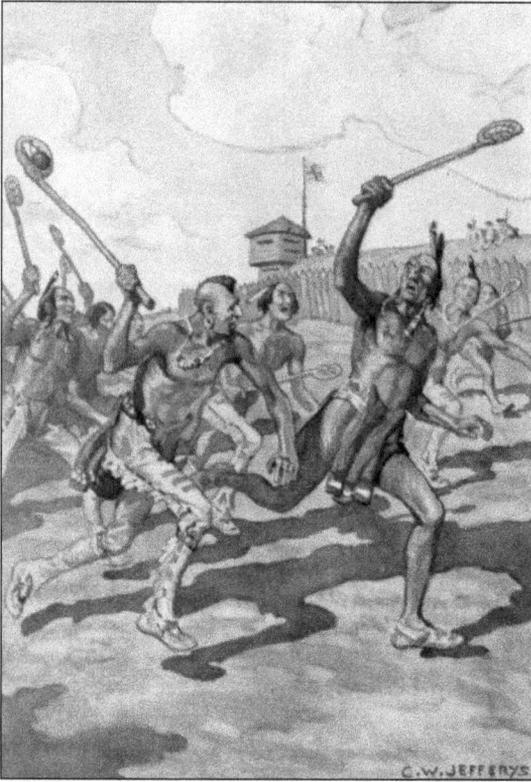

PONTIAC'S LACROSSE GAME IN MAJ. JOHN RICHARDSON'S HISTORICAL NOVEL WACOUSTA. Pontiac, leader of the Ottawa people, conceived a plan to oust the British from the fort at Detroit in 1763. The plan was to play a game of lacrosse outside the fort where the ball would go over the wall. When getting permission to retrieve the lost ball, the warriors would rush the fort once the drawbridge was lowered; however, a Native American woman informant foiled the plan. (Author's collection.)

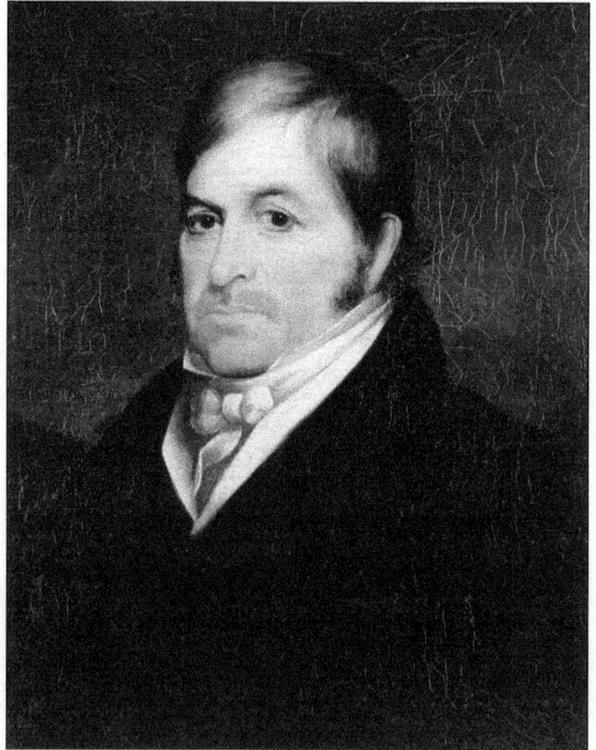

SOLOMON SIBLEY. Sibley came to Detroit in the 1790s. He was one of the first lawyers there and the first mayor in 1806, drafting the city's first charter. He married Sarah Whipple Sproat Sibley. Together they used their wherewithal to oversee the settlement at Pontiac. They financed the first buildings and mills at Pontiac. According to the Solomon Sibley manuscript file at the Burton Historical Collection of the Detroit Public Library, "There was a wagon in Detroit, the property of Judge Sibley, that was lent to those who needed it." (Courtesy of Burton Historical Collection, Detroit Public Library.)

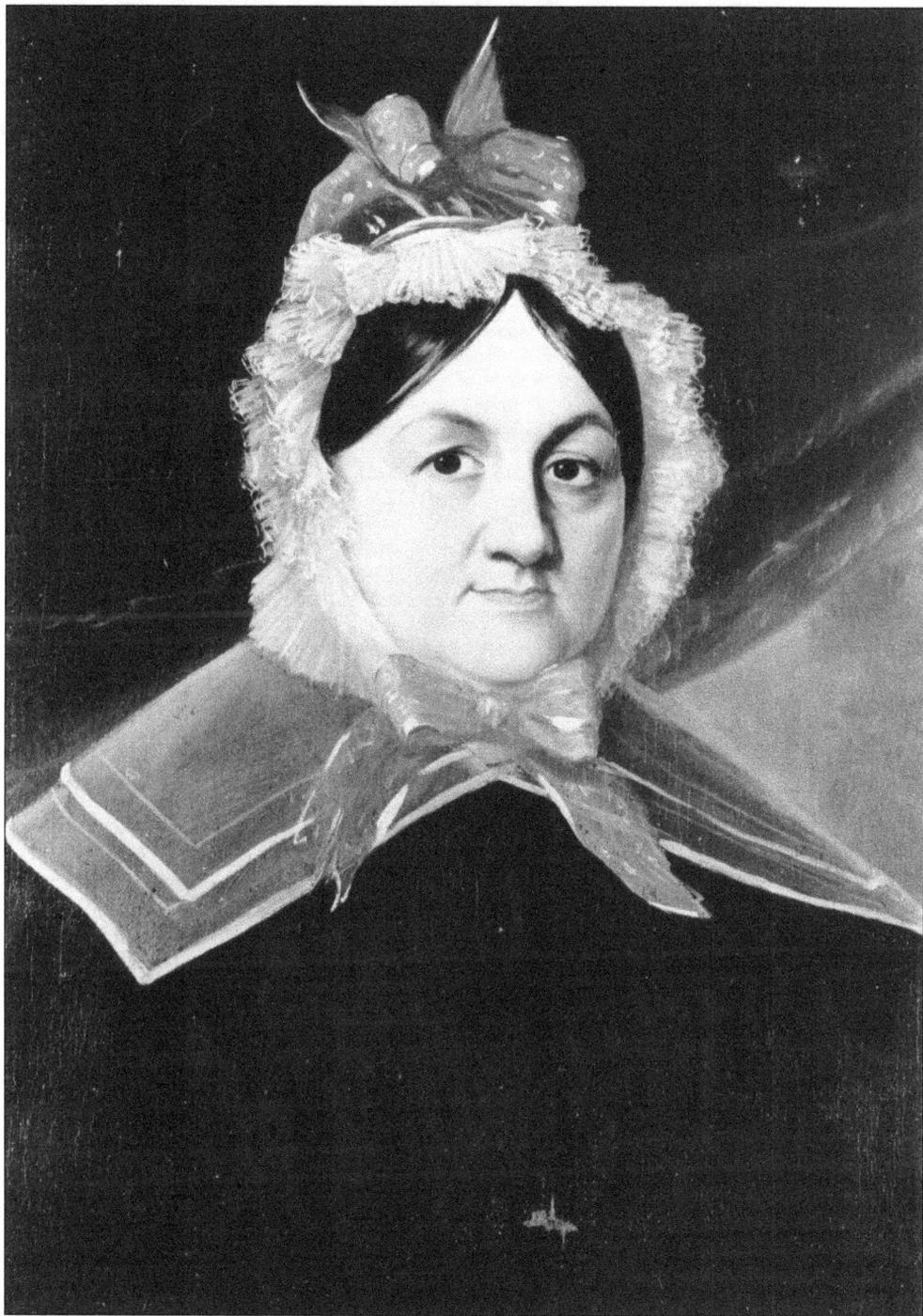

SARAH WHIPPLE SPROAT SIBLEY. Sarah and Solomon had nine children. When Solomon was away in Washington D.C., Sarah stayed in touch with Pontiac settlers to make sure needs were met and that the company of Mack and Sibley had capital. She is credited with having brought the first piano to Detroit. She built a house after her husband's death in 1846 that still stands on East Jefferson Avenue in Detroit. (Courtesy of Burton Historical Collection, Detroit Public Library.)

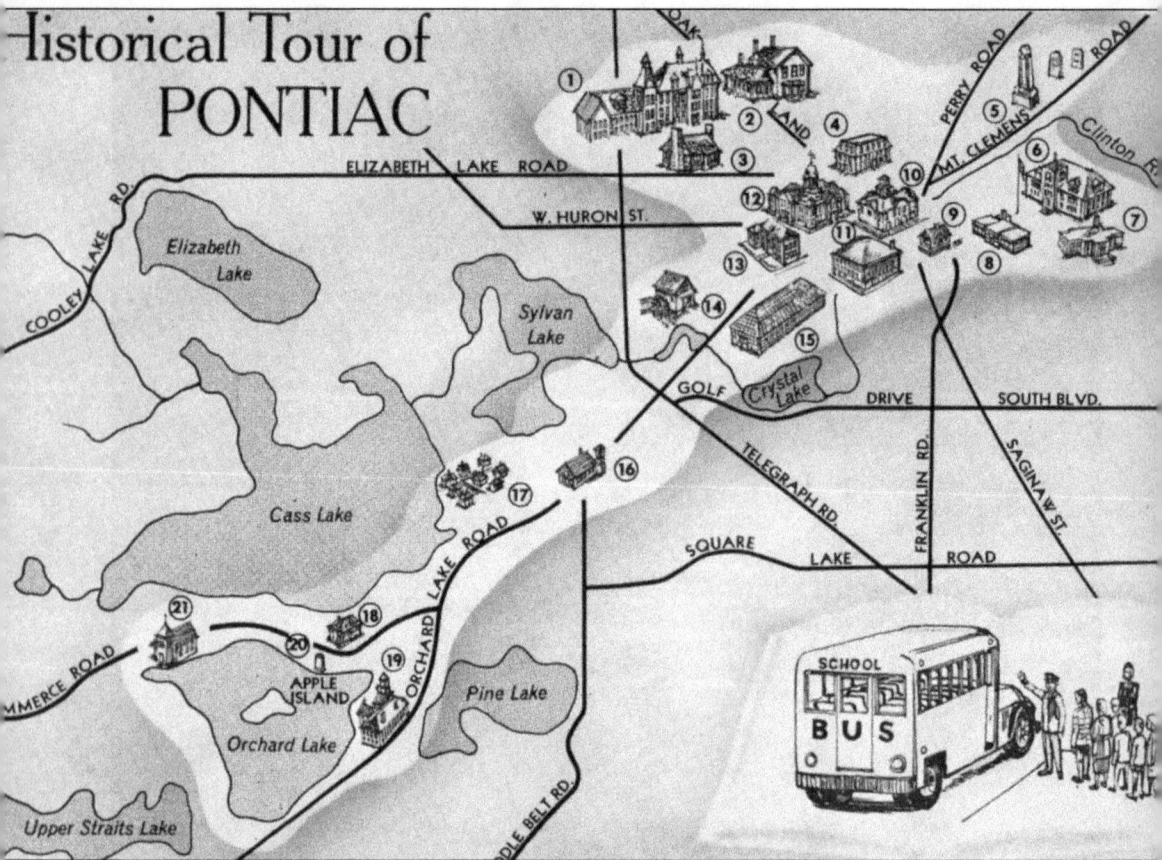

Historical Tour of PONTIAC

SCHOOL HISTORICAL TOUR OF PONTIAC. A typical tour for a third-grade class in a Pontiac school in the 1960s included the following locations numbered on the map: (1) Pontiac State Hospital, (2) Gov. Moses Wisner home, (3) the log cabin at the state hospital, (4) the Furlong Building, (5) Oak Hill Cemetery, (6) Central Elementary School, (7) Pontiac City Hall, (8) the Safety Building, (9) the site of the first house, (10) Fire Station No. 1, (11) Chapman Hotel (Hodges House), (12) Temple of Justice (county courthouse), (13) Pontiac Central High School, (14) Dawson Millpond, (15) Pearce Floral Company, (16) Whitfield Elementary School, (17) Keego Harbor, (18) David Ward's home, (19) Saint Mary's College, (20) the plaque at end of the Native American Trail, and (21) Orchard Lake Community Presbyterian Church. This educational tour visited historic sites in the city limits but also the surrounding lake communities. Whitfield School was in the Pontiac School District but outside the city limits. (Courtesy of Linda Porter.)

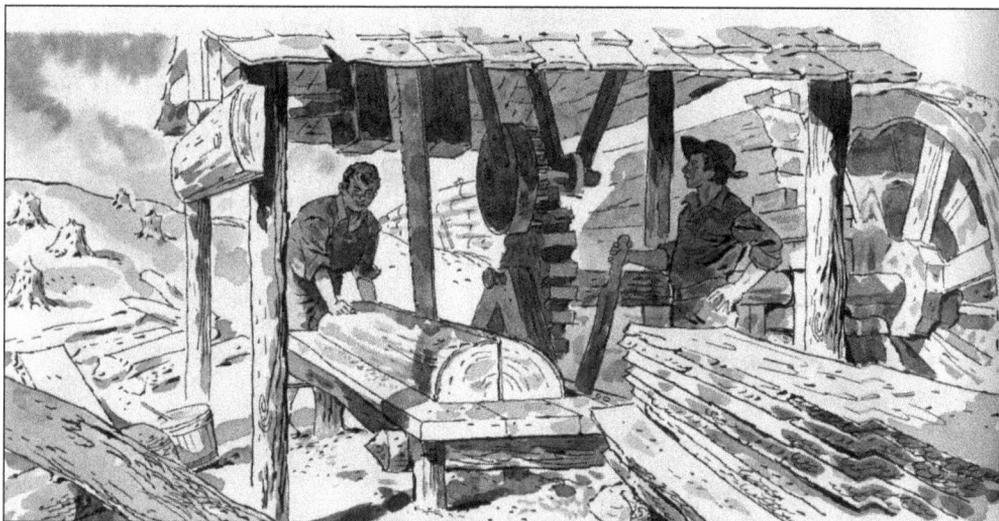

EARLY SAWMILL. Early water-powered sawmills didn't use a circular blade, as there wasn't enough power in early mills for that. Early saws used a vertical blade, as shown, to cut logs into boards. Logs were moved by hand through the blade. Pontiac's first sawmill was up and running as early as 1820, as referenced in a letter from Sarah Sibley to her husband, Solomon. (Courtesy of Linda Porter.)

SIBLEY-HOYT HOUSE. There is a cabin in the heart of this house, built by the Sibleys, that was on a 10-acre out lot and part of the original village of Pontiac. They purchased the out lot along with the "mill privilege," water rights to the Huron River of St. Clair, now the Clinton River. It was one of the first structures in the new village. The first cellar likely belonged to this house. Another house was moved here by the Hoyts and added to the cabin in 1867. (Author's collection.)

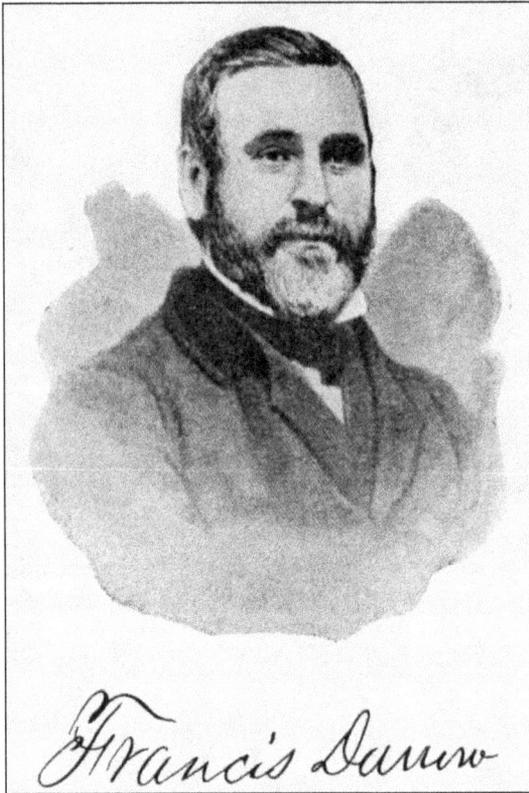

FRANCIS DARROW. Darrow came to Pontiac in 1831. He married Augusta LeRoy, the daughter of Oakland County's first prosecuting attorney, Daniel LeRoy. Darrow formed a partnership with his brother-in-law, Abel Peck, to erect the first brick building in town and to establish the second subdivision, Darrow and Peck's Subdivision. Darrow was an ardent abolitionist serving as an officer in Oakland County's Free Discussion and Anti-Slavery Society in 1836. (Author's collection.)

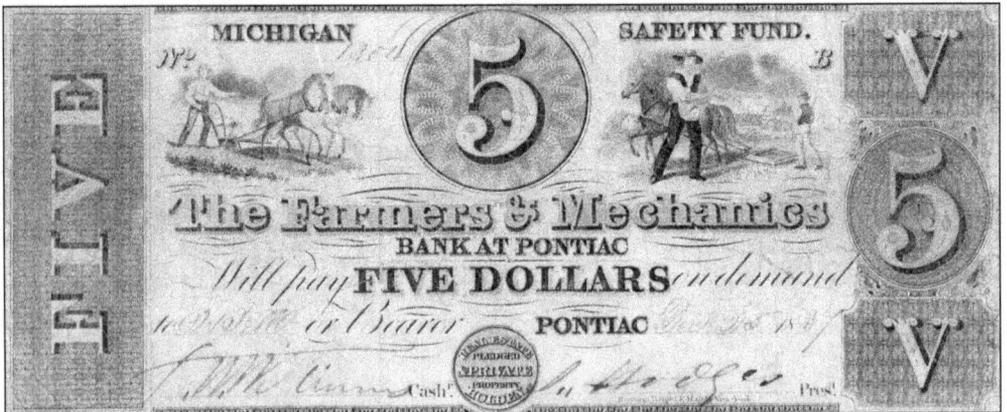

1837 BANK NOTE. Before federal currency, paper bills were issued by local banks. This bill dates to 1837 and was issued by Farmers and Mechanics Bank, one of several wildcat banks that popped up in Pontiac as a result of the recession of the 1830s. President Jackson had called for land sales to be paid for in silver and gold, causing a drain on hard currency. These banks, like Farmers and Mechanics, quickly became insolvent. (Courtesy of Service Glass.)

SEELEY HOUSE. This Greek Revival house on West Lawrence Street was probably the first house built in Darrow and Peck's Subdivision in 1836. Thomas Drake, who was the owner of a sawmill north of Pontiac and the founder of the *Pontiac Gazette Newspaper*, built the house. Most of the original house was replaced with an auditorium by the First Church of Christ, Scientist in 1921. It is currently the home of Mount Zion Missionary Baptist Church. (Courtesy of OCPHS.)

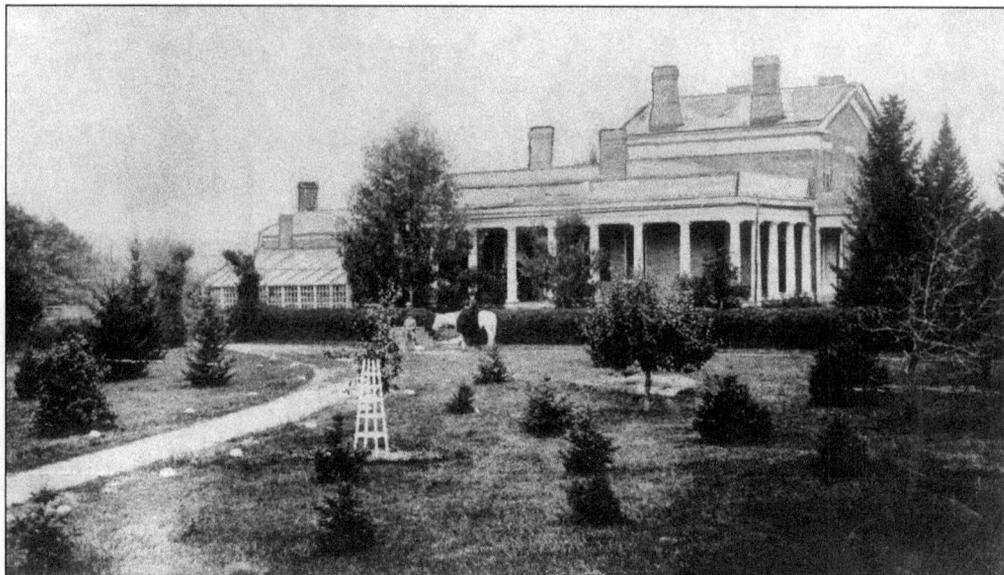

PINE GROVE. This is the home of Michigan's 12th governor, Moses Wisner, his wife, Angeolina, and their family. The house started as a small brick structure in 1845. The larger facade was added in 1858, when Wisner was elected governor. With no gubernatorial mansion in Lansing, Wisner made changes to accommodate the duties of his newly elected position. It is currently the home of the Oakland County Pioneer and Historical Society. (Courtesy of OCPHS.)

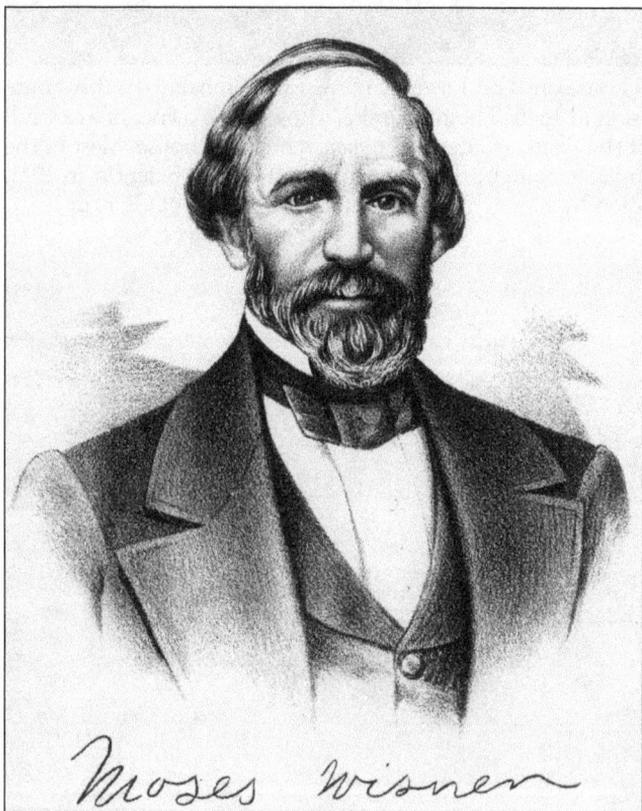

MOSES WISNER. Born in 1815, Wisner came to Pontiac in 1845 and built the family homestead. After his first term as governor (1859–1861), he enlisted in the Union army. As a colonel, he organized the 22nd Michigan Infantry in Pontiac and left Michigan in September 1862. He died on January 5, 1863, of typhoid in Kentucky. Wisner was an attorney by trade but also loved gardening. (Courtesy of OCPHS.)

MARY ANNA WILLIAMS HODGES.
Daughter of Oliver Williams, Mary
Anna married Schuyler Hodges in
1828. Before the age of 16, she walked
many miles to take care of the sick
and sat up many a night watching
over the dying in Pontiac. According
to *The History of Oakland County
1817–1877*, Hodges commented,
"Many nights the only sound to
break the stillness was the chirping
of the August cricket upon the
hearth." (Courtesy of OCPHS.)

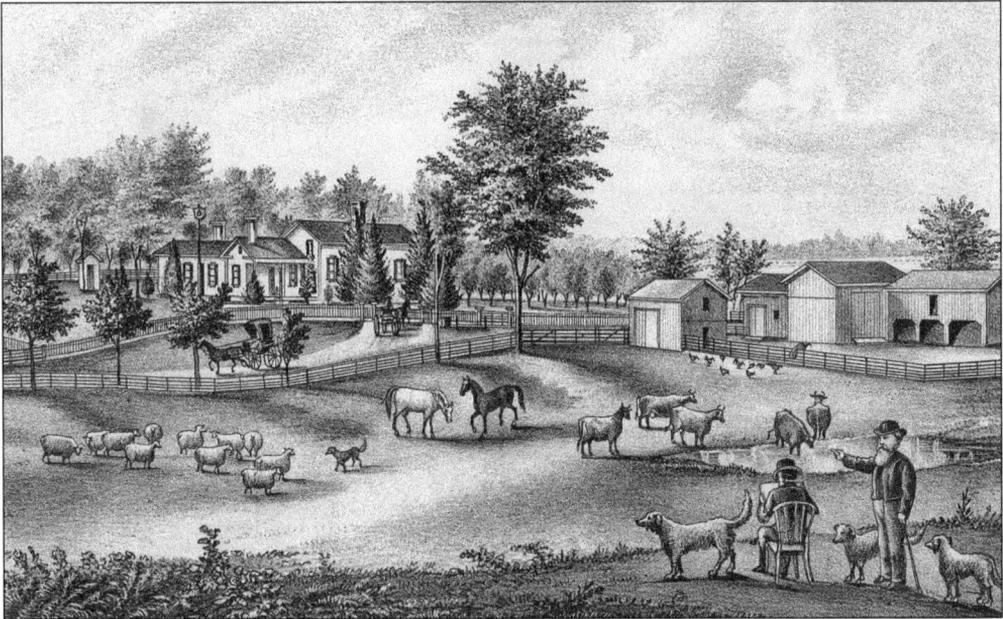

SPENCER FARM. This engraving of a typical farm was included in *The History of Oakland County
1817–1877*. There are cows, sheep, dogs, horses, an orchard, and farmland. There is a bell high up
in front of the house and an outhouse. The slope of the roof indicates it was built in the 1840s
or 1850s. (Courtesy of OCPHS.)

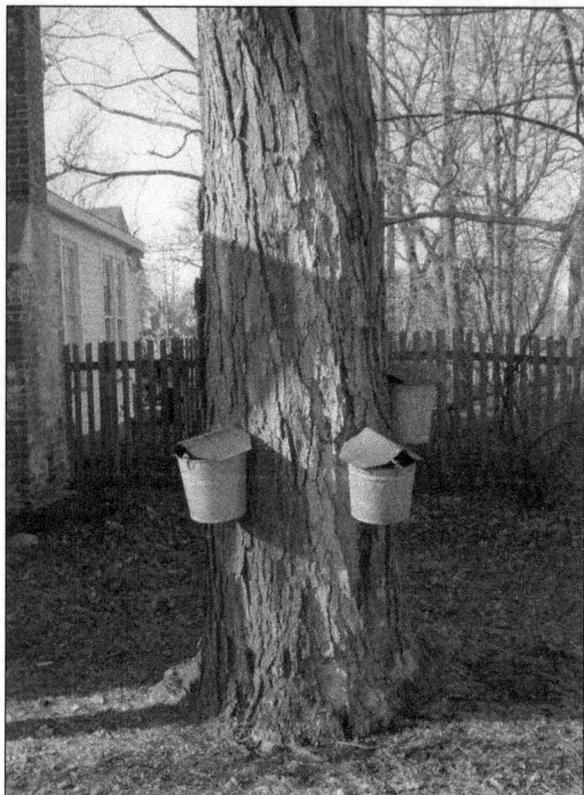

MAPLE SUGARING. Buckets are hung on sugar maple trees in March and April at the Sibley-Hoyt House in Pontiac. Pioneers relied on maple syrup in northern climates for a sweetener throughout the year. The process was learned from Native Americans. It takes 32 gallons of sap to produce 1 gallon of syrup. Fine lumber for furniture also comes from sugar or hard maple trees. (Author's collection.)

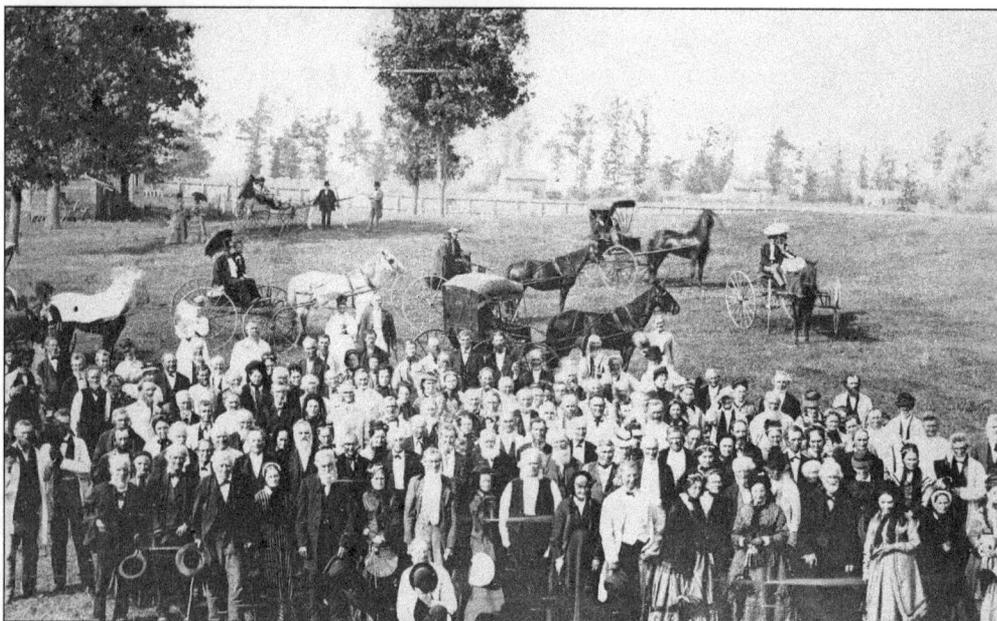

PIONEER'S REUNION. In 1874, those still living who were the first settlers of Pontiac and their families gathered for a reunion to recall old times when Pontiac was a mere path in the wilderness, with few houses and no railroad. By the time of their reunion, Pontiac had progressed to having 18 bridges, 1 being iron and 4 of them crossing Pontiac Creek. (Courtesy of OCPHS.)

Two

OAK LAND, OAK HILL

Pontiac is the heart of Oakland. In 1820, it became the seat of the new county, named for its abundance of oak openings. Nowhere else will one find such a wealth of oaks and waterways. Oakland was the first county designated in the Michigan Territory that was not bordering a Great Lake or connecting waterway. It initially comprised portions of yet to be created counties, but by 1822 it had its present-day shape. Pontiac was the natural selection for the county center, both for geographic reasons and its varied resources. The first judges, such as William Thompson, lived in Pontiac. Through all of the 19th century and half of the 20th, the county courthouse and jail were in town. The county made the unprecedented decision to move the county courthouse and jail from the city center to the outskirts in 1960. This was because of the unbridled growth, largely due to the automotive industry and lack of parking. Pontiac annexed a site in Waterford, where some county services already existed.

Oak Hill, Pontiac's first cemetery, is one of four cemeteries here. The Pontiac Company set Oak Hill aside in 1822, but the first burials didn't occur until 1839. Stephen Mack and his daughter Lovina were disinterred from the Mack homestead and buried at Oak Hill. Others who had been laid to rest on their own land were also relocated there or to Mount Hope, the Catholic cemetery that opened in 1855. Those that had been buried at the pioneer cemetery at Saginaw and Huron were removed to final rest at Oak Hill. In 1929, the city opened a new cemetery, Ottawa Park, in Clarkston due to the limited space at Oak Hill. Also, Perry Mount Park and Crematory is a family-owned and -operated establishment that is 100 years newer than Oak Hill, located on the north end of town.

FIRST WRIT. On July 10, 1820, the county court of Oakland issued this writ to arrest four individuals for trespassing and damaging another's property. Damages were assessed at $1,000. The court ordered them to be held and to be made responsible to pay. William Thompson was Oakland County's first judge. The county clerk was Sidney Dole. (Author's collection.)

CIVIL WAR COURTHOUSE. This 1858 building was Oakland's second courthouse, measuring 60 feet by 100 feet. It was larger than the state capital at the time. It succeeded a structure framed with logs that served as the courthouse and jail. The southwest corner of Saginaw and Huron Streets was home to three courthouses from 1824 to 1960. The land was originally donated by the Pontiac Company. (Courtesy of OCPHS.)

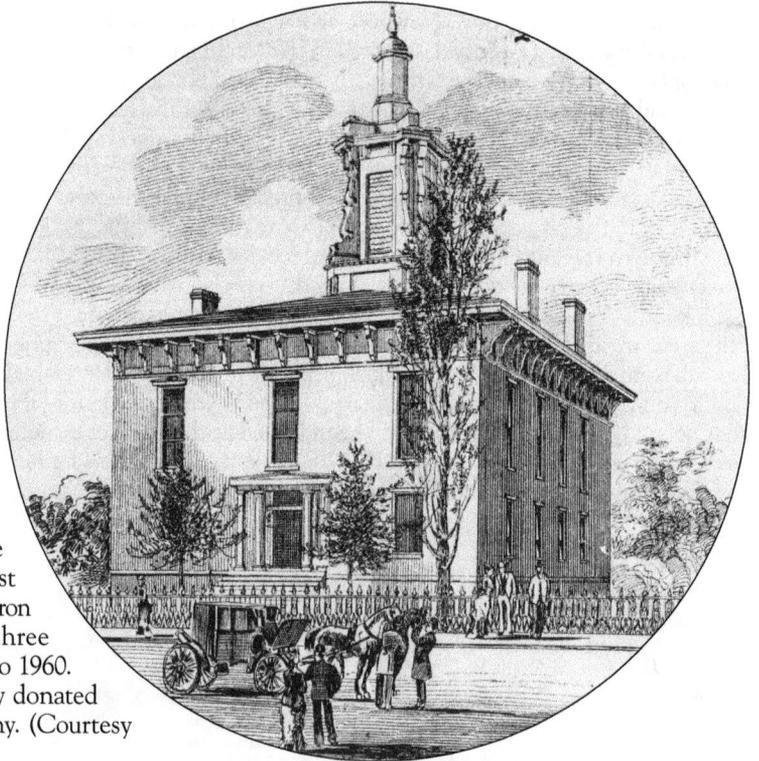

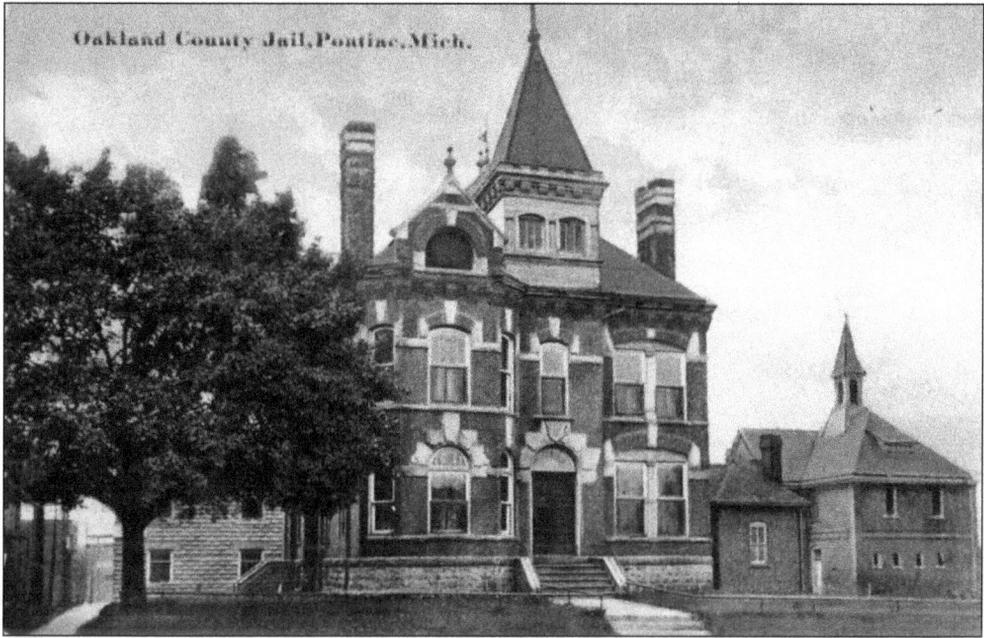

THIRD COUNTY JAIL. Erected in 1885, this building was also referred to as the courthouse annex after the fourth jail was built in 1922. The jail preceding this was located behind the courthouse, like previous jails. It was built with bricks and stones and had a tin roof. The sheriff's family lived on the first floor, and inmates lived in the 14 jail cells on the second floor. The cells were 6 feet, 6 inches high with boilerplate on the walls. (Courtesy of Service Glass.)

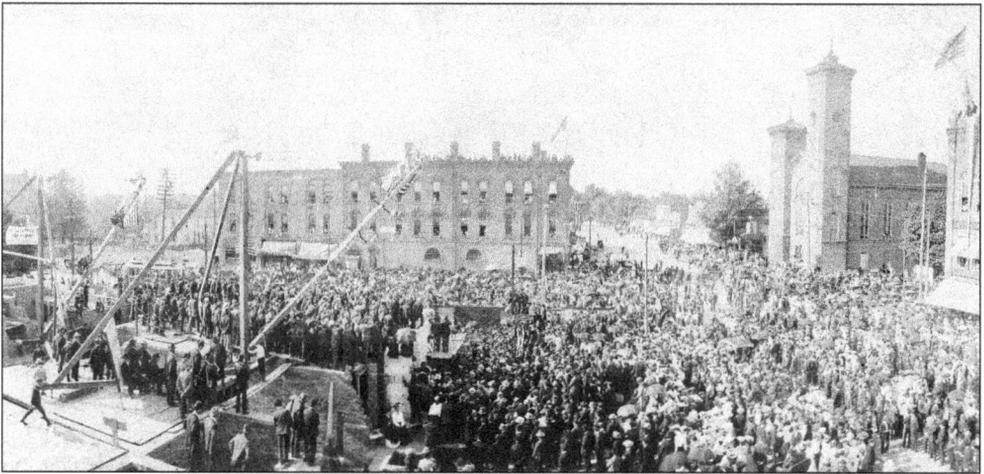

PLACING CORNERSTONE. Reportedly over 10,000 people attended the 1904 courthouse ground-breaking. A gentleman offered to place bets with passersby who thought they might outlive the new temple of justice. There were no takers. The Cleveland sandstone structure measured 100 feet by 90 feet. Joseph E. Mills, the architect, was a student of Elija Myers. Freemasons consecrated the cornerstone, which is now held at the Oakland County Pioneer and Historical Society's museum. (Courtesy of OCPHS.)

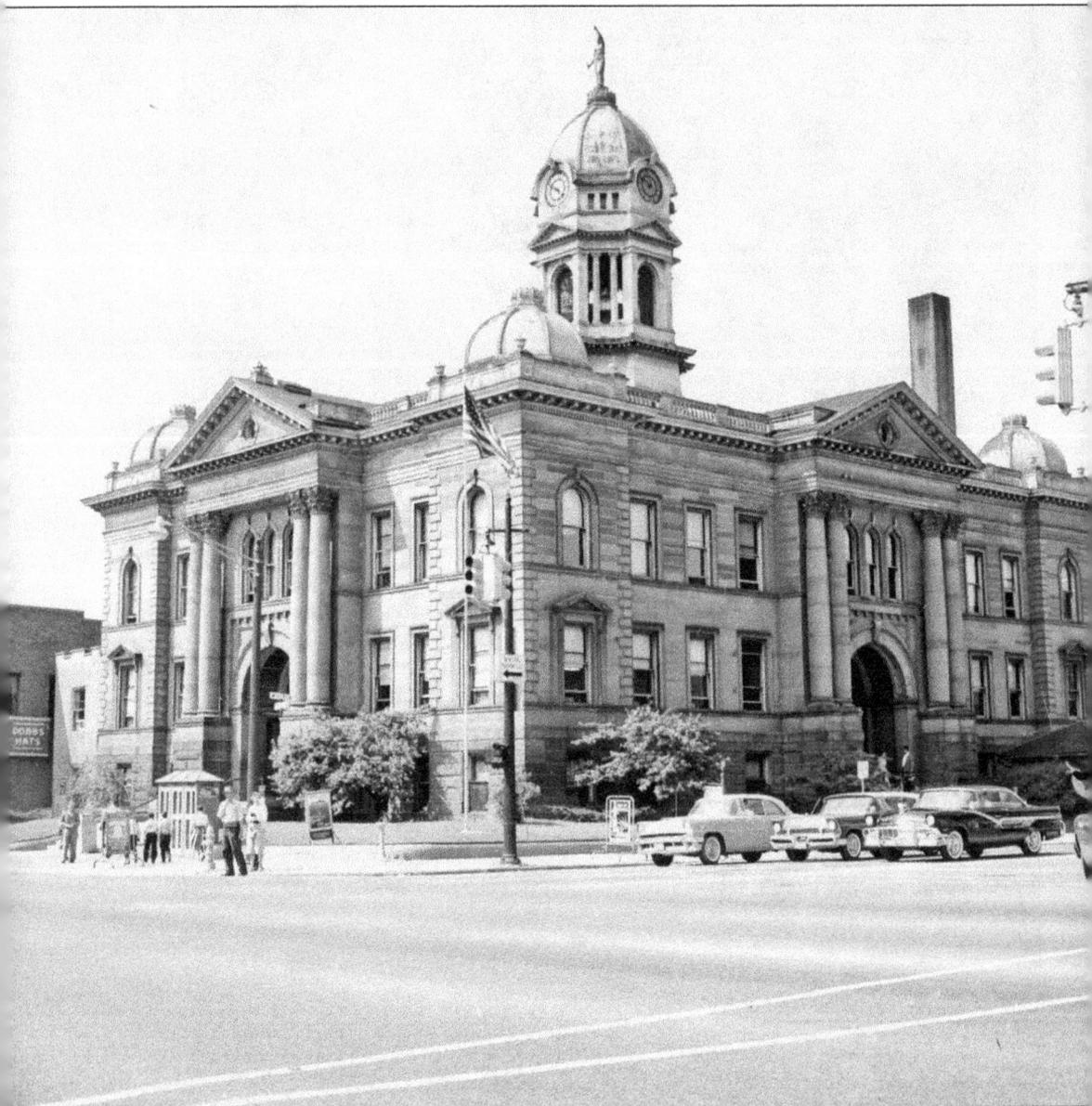

1904 COURTHOUSE. In 1909, this building housed the first probate court in the state, which handled juvenile matters. The lower level of the building held public restrooms, the commissioner of the poor, the school commissioner, and an auditorium. The main floor held the clerk's office, judge of probate and the courtroom, and other county departments. The upper floor contained the circuit court, prosecuting attorney, and county supervisors. One story has a man selling his wife's pies in front of the courthouse during the Depression; it was a different time. A dedication from the county infirmary a few years later read, "To all the finer emotions of men and women who have in their heart learned the lesson that they are their brother's keeper, to the aged and infirm, to the worthy men and women of Oakland County who find the last mile of life's road too difficult to travel alone this building is dedicated—dedicated to gentle charity, to human brotherhood, and to the end that there shall be less of suffering and more of peace." (Courtesy of Walter P. Reuther Library, WSU.)

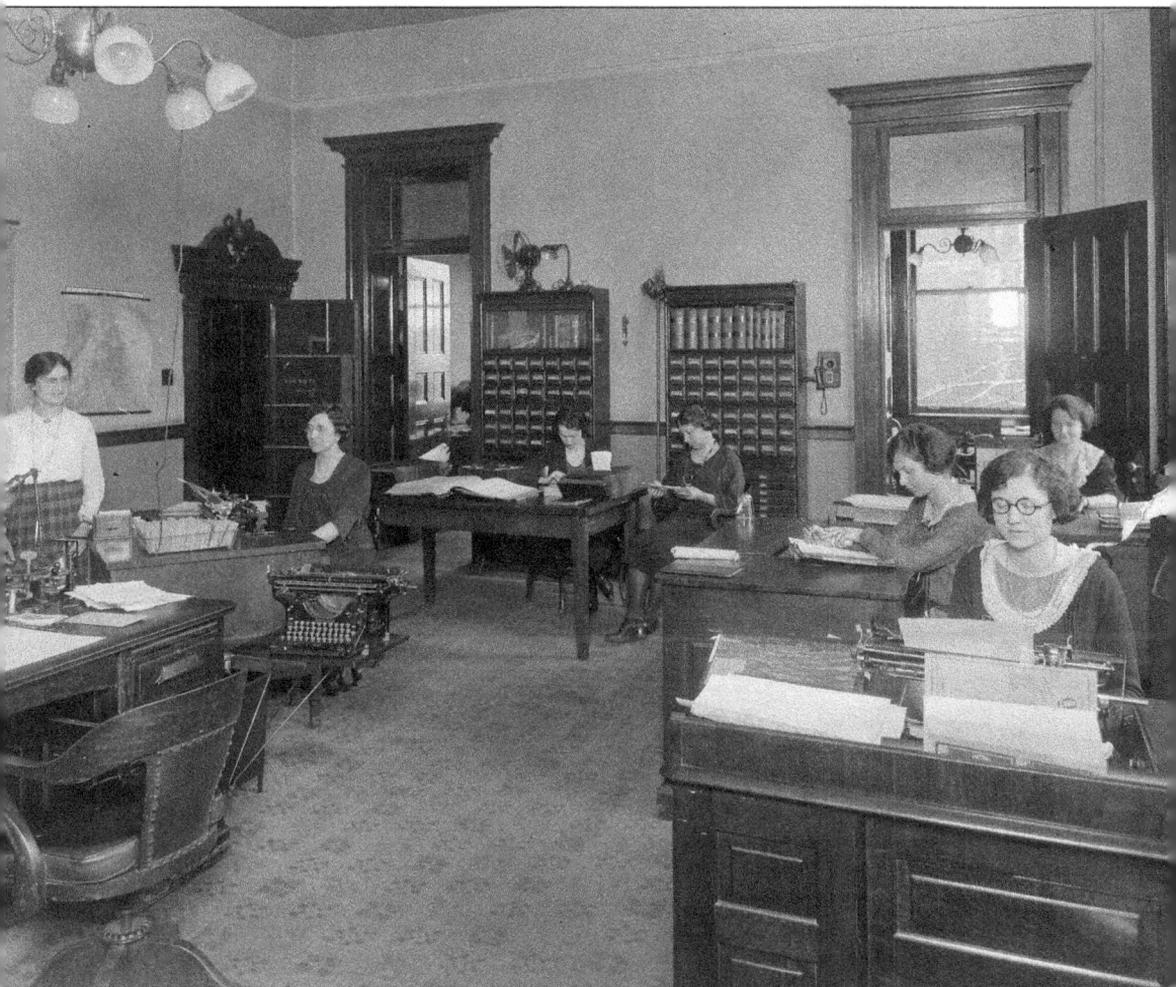

COURTHOUSE SECRETARIES. Courts and local governments are known for generating volumes of paperwork. No judicial system in the world could function back in the mid-1900s without diligent typists and clerical workers such as these. Those were the days when typewriters, carbon paper, and shorthand were the foundation of any busy office or courthouse. (Courtesy of OCPHS.)

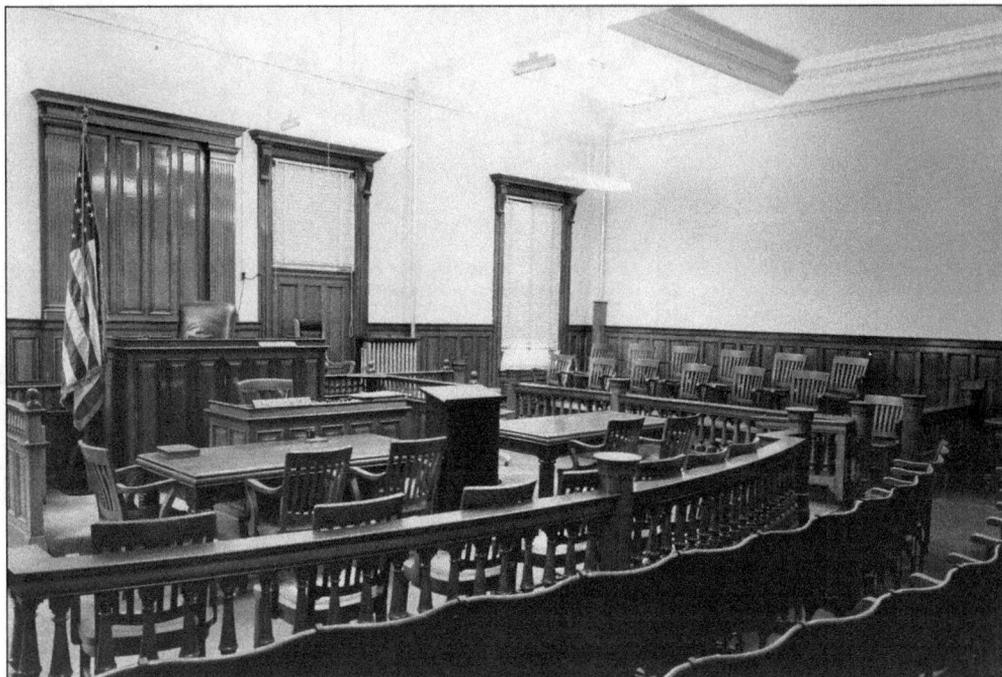

1904 COURTROOM. This courtroom and others like it remained largely unchanged from 1905 to 1961, when this courthouse was used. After it opened, the county grew at a quickening pace. After the county took ownership of the Masonic Temple around 1943, many county offices were located there. There was a county abstract office on South Saginaw Street early on. (Courtesy of OCPHS.)

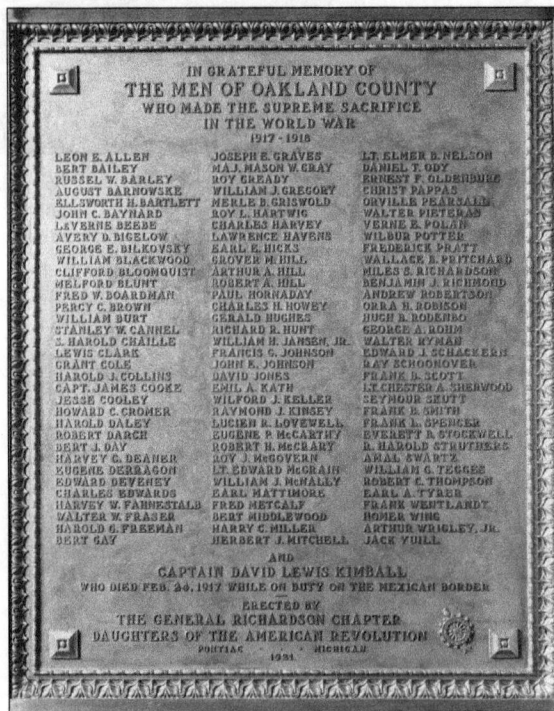

IN GRATEFUL MEMORY OF
THE MEN OF OAKLAND COUNTY
WHO MADE THE SUPREME SACRIFICE
IN THE WORLD WAR
1917 - 1918

LEON E. ALLEN	JOSEPH E. GRAVES	LT. ELMER D. NELSON
BERT BAILEY	MAJ. MASON W. GRAY	DANIEL T. ODY
RUSSEL W. BARLEY	ROY GREADY	ERNEST F. OLDENBURG
AUGUST BARNOWSKE	WILLIAM J. GREGORY	CHRIST PAPPAS
ELLSWORTH H. BARTLETT	MERLE D. GRISWOLD	ORVILLE PEARSALL
JOHN C. BAYNARD	ROY L. HARTWIG	WALTER PIETCRAS
LaVERNE BEEBE	CHARLES HARVEY	VERNE E. POLAN
AVERY D. BIGELOW	LAWRENCE HAVENS	WILBUR POTTER
GEORGE E. BILKOVSKY	EARL E. HICKS	FREDERICK PRATT
WILLIAM BLACKWOOD	GROVER M. HILL	WALLACE B. PRITCHARD
CLIFFORD BLOOMQUIST	ARTHUR A. HILL	MILES S. RICHARDSON
MELFORD BLUNT	ROBERT A. HILL	BENJAMIN J. RICHMOND
FRED W. BOARDMAN	PAUL HORNADAY	ANDREW ROBERTSON
PERCY C. BROWN	CHARLES H. HOWEY	ORRA H. ROBISON
WILLIAM BURT	GERALD HUGHES	HUGH B. RODENBO
STANLEY W. CANNEL	RICHARD R. HUNT	GEORGE A. ROHM
S. HAROLD CHAILLE	WILLIAM H. JANSEN, JR.	WALTER RYMAN
LEWIS CLARK	FRANCIS G. JOHNSON	EDWARD J. SCHLACKERN
GRANT COLE	JOHN K. JOHNSON	RAY SCHOONOVER
HAROLD J. COLLINS	DAVID JONES	FRANK D. SCOTT
CAPT. JAMES COOKE	EMIL A. KATH	LT. CHESTER A. SHERWOOD
JESSE COOLEY	WILFORD J. KELLER	SEYMOUR SKUTT
HOWARD C. CROMER	RAYMOND J. KINSEY	FRANK B. SMITH
HAROLD DALEY	LUCIEN R. LOVEWELL	FRANK A. SPENCER
ROBERT DARCH	EUGENE P. McCARTHY	EVERETT B. STOCKWELL
BERT J. DAY	ROBERT N. McCRARY	R. HAROLD STRUTHERS
HARVEY C. DEANER	ROY J. McGOVERN	AMAL SWARTZ
EUGENE DERRAGON	LT. EDWARD McGRAIN	WILLIAM G. TEGGEE
EDWARD DEVENEY	WILLIAM J. McNALLY	ROBERT E. THOMPSON
CHARLES EDWARDS	EARL MATTIMORE	EARL A. TYRER
HARVEY W. FAHNESTALB	FRED METCALF	FRANK WENTLANDT
WALTER W. FRASER	BERT MIDDLEWOOD	HOMER WING
HAROLD G. FREEMAN	HARRY C. MILLER	ARTHUR WRIGLEY, JR.
BERT GAY	HERBERT J. MITCHELL	JACK YUILL

AND
CAPTAIN DAVID LEWIS KIMBALL
WHO DIED FEB. 24, 1917 WHILE ON DUTY ON THE MEXICAN BORDER

ERECTED BY
THE GENERAL RICHARDSON CHAPTER
DAUGHTERS OF THE AMERICAN REVOLUTION
PONTIAC 1921 MICHIGAN

WORLD WAR I COUNTY VETS. This plaque was located in the 1904 courthouse in Pontiac. It commemorates those soldiers from Oakland County who lost their lives in the Great War. Capt. David Lewis Kimball, memorialized at the bottom of the plaque, died in Mexico before the United States entered the war in Europe. He was honored with a military funeral procession through the streets of Pontiac. (Courtesy of OCPHS.)

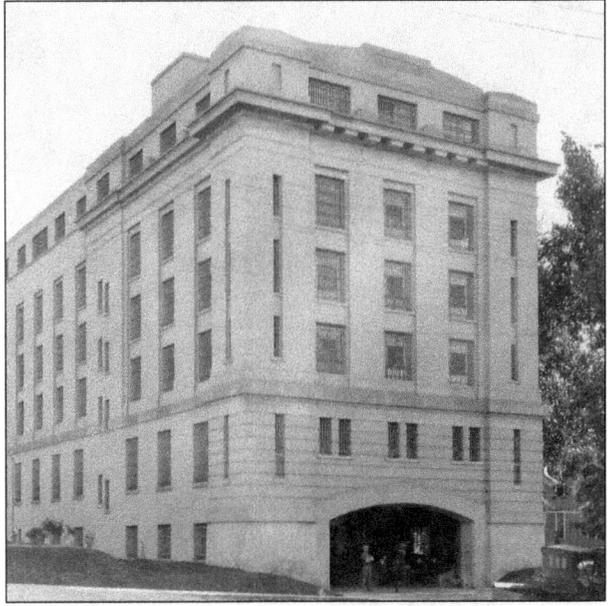

FOURTH COUNTY JAIL. This building was constructed after the 1904 courthouse. The redbrick jail that had been on Wayne Street south of Huron Street was not all that old but couldn't manage the volume of prisoners from Oakland County's explosive growth. This jail had the added feature of loading prisoners in an underground garage, which was no doubt more secure for deputies. (Courtesy of OCPHS.)

1960 COUNTY COMPLEX SITE. In the late 1950s, Oakland County made an unprecedented decision to build a new courthouse outside the city center. Pontiac's downtown had a serious shortage of land and parking. In order for the county to meet its legal obligation and locate within the city limits, the city had to annex a large tract of land to accommodate the new county complex. (Courtesy of Oakland County.)

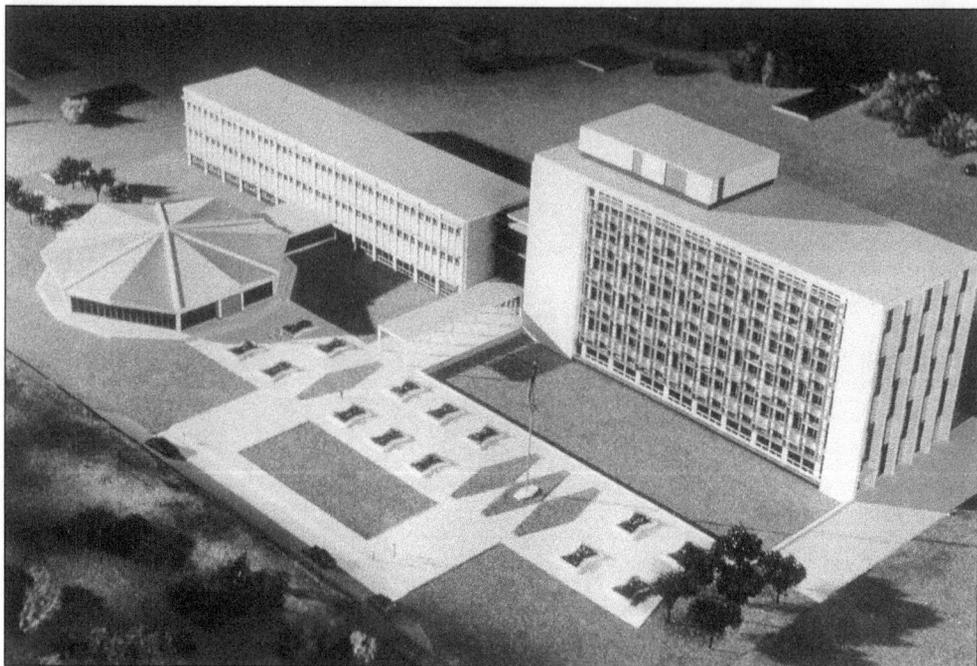

1960 COURTHOUSE. This photograph shows the model for the new Oakland County Courthouse that opened in 1961. It has a civic auditorium, the round separate structure in the front, and space for unlimited parking and expansion. It joined other county buildings that had been on the property for several decades, such as the health department. Almost immediately after opening, a large wing was planned due to an underestimated need for space. (Courtesy of Oakland County.)

1960s COUNTY JAIL. This is the fifth jail building for the county, not including the first primitive arrangement prior to 1823. Construction began on December 12, 1969, and the building was dedicated on August 3, 1972. It was built on the county complex site with the courthouse. It has undergone major expansions and additions since it was built, which includes off-site facilities. (Courtesy of Oakland County.)

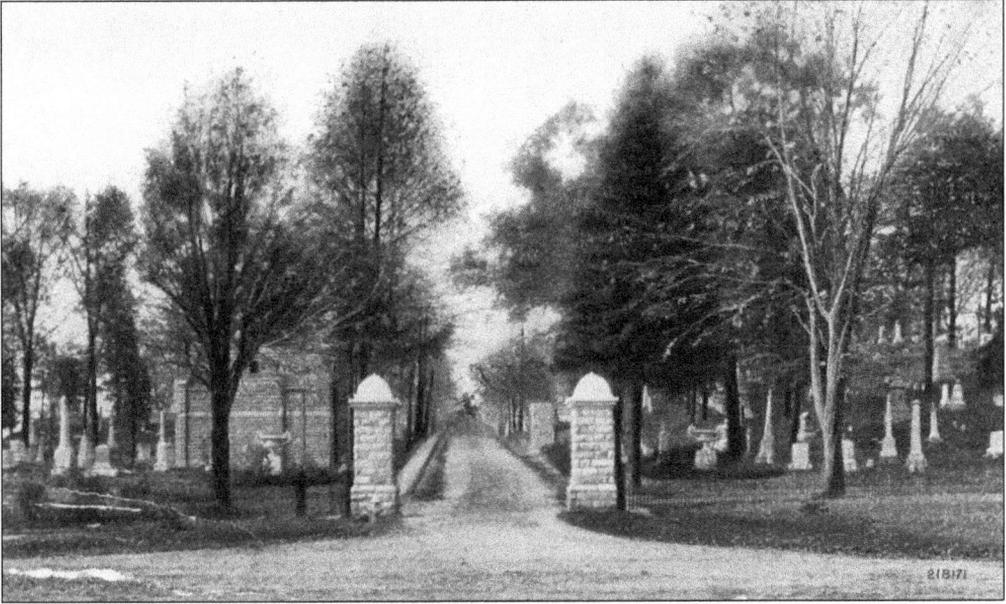

OAK HILL CEMETERY. This is one of Oakland County's most interesting burial places. In 1822, the founders of Pontiac set aside out lot nine for a cemetery, but it wasn't laid out until 1839. There are two additions to the original section comprising 60 acres in all. In 1935, fees for welfare funerals ranged from $7.50 for stillborns to $50 for those five and older. (Courtesy of Service Glass.)

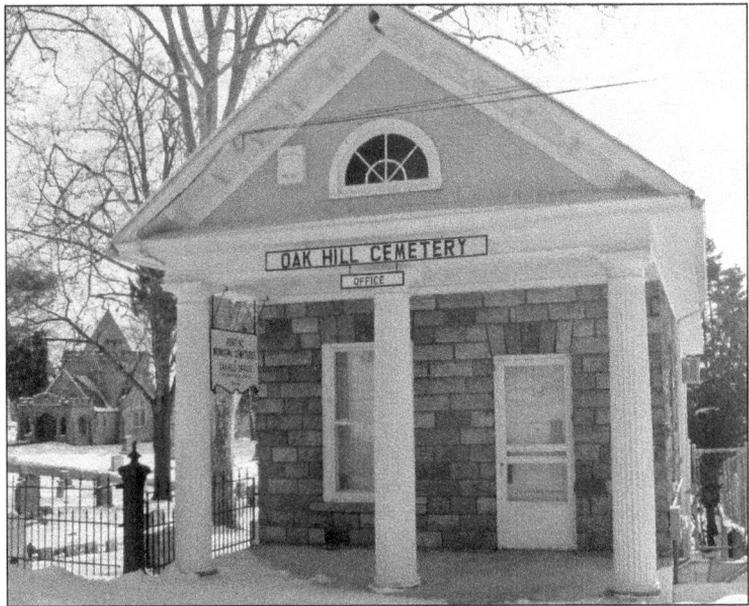

CEMETERY OFFICE. One of Pontiac's oldest structures, Oak Hill's office building dates to 1839, which was when the cemetery was laid out and burials began. It has housed cemetery records for almost two centuries. In 1942, the Civilian Defense Corps sent a letter to the cemetery to have them formulate a plan for mass burials in case of a bombing. (Author's collection.)

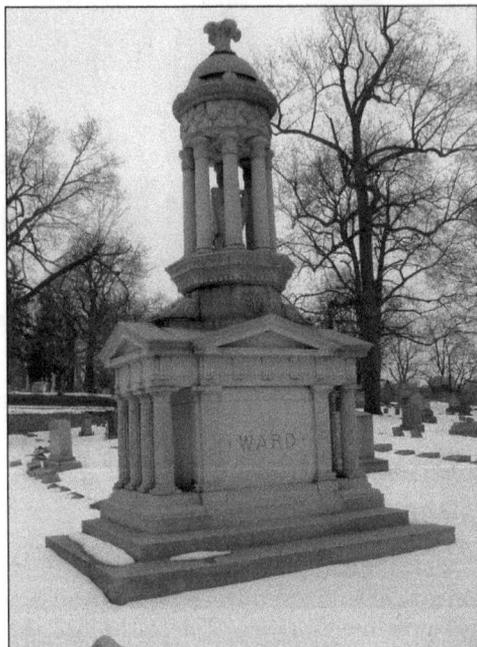

WARD MONUMENT. The Ward family was a prominent family for decades in Pontiac and the surrounding area. Streets are named for family members. A large house used to stand on Commerce Road facing Orchard Lake that was the home of Dr. David Ward and his family. The Ward family intermarried with the Palmers of West Huron Street. This monument is an example of the extraordinary detail and cost that went into memorializing citizens of means. (Author's collection.)

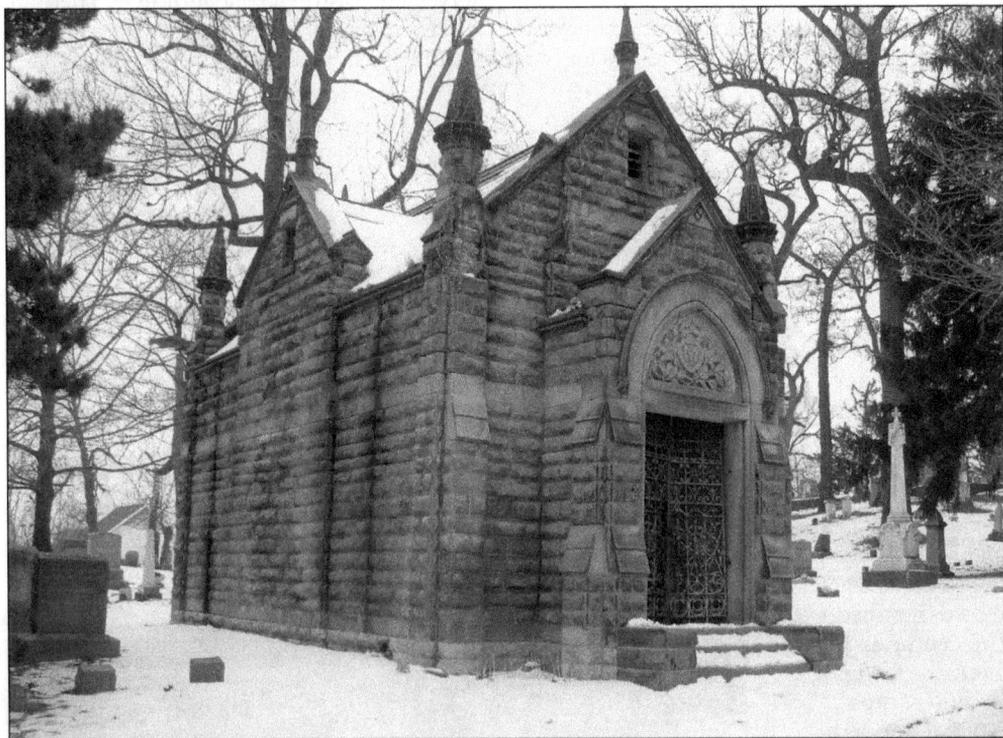

MAUSOLEUM. This is the largest of several crypts in the cemetery. There is nothing comparable in Oakland County to the collection of tombstones and mausoleums here at Oak Hill. In 1929, to have a mausoleum erected cost $1,500 plus the price of the lot and the actual cost of building the structure. Two grave sites cost $50 and could be purchased on a payment plan. (Author's collection.)

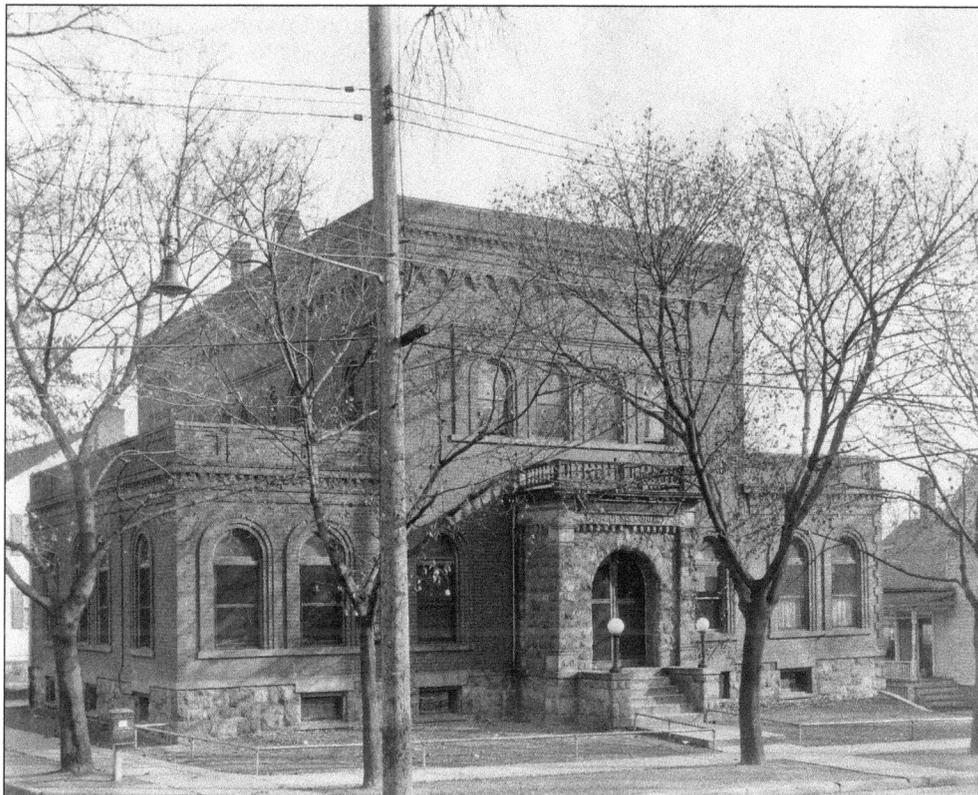

STOUT MEMORIAL LIBRARY. Dedicated in 1898, this is the county's first public library, built at the bequest of Byron G. and Hanna C. Farnham Stout. She was a founding member of the Ladies Library Association, which started over a decade earlier, opening the first library in a rented space downtown. This building functioned under the association until 1924, when the city took it over. (Courtesy of Pontiac Public Library.)

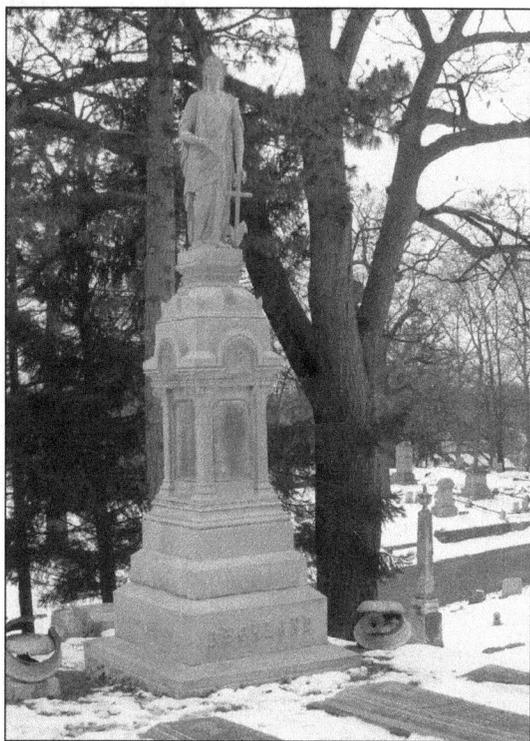

CAST METAL MONUMENT. This marker is cast zinc alloy, a trend in Victorian times. It belongs to the Buckland family, who built the chapel across the highway from this original section. The oak tree to the immediate right doesn't look so large from a distance, but its circumference is in excess of 15 feet. It was likely here when Pontiac was settled in 1818. The cemetery is home to many prize trees. (Author's collection.)

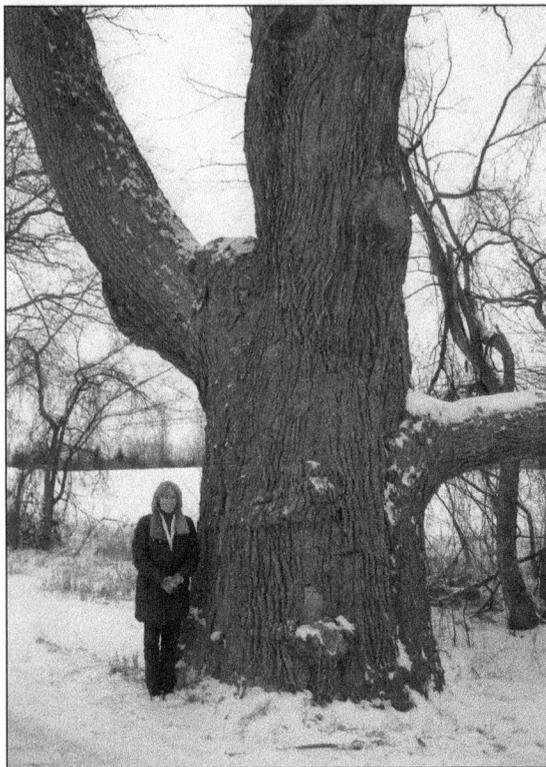

SHUETTE OAK. An example of one of Oakland County's massive oaks, this tree measured 18 feet, 9 inches in circumference, 114 feet in height, and 120 feet in spread when it was listed on the National Register of Big Trees in 1973 by American Forests. Located at the corner of Letts and Rush Roads, it currently measures over 21 feet in circumference. (Author's collection.)

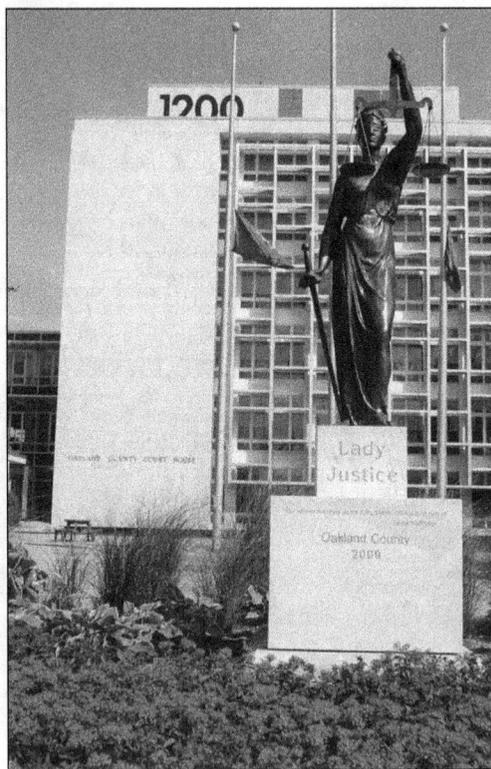

LADY JUSTICE. The Greek goddess Thermis is blindfolded to show impartiality, her sword indicates power to enforce the law, and her scales represent balanced judgment. The original sculpture, 9 feet tall and 160 pounds, sat atop the 1904 courthouse dome. Lady Justice was removed prior to the courthouse demolition in 1962 and put into storage for 20 years. Later the sculpture stood in front of the current courthouse entrance, where exposure to the elements caused damage. The original was restored and is displayed inside the courthouse. This replica takes its place outdoors. (Courtesy of Oakland County.)

Three

BECOMING A PLACE

In 1837, Pontiac had changed from an informally organized settlement to an incorporated village. The new legal entity allowed for a seven-member board of trustees, of whom a president was chosen. The first trustees for the Village of Pontiac were, in order of most votes: Schuyler Hodges, Randolph Manning, George W. Williams, Gideon O. Whittemore, Orison Allen, Benjamin Davis, and Daniel LeRoy; LeRoy was chosen as president. As the village was incorporated by an act of the state legislature, so were its boundaries. Michigan became a state this year as well.

On March 15, 1861, Pontiac was incorporated as a city, and the boundaries remained as they were. On April 1 of that year, offices for city government were voted on. The Civil War was about to break out. The campaign for enlistees into the Union army and funds to help those families who provided such volunteers was coupled with a roster of new city officers. Moses Wisner was governor at this time and was completing his first and only term. In 1862, he joined the army, and it was only a few months after leaving Pontiac to fight the Confederacy that he succumbed to typhoid and died at the age of 47 years old. Over the previous 10 years, Pontiac's population had more than doubled, and it was now around 2,500. The city had grown from a wilderness outpost to a well-established hub of commerce. The great waterpower of the Clinton River was largely responsible for this growth. The river was used for saw, grist, woolen, plaster, and planing mills. Wool, in particular, had become a major source of commerce for the new city during this period. Other changes responsible for this growth were the completion of the Erie Canal, the Detroit to Pontiac Turnpike, and of course the railroads that became operational in the 1840s.

Although the Emancipation Proclamation had taken place three years before, on December 18, 1865, the 13th Amendment was enacted into law, banning slavery in the United States. Pontiac was becoming industrialized, and the wagon- and carriage-making business was gaining legs. Pontiac was about to embark on a new chapter in its history in the coming decade.

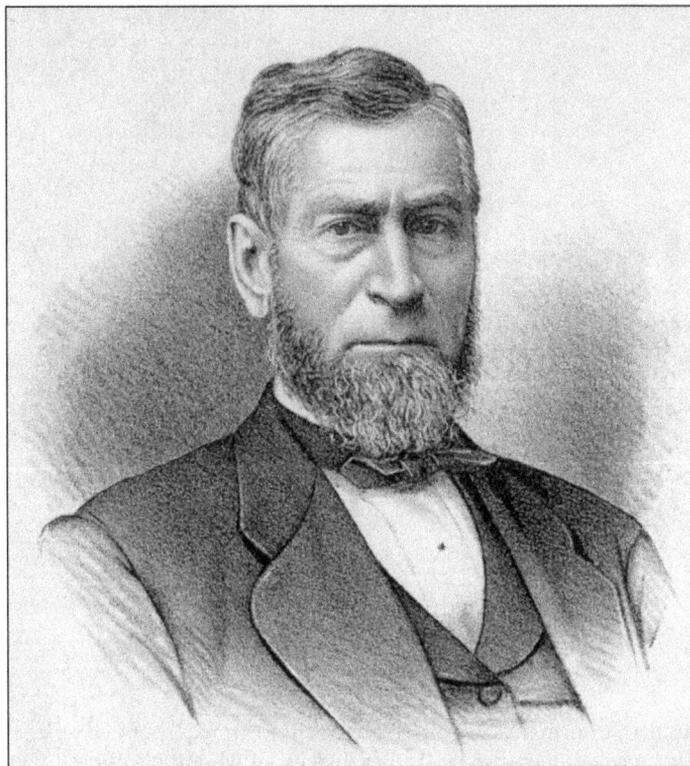

JUDGE BALDWIN. Augustus C. Baldwin was born in New York in 1817 and came to Pontiac in 1837. Over the years, he was a schoolteacher, state legislator, attorney, prosecuting attorney, and farmer. He was a U.S. congressman for a single two-year term. He was elected judge of the sixth judicial circuit in 1875. He was highly regarded as a judge and community leader. (Courtesy of OCPHS.)

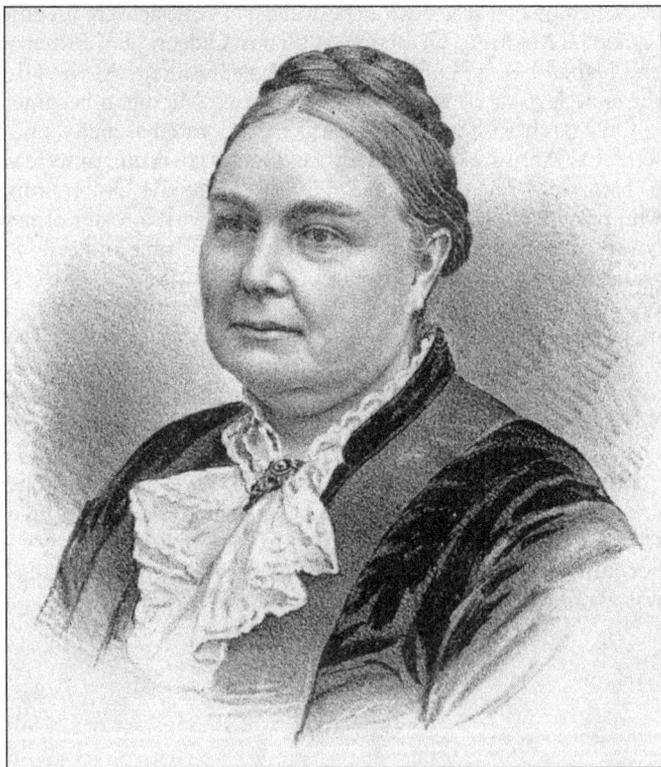

ISABELLA BALDWIN. Isabella Churchill Baldwin married Augustus in 1842. Together they lived in Milford, Bloomfield Township, and Pontiac. The Baldwins were said to have had the largest literary library in the northwest, and Judge Baldwin personally had the largest legal library in the territory, with around 14,000 volumes. The Baldwins were heavily involved in the local schools and the agricultural and horticultural interests of the state. (Courtesy of OCPHS.)

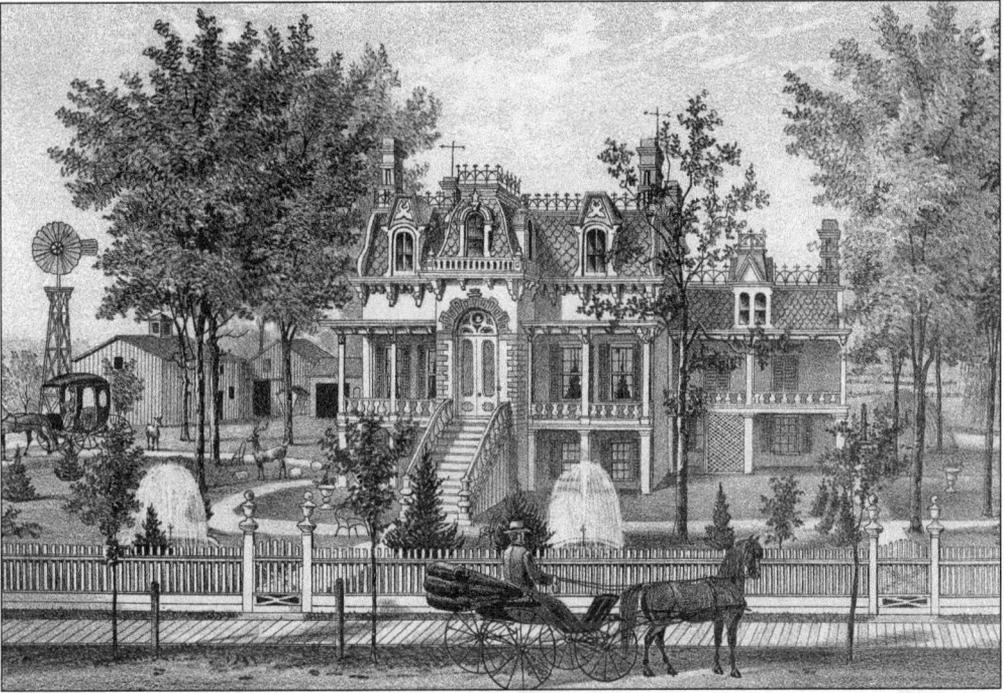

BALDWIN RESIDENCE. The high-level entry with an exposed basement was highly unusual for this part of the country back then. Fountains in the yard, large finials on the fence posts, and an egregious use of ornamentation on the dormers and roofline were all considered excessive. Also, there were five chimneys, three separate porches, a wooden sidewalk, and a mansard tiled roof. (Courtesy of OCPHS.)

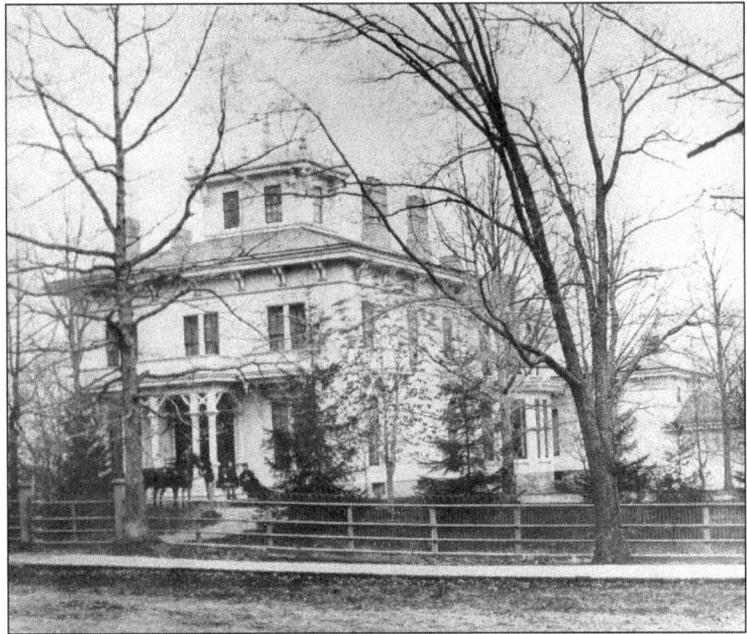

MYRICK-PALMER HOUSE. Built in 1852, the house is named for its builder, Myrick, and the Palmers, who lived there for generations. The belvedere on top was burned off in 1935 and rebuilt in 1992. The property was almost purchased by the Central Methodist Church in 1928 for the site of another church. (Courtesy of Mark Thomas.)

33

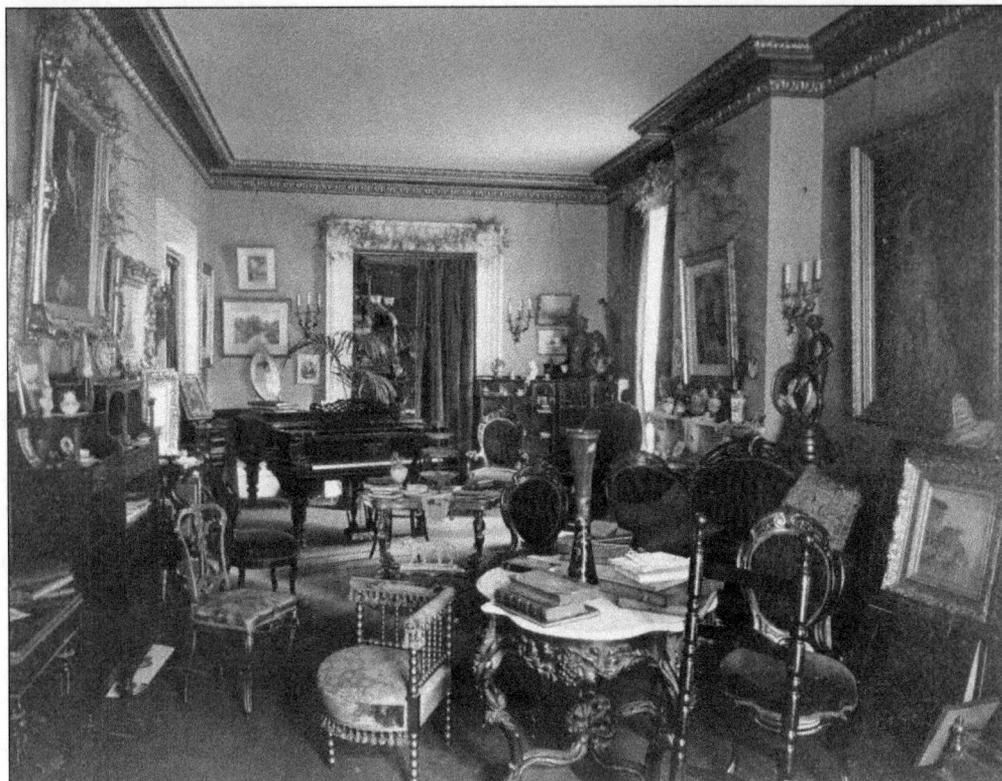

MYRICK-PALMER INTERIOR. This photograph is from the 1880s. It was said that successive generations who inherited the home were instructed to make their living quarters upstairs so as to leave the main floor parlors as they had been from previous generations. The house's interior to this day is essentially unchanged from the day it was built and remodeled over a century ago. (Courtesy of Mark Thomas.)

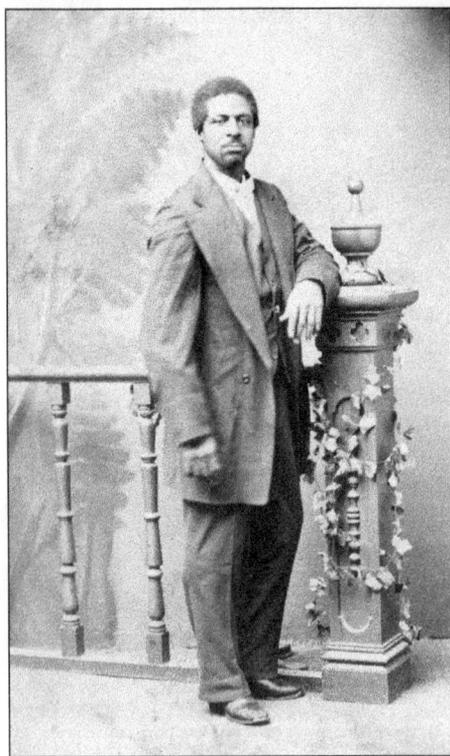

GENTLEMAN'S PICTURE. This picture appears to have been taken around the time of the Civil War based on the look of the photo studio. The image was taken by William Quatermass, a photographer in Pontiac. His studio was at 147 Saginaw Street. There were many African Americans living in Pontiac at this time. Their presence increased during the 1850s and dramatically after the war. (Courtesy of OCPHS.)

CLINTON RIVER EAST. When the town was founded, the river was named the Huron on St. Clair, referring to Lake St. Clair. Later it was renamed the Clinton for the former mayor of New York City and the governor of New York state, DeWitt Clinton. He was best known for spearheading the construction of the Erie Canal. This scene is east of town with the mills in the background. (Courtesy of Annalee Kennedy.)

DAWSON MILL. At Orchard Lake Road, the first waterpower below the lakes was a mile west of town. Charles Dawson opened a mill there on the east side of the road around 1850. There had been a sawmill near this site as early as 1833. Dawson also owned a flour mill by Oak Hill Cemetery for two years. There are still remnants of old foundations at this location. (Courtesy of Pontiac Public Library.)

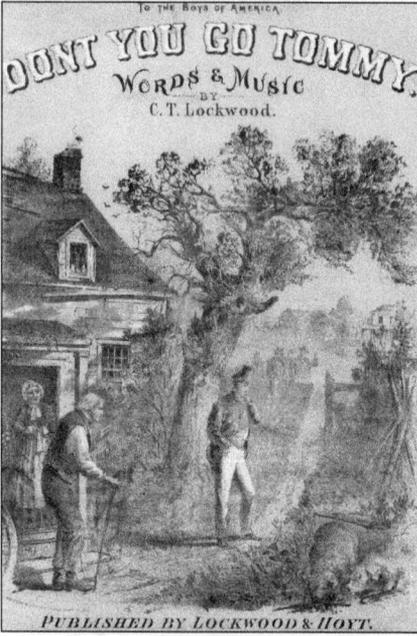

LOCKWOOD AND HOYT. Charles Lockwood and George Hoyt had two partnerships, a music store and a publishing business, in Pontiac. Both establishments were called Lockwood and Hoyt. Lockwood was an accomplished, nationally recognized composer and songwriter; Hoyt was an acclaimed professor of music who came to Pontiac with Charles Palmer in 1850 from Romeo. This piece of sheet music was a popular seller just after the Civil War. (Courtesy of Ray Henry.)

OAK GROVE SCHOOL. In time for the start of school, Pontiac's first high school was dedicated on August 30, 1871. It was 96 feet by 100 feet with three stories above the basement. The basement had a 14-foot ceiling, the first two floors had 15-foot ceilings, and the third floor had a 26-foot ceiling. The tower was 100 feet tall and could be seen from anywhere in the city. (Courtesy of OCPHS.)

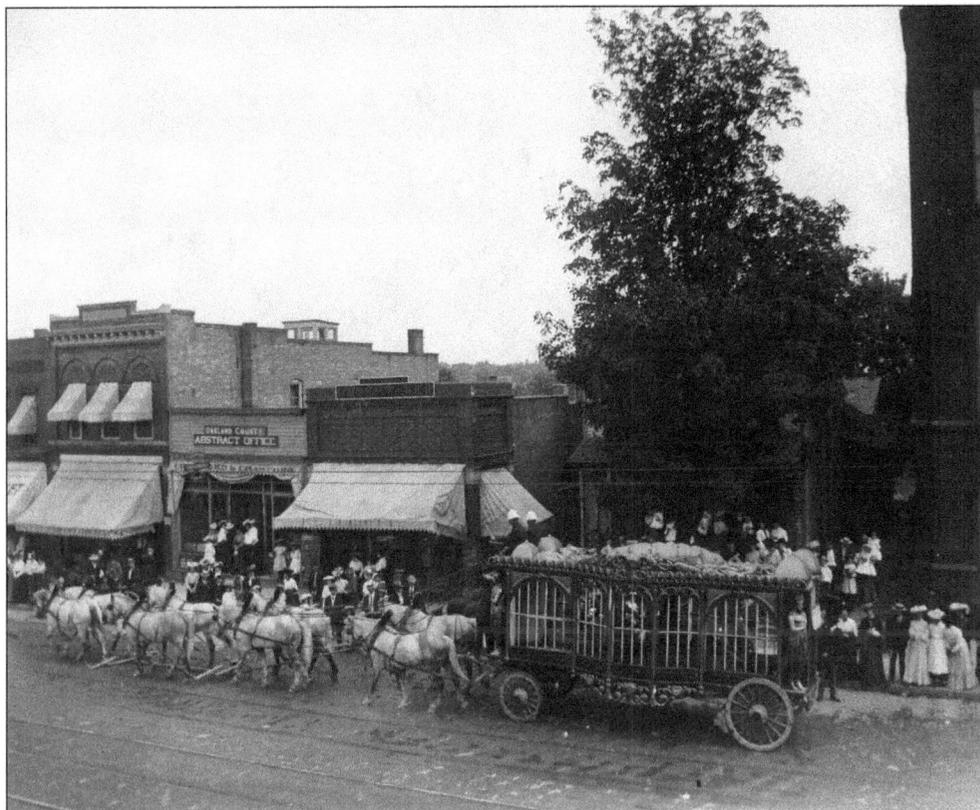

CIRCUS PARADE. When the circus came to town, it made a caravan from the train station to the fairgrounds by way of Main Street. There were calliopes (organs on wheels), tigers in caged wagons, and elephants. Before there were movies, radios, and record players, there was the circus. It was a childhood memory not soon forgotten. (Courtesy of Pontiac Public Library.)

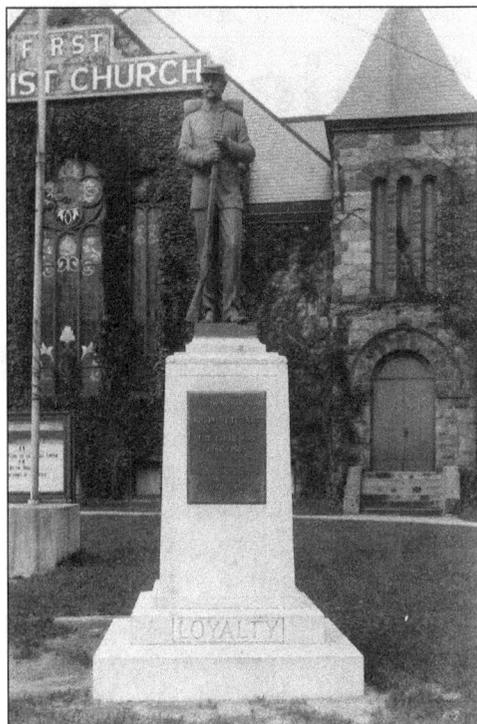

CIVIL WAR MEMORIAL. "In Loving Memory of Union Veterans of the Civil War 1861–1865, Erected by Frances C. Butterfield, Tent No. 9, Daughters of the Union Veterans, 1927," reads the plaque on the memorial statue. It was first located in front of the First Baptist Church at Oakland Avenue and Saginaw Street, and later it moved to the front of the city hall on the Woodward Loop side where it stands today. (Courtesy of Pontiac Public Library.)

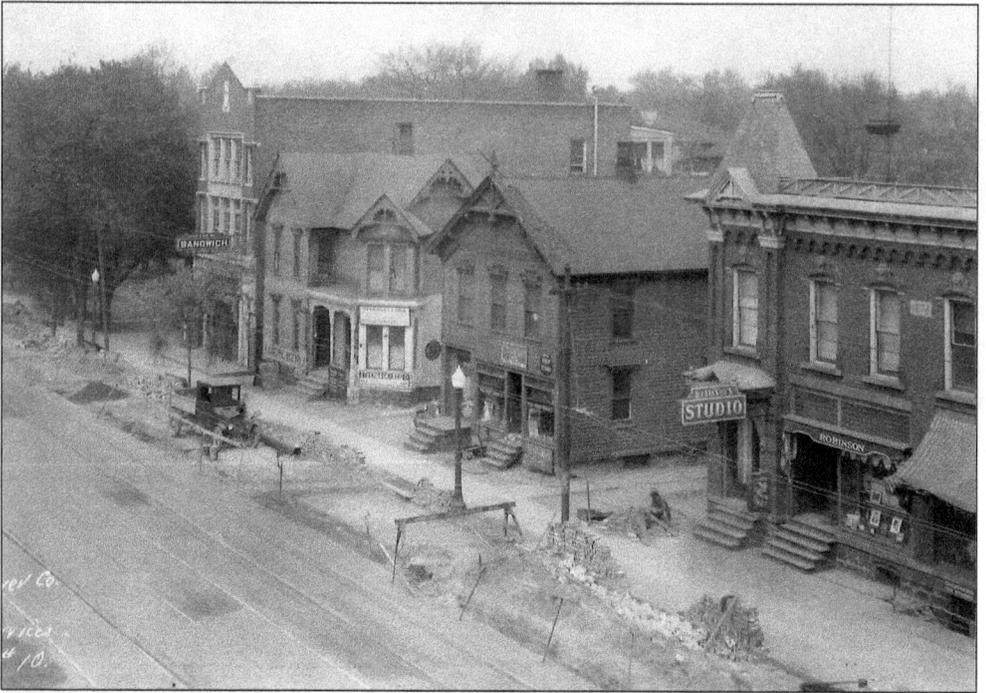

CONSUMER'S POWER. The local gas company is installing a 10-inch gas line. The date is May 13, 1927. Robinson Photography Studio is in the foreground, and a sandwich shop is located down the street on North Saginaw Street. This illustrates a time when residences were being converted to commercial use. The house in the middle needs a roof. These houses were removed a few years later when department stores moved in. (Courtesy of Pontiac Public Library.)

STATE FAIR. The Michigan State Fair, the nation's oldest, moved around for years before settling in Detroit. At the beginning of the 20th century, Pontiac won the bid to host it for three years. The state fairgrounds were west of town on Huron Street, where Webster School is located. In 2009, the state cut all funding to the fair, likely bringing its long history to a close. (Courtesy of Pontiac Public Library.)

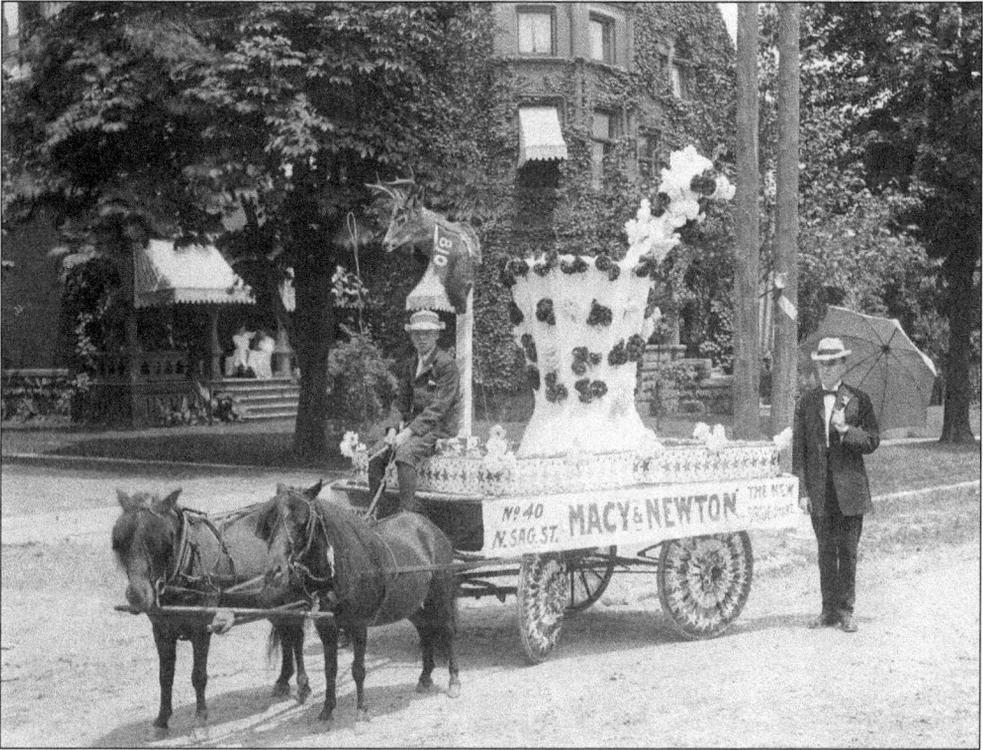

DRUGSTORE FLOAT. This father and son are readying their float for a Fourth of July parade. Early pharmacies are credited with having created at least two famous soft drinks: Coca-Cola and Vernors, a Detroit original. Touted as the New Drug Store, the float is parked in front of the Galbraith House on East Huron Street. (Courtesy of Pontiac Public Library.)

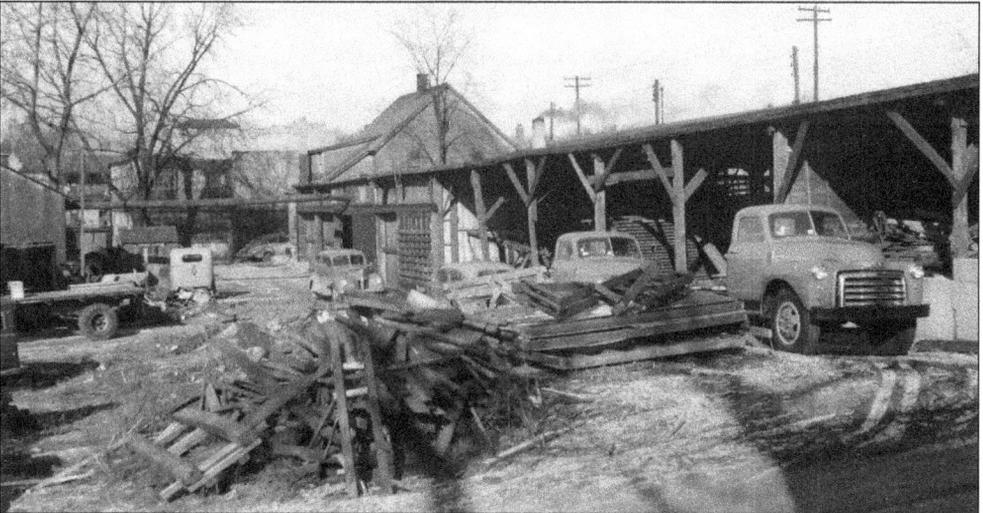

SLATER'S MILL. The Slater family had much to do with building. They sold building materials and constructed many of the city's landmarks, including the Masonic Temple. They built many apartment complexes that were much needed in the 1910s, 1920s, and 1930s, when the automobile business was growing too fast for the housing industry to keep up with housing needs for its workers. (Courtesy of Annalee Kennedy.)

URBAN RENEWAL. In the 1960s, the city bought into an urban renewal plan that included leveling many of the city's buildings. But the plan lacked the resources to build others to take their places. This 1979 picture shows the south end of downtown before anything had been rebuilt. In fact, it's still largely the same. The transportation center is under construction on the far right corner. (Author's collection.)

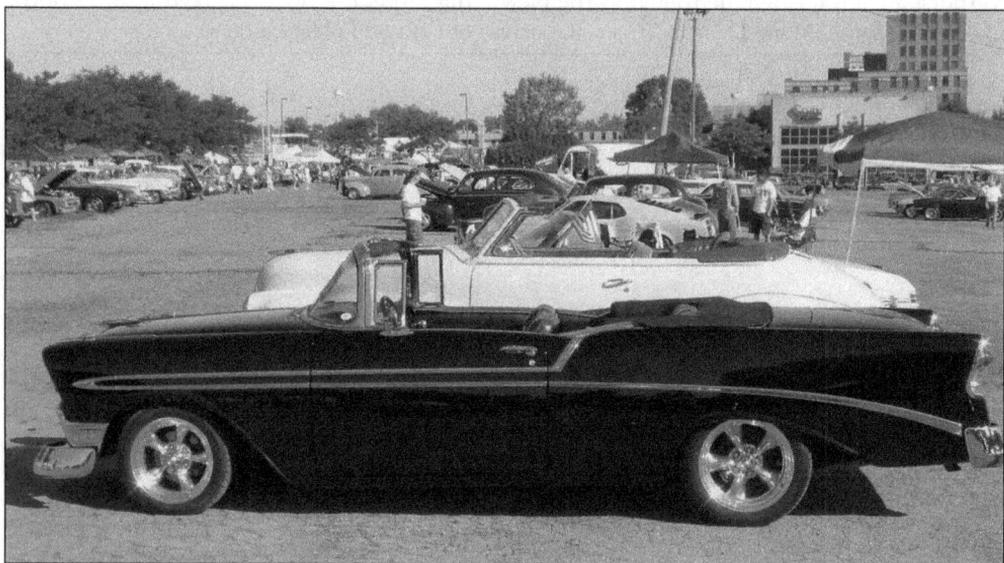

DREAM CRUISE. Every August, a car festival takes place from Pontiac to the south end of the county. It celebrates the years when teenagers cruised Woodward Avenue in their hot rods, muscle cars, and the folks' four-door. This picture was taken in the very same parking lot shown in the above picture, 30 years later. It is a great event to dream about owning this cherry 1956 Chevy. (Author's collection.)

Four

CELLAR TO STEEPLE

In fall of 1818, J. J. Todd traveled from Detroit to Mount Clemens. Along the way, he took on various jobs. One was digging a 12-foot-high, 12-foot-wide, 6-foot-deep cellar for $10. A cellar was critical in pioneer days. In the summer, it kept dairy products cool. In the winter, it kept root vegetables and canned goods from freezing. Early cellars were roughly 6 feet deep with fieldstone walls and earthen floors. There was a door in the floor or outside bulkhead for access.

Construction methods in the new town of Pontiac were modern almost from the start. There was a sawmill operating in two years from the first settler arriving. A brick factory was established early, as was a plaster and planing mill. Darrow and Peck, a mercantile business, erected the first brick building in town in 1836. These two brothers-in-law also created the second subdivision, Darrow and Peck's between Williams Street and the railroad. Williams was the first subdivision.

A great fire in 1840 destroyed many buildings in two city blocks at Lawrence and Saginaw Streets. Floods occurred throughout the years, which forced the burying of a section of the Clinton River in the late 1950s when the city began its new master plan. Steeples came and went. Sometimes the steeples were blown off, while others were removed or added when church additions were made. Church fires were common. One congregation lost its church to fire three times over a 50-year span. The burgeoning automotive industry in the early 1900s created a demand for new housing that was impossible to stay ahead of for some time.

The creation of Wide Track Drive, now called the Woodward Loop, was a result of the new master plan. Many historic buildings were demolished to make way for this new roadway that runs in a one-way fashion around the city's downtown. There has been much criticism over the years for both the burying of the Clinton River, eliminating the millponds, and the building of Wide Track, but it's all in hindsight.

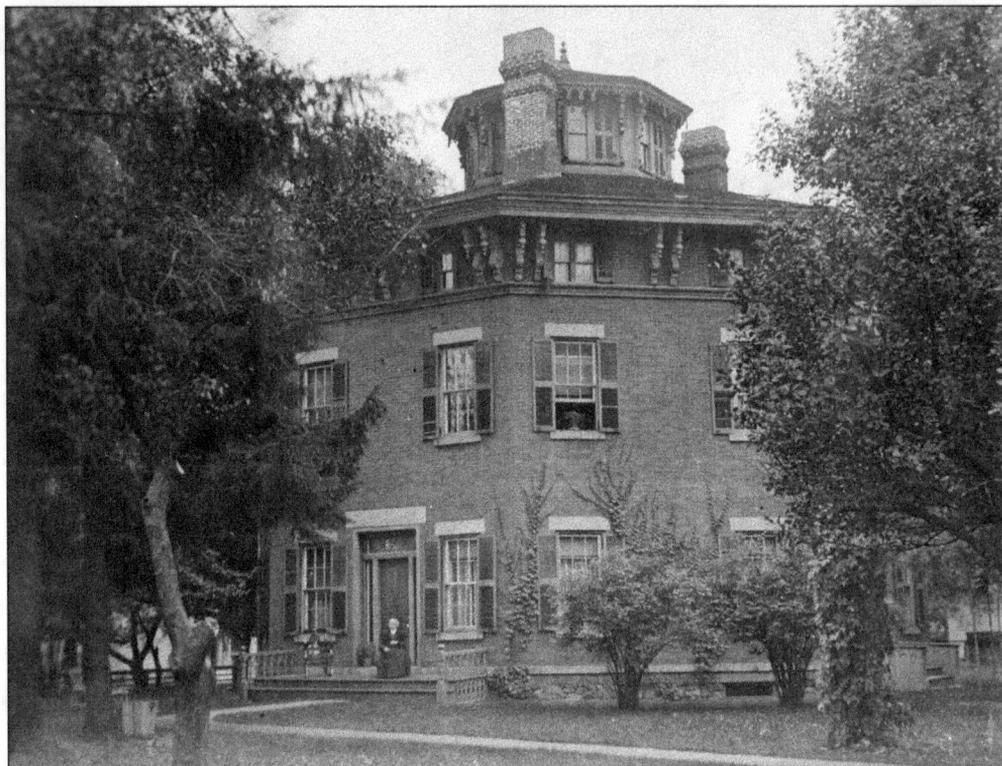

OCTAGON HOUSE. This house used to sit on the south side of West Huron Street between Williams Street and the railroad tracks. This 1850s architectural style was largely promoted by Orson Fowler, a leading lecturer on the subject of phrenology, the study of how the shape of one's head determines personality. He believed that the octagon house had many advantages, such as being easier to heat and cool, cheaper to build, and less wasteful of space than conventional houses. Thomas Jefferson had a summer house that was in the shape of an octagon. (Courtesy of OCPHS.)

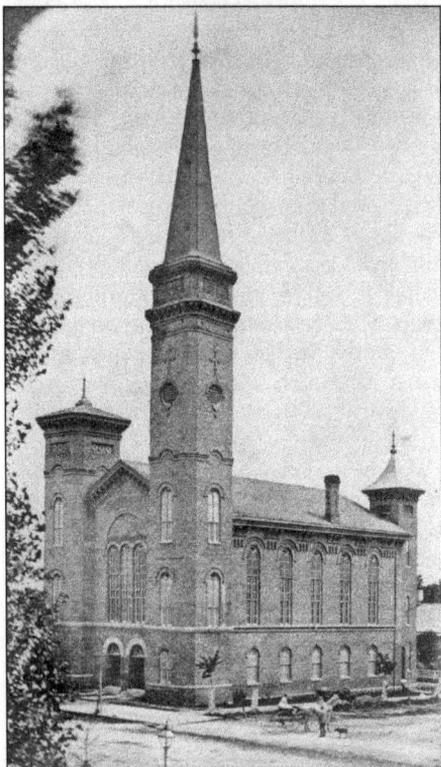

CONGREGATIONAL CHURCH. This building was located on the northeast corner of Saginaw and Huron Streets. This is one of the few images showing it with the steeple intact that was later blown off in a wind storm, never to be replaced. The style of church architecture fancied various towers and a steeple; some had no steeple, just towers. (Courtesy of OCPHS.)

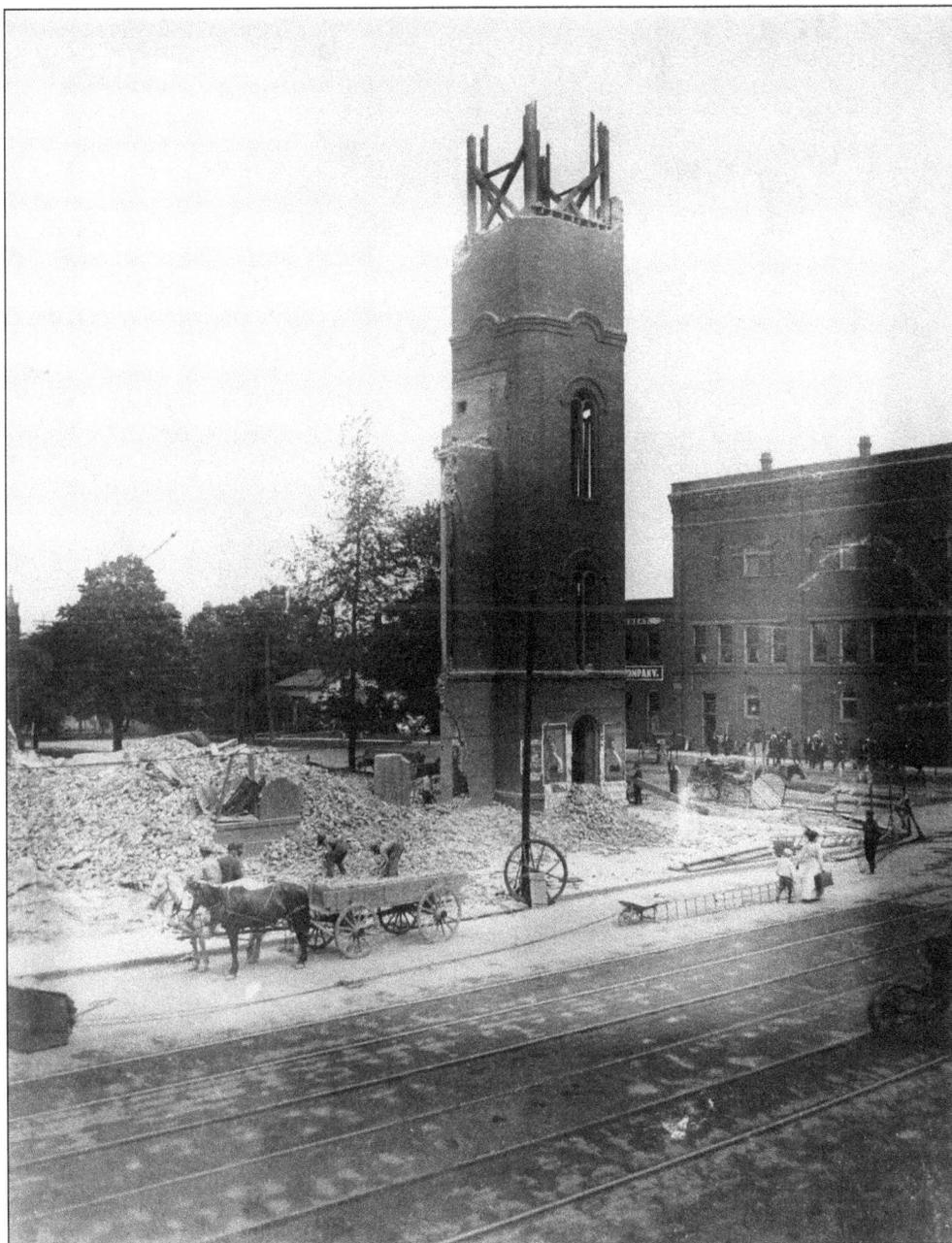

CHURCH FIRE. The Congregational Church of Pontiac was organized in 1831. This building was dedicated in December 1868 after it cost $20,200 to construct. This was a large debt for a church to incur at that time. It had difficulty paying down its debt and briefly considered merging with the Presbyterian church. Although this was a brick edifice, the fire left nothing but the main tower. It had one of the tallest steeples in town before being blown off. The reason the main tower was left standing is likely due to it being solid masonry construction. Workers had to clear the site by hand. No doubt the bricks were salvaged and reused. The church moved around the corner upon rebuilding. (Courtesy of OCPHS.)

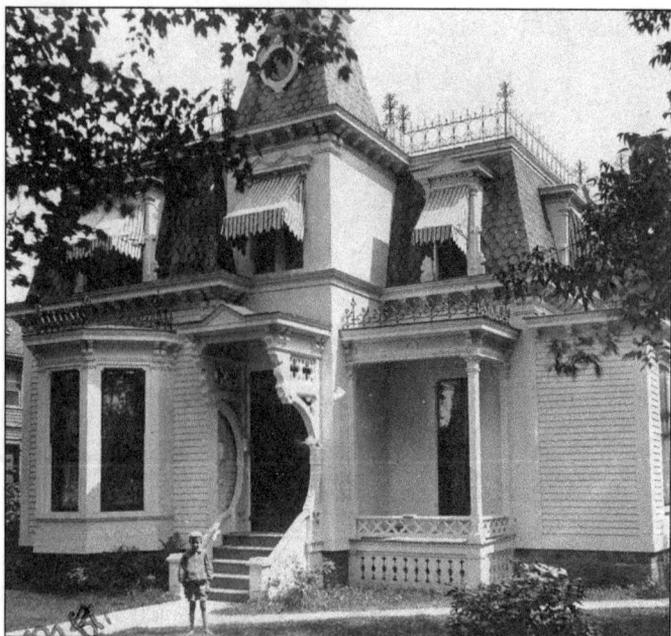

RICHMOND RESIDENCE. The crispness of the lines on this house's exterior indicates that it is very new or very well preserved. This architectural style, largely Second Empire, was built between 1850s and 1880s. The house stood at Williams and West Huron Streets, most likely on the southwest corner. The mansard roof predominates its style. This type of roof was conceived in Europe as a way to lower one's property taxes. The low roofline enclosing the second story exempted that floor space from being taxed. (Courtesy of OCPHS.)

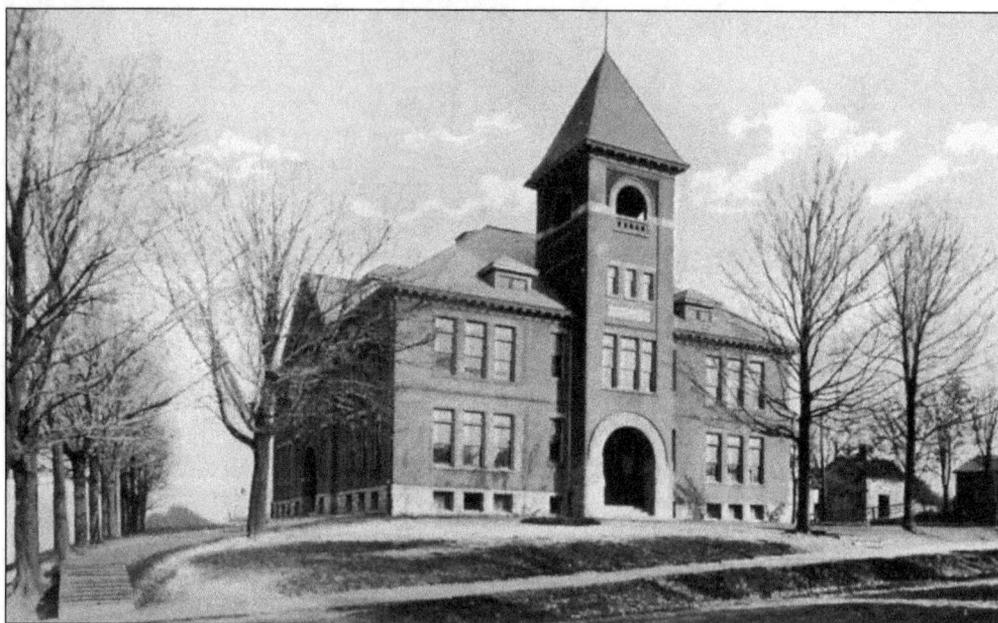

CENTRAL SCHOOL. Built in 1893 at a cost of $12,000, this was a school for kindergarten through eighth grade, replacing the Old Union School on the same site. It housed 400 students before additions were made in 1918 and 1948. After World War I, it became Central Elementary and later an adult education center before closing. (Courtesy of Annalee Kennedy.)

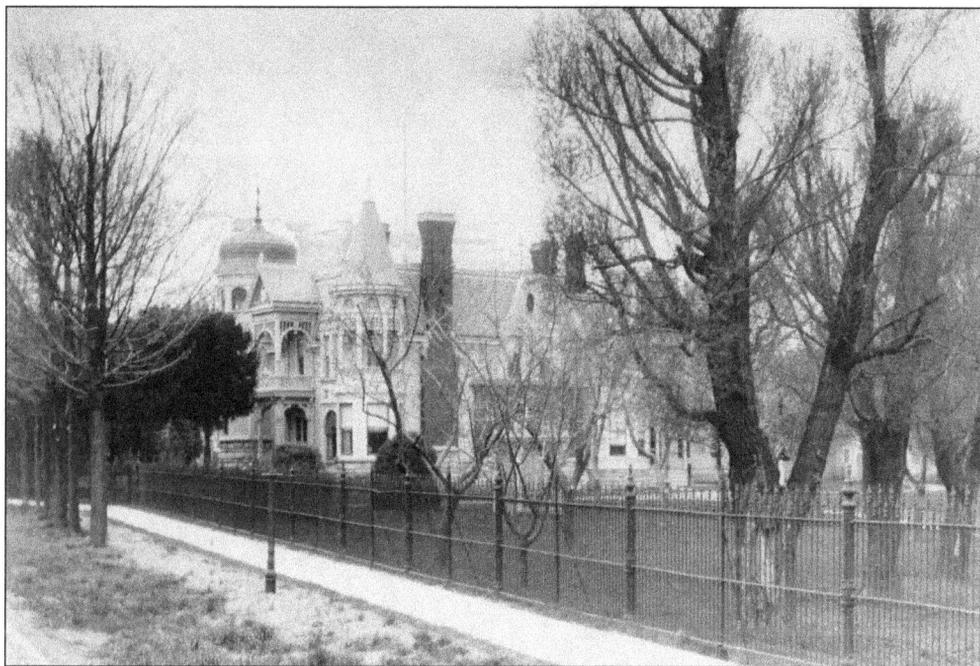

HINMAN RESIDENCE. This grand estate was located on Orchard Lake Road between Front Street and the railroad tracks. Its property encompassed 7 acres. The Clinton River ran through the property, necessitating a footbridge. It is of an eclectic Victorian style. It had eight fireplaces, and one chimney had a stained-glass window. With telephone, electrical service, and modern indoor plumbing, the house was a model of modernity. (Courtesy of Burton Historical Collection, Detroit Public Library.)

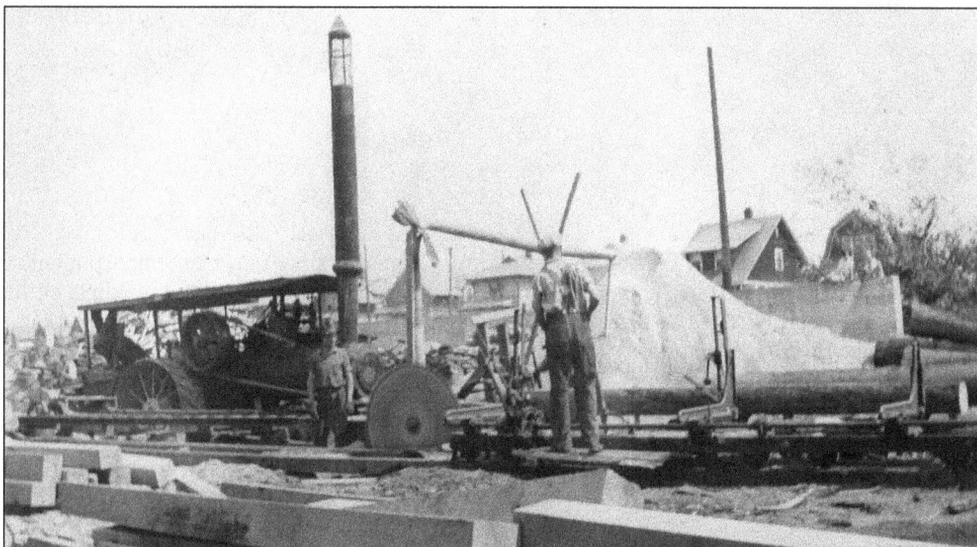

BENSON'S SAWMILL. M. A. Benson started in business in 1920 with a team of horses and a carload of coal. He unloaded the first coal car by hand and vowed to never do that again. Benson's was originally located at 517 North Saginaw Street, but by 1924 the business had grown so much it had to expand to a larger parcel at 549 North Saginaw. An early portable sawmill is powered by a tractor on the left. (Courtesy of Benson's Building Supply.)

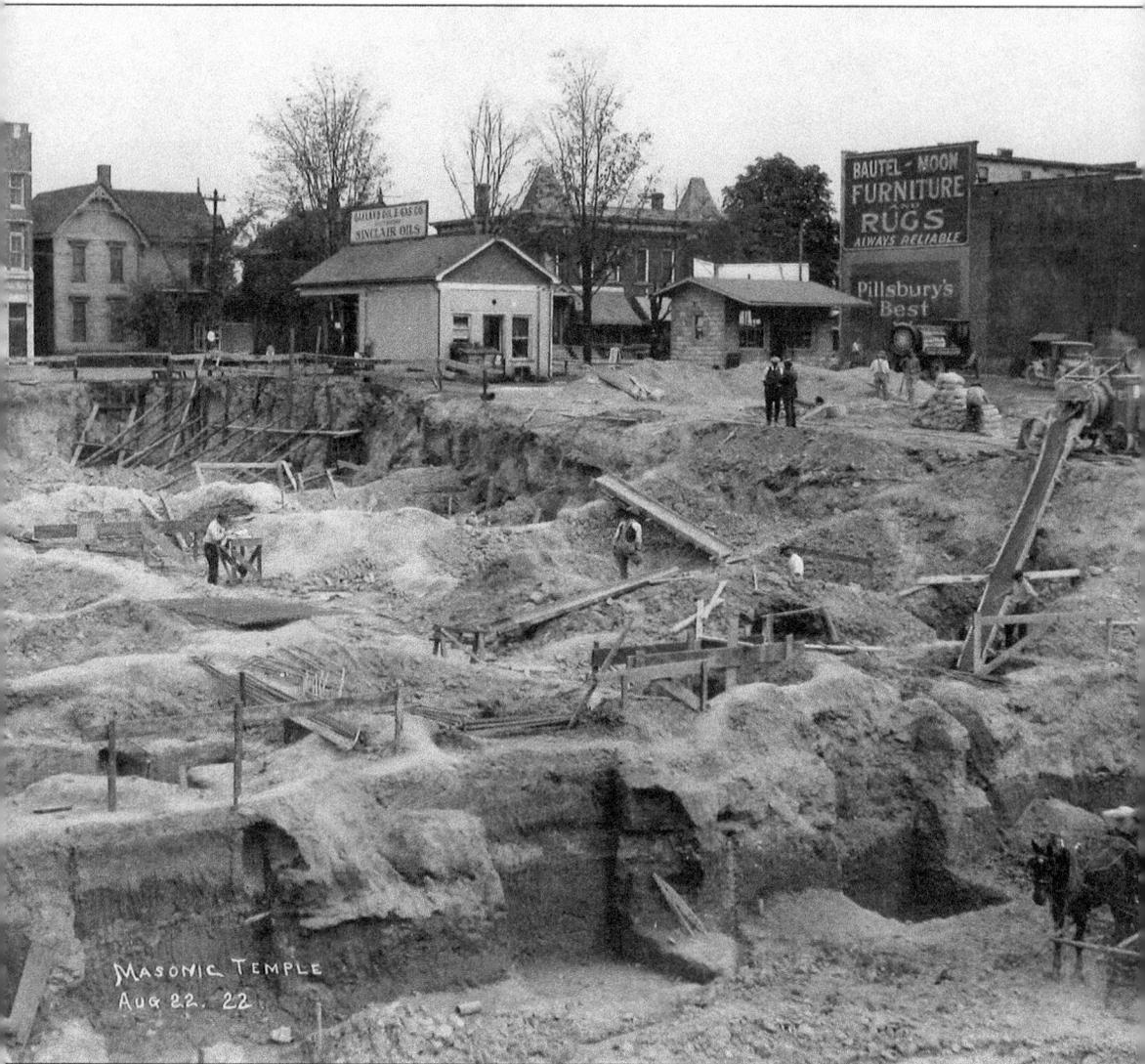

MASONIC TEMPLE. Started in 1922 by Slater Building Company of Pontiac, this temple put fellow Masons at odds from the start. The older members fought the plan for this grand building, citing a burdensome debt, but yet the temple was dedicated in November 1928. It was lost as a result of heavy debt in 1943, ultimately going to the county. The far left corner of the excavation is being shored up against a cave-in using boards. In the near right corner, a team of horses can be seen. Even though the year is 1922, this is an example of how some companies still relied on horses and wagons versus trucks. The cement mixer at the top right illustrates how everything made from concrete at the time was done. All of the ingredients for cement were mixed into the mixer by hand. It appears there are two shovel men and one bag man. (Courtesy of Pontiac Public Library.)

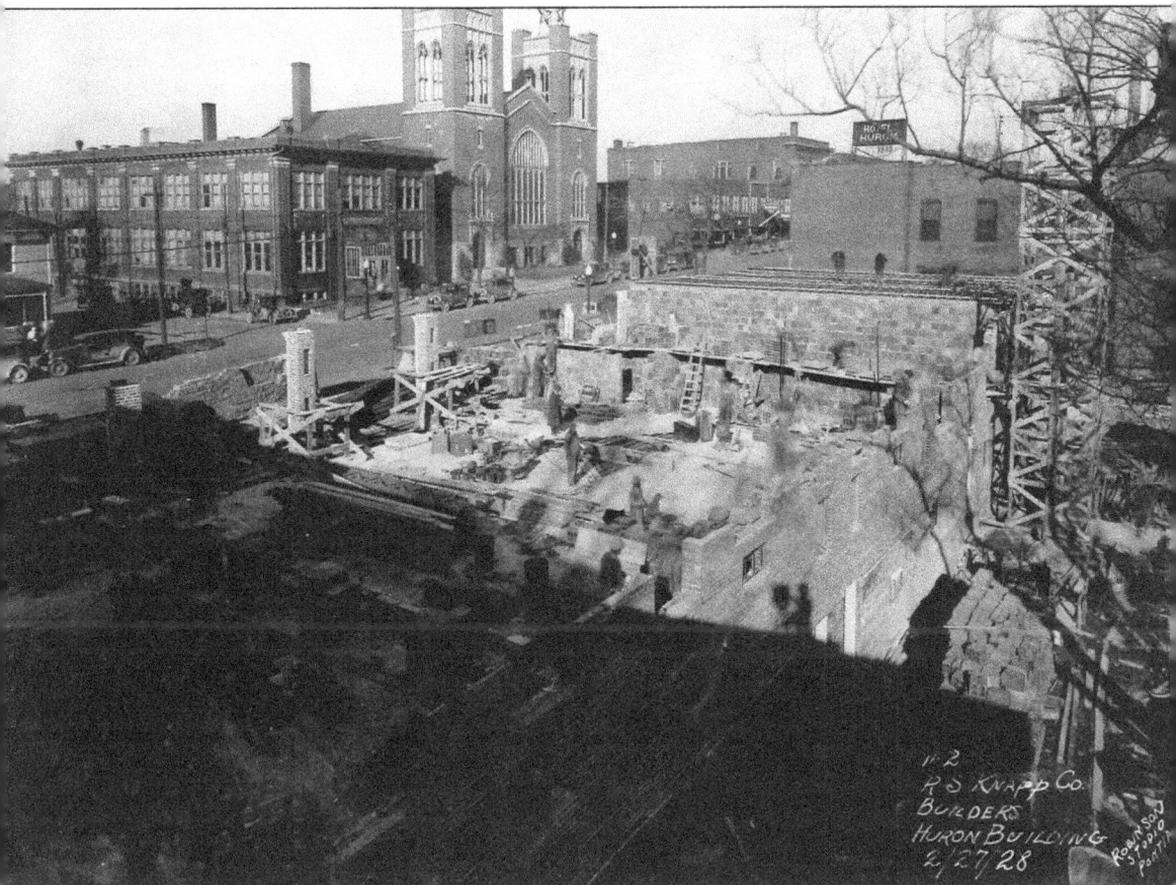

HURON BUILDING. On February 27, 1928, on North Saginaw Street, the weather appears mild, as masons are hard at work in the middle of winter. The building still stands with several makeovers. The Pontiac Press Building is located across the street, and the First Presbyterian Church is to the right of that. (Courtesy of Pontiac Public Library.)

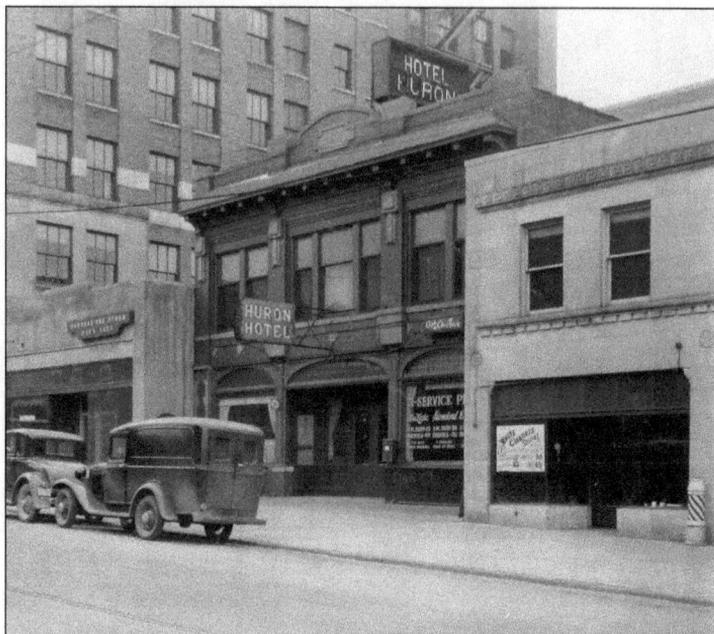

HURON HOTEL. This building still stands in Pontiac, though it is no longer used as a hotel. It was one of many in town at the time, including the Roosevelt, Waldron, and Chapman House. A lot of new buildings were going up during this period in Pontiac. The 10-story Riker Building had gone up next door, and the Pontiac State Bank was new. The financial boom came to an end here like everywhere with the Great Depression. (Courtesy of Pontiac Public Library.)

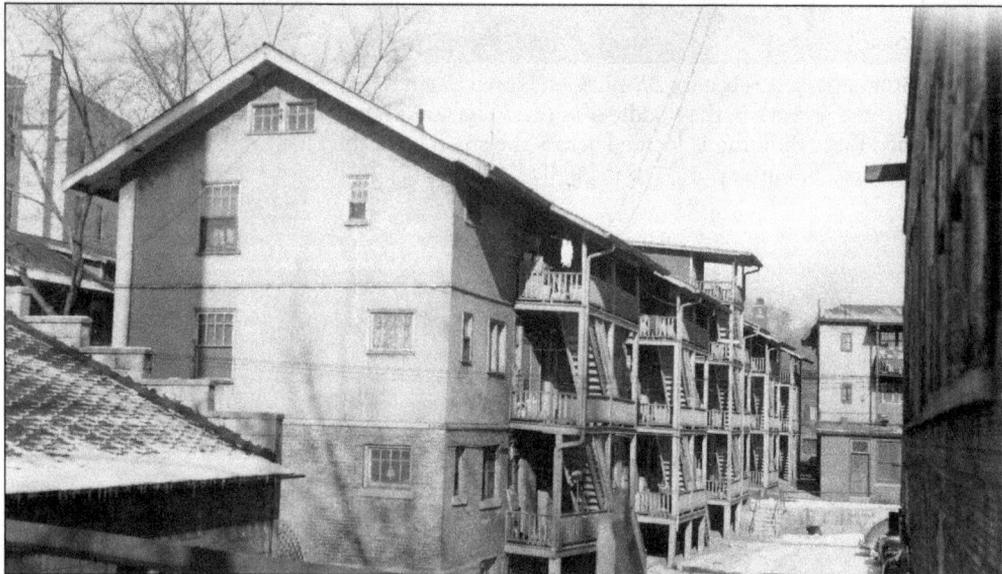

ARCADIA APARTMENTS. This is one of several apartment buildings constructed by the Slater family business. It came about as a result of the rapidly expanding automotive industry. Some of these are still standing, while others have been demolished when bigger projects needed space. A person who lived here as a child recounts a neighbor across the way sending him candy on the rotating clotheslines that were behind most apartments. (Courtesy of Annalee Kennedy.)

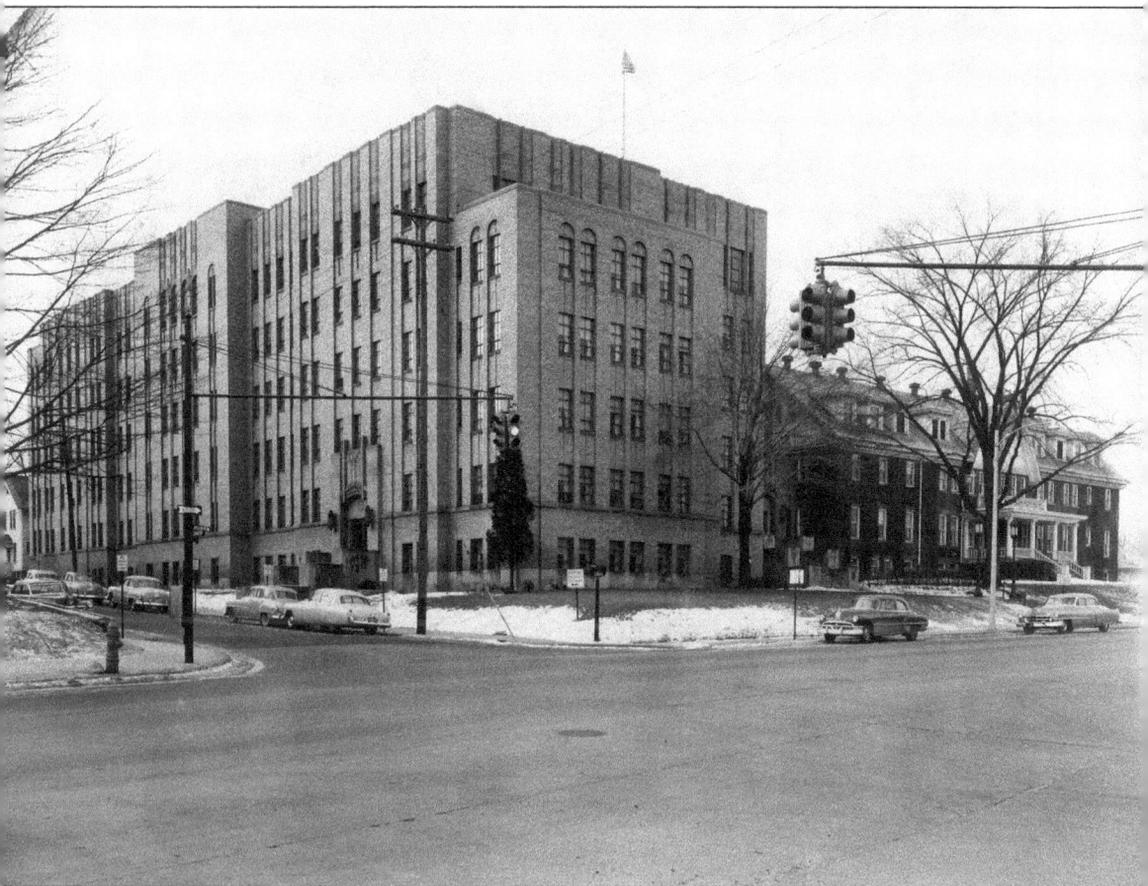

PONTIAC CITY HOSPITAL. Oakland County Hospital Association celebrated its 100th anniversary in May 2010. They established the Pontiac City Hospital, which was the county's first. The 1929 building adjoined it, with the name changing to Pontiac General Hospital. In 1958, a few years after this photograph was taken, the original building was replaced with a large addition. The hospital association still owns this land, now occupied by Doctor's Hospital. (Courtesy of Rich Sign.)

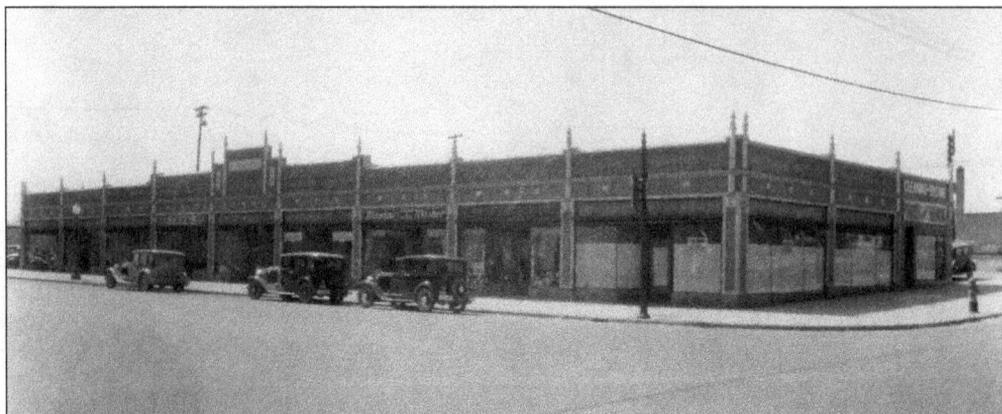

CASS BUILDING. Pontiac Paint, with its art deco sign, occupies this building today. There were several storefronts in this building on what was once Cass Street. The Seeds store on the left probably sold seeds grown in Pontiac. One of the largest seed producers of the time, the Ferry Seed Company, had acreage on the south side of town before moving to Rochester, where it grew into a massive enterprise. (Courtesy of Pontiac Public Library.)

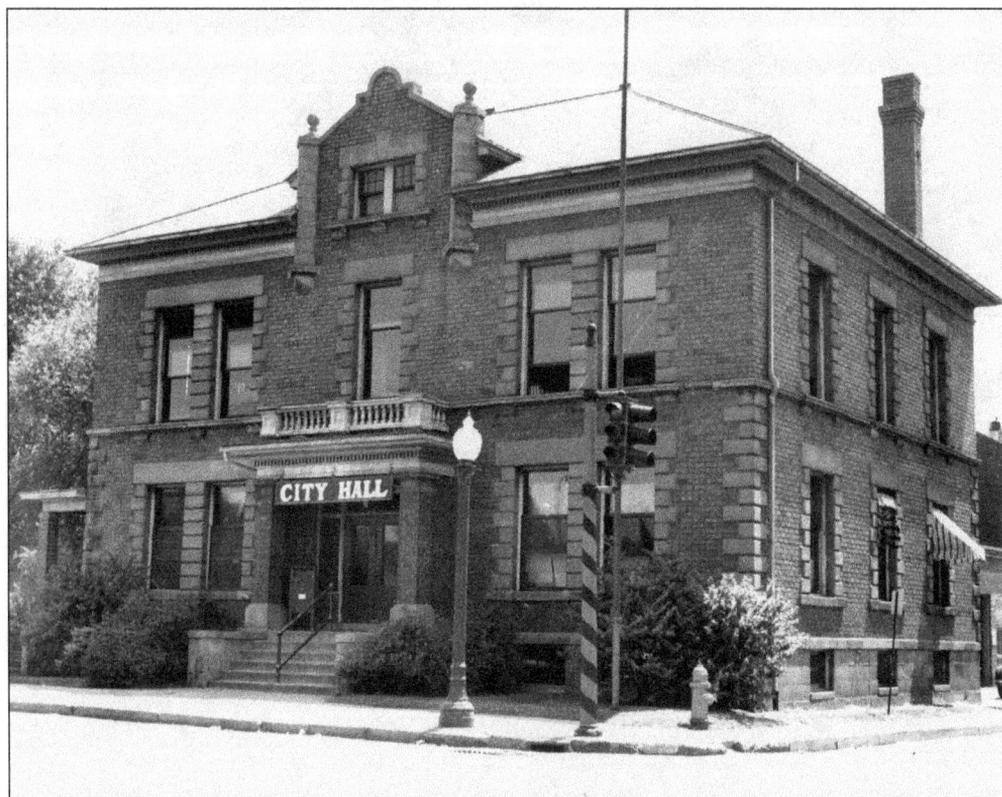

OLD CITY HALL. Previous to the current municipal building, this one was located at Mill and East Pike Streets facing north. In 1912, located in this building were the following: the mayor, offices of utilities, public improvements, a clerk, an assessor, a city engineer, a treasurer, an attorney, a health officer, an inspector, water, and police and fire departments. Subsequently there were a vinegar factory, seven lumberyards, eight cement block companies, and a bottle works company located here. (Courtesy of the *Oakland Press*.)

OTTAWA HILLS. Built in 1951, this church, formerly Grace Lutheran, sits on the edge of the Ottawa Hills neighborhood. Ottawa Hills adjoins Seminole Hills, one of Pontiac's local historic districts. Ottawa Hills does not have historic status. The goal of the local district is to maintain the integrity of the original architecture and features of the homes. (Courtesy of Pontiac Public Library.)

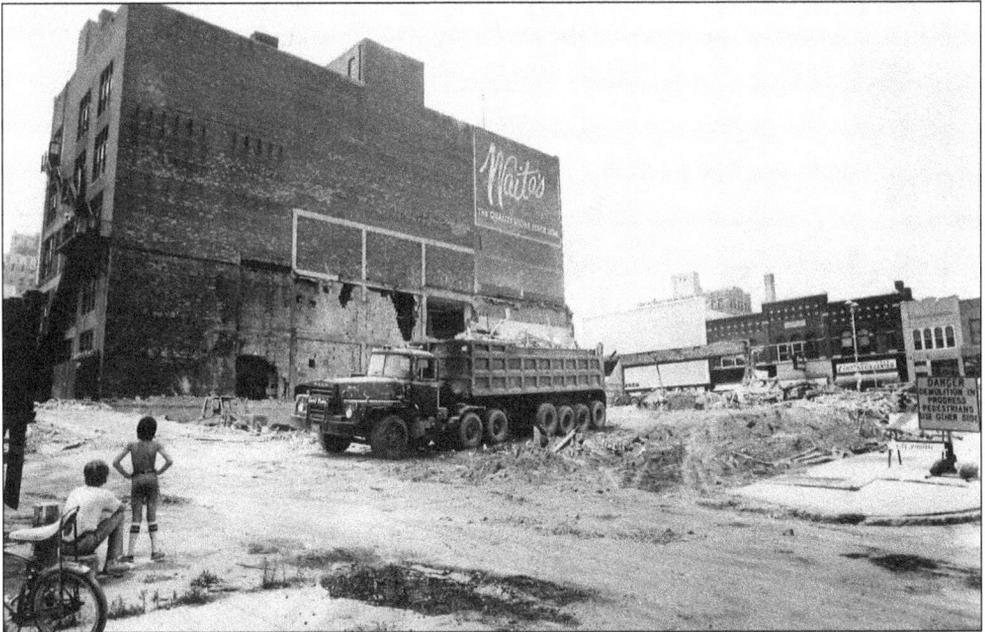

DOWNTOWN DEMO. At the time this photograph was taken, demolition downtown was becoming more and more common. This scene shows an intact Waite's Department Store, but soon it will fall to the wrecking ball. The kids watching are evidence that it is summertime. The Sting-Ray bike to the left was a popular bike style for many years with the banana seat and high handlebars. The truck brand is Mack, not related to the founding father. (Courtesy of Pontiac Public Library.)

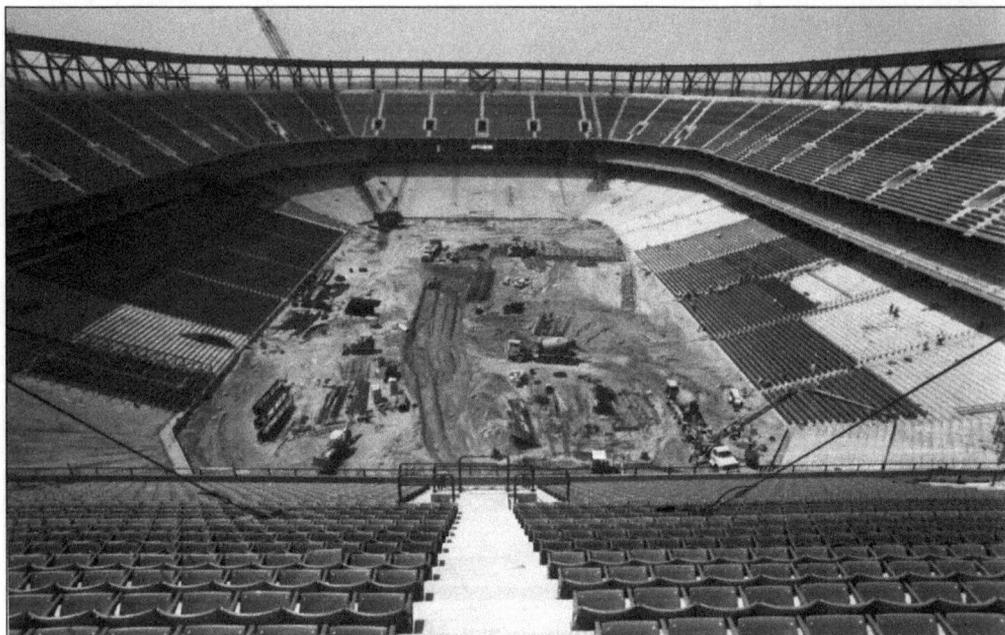

SILVERDOME CONSTRUCTION. The stadium, originally called Pontiac Metropolitan Stadium, was sold in 2009 for $583,000, which was only 1 percent of the 1975 build price. Home to the Detroit Lions for 26 years and the Pistons for 10, the Michigan Panthers and Detroit Express also used the Silverdome as a home field. Also, Super Bowl and World Cup soccer events were held here. The original construction project, managed by Barton Malow Company, came in under budget and on time and boasted the then-largest inflated roof in the world with a capacity of 80,200. (Courtesy of Walter P. Reuther Library, WSU.)

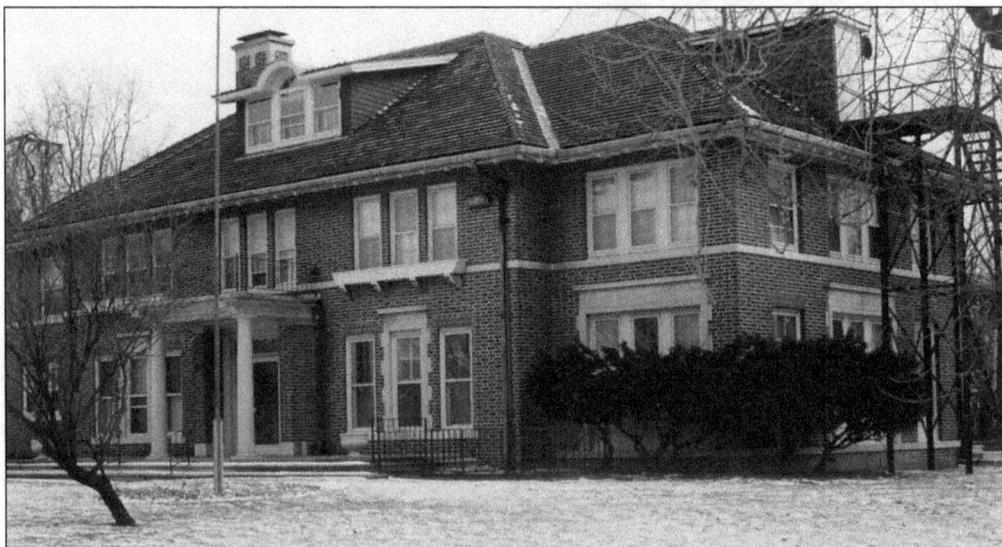

BEAUDETTE HOUSE. Built by the O. L. Beaudette family in 1917, this Georgian Revival style home anchors the Franklin Boulevard Historic District. Oliver Beaudette was the only son of O. J. and Louise Beaudette, who were known for construction of coach and auto bodies. The house was occupied by the YWCA for many years. It has been restored as a residence. (Courtesy of Ken and Pat Burch.)

Five

EASTERN MICHIGAN ASYLUM

Before the automobile industry wreaked glory and disappointment on Pontiac, a single event brought monumental change. In 1873, the state of Michigan needed a new mental health hospital to alleviate overcrowding at the single state facility of its kind in Kalamazoo. Cities in Eastern Michigan were requested to bid for the right to locate it in their community. The state also encouraged bidders to donate the land for the project. An amount of $400,000 was appropriated for the construction.

Pontiac was the winner despite Detroit also bidding. Over 16 million bricks were used to build the initial structures. Brick maker William Osmun set up a brick-making yard on the site, where there was a vast clay deposit. Before the building began, White Lake Road, now Pontiac Lake Road, ran all the way to Huron Street. Once the hospital was operational, the road ended on the west side of the campus. It picked up on the east side of the campus, now being called Asylum Drive. Upon the asylum's name change to Pontiac State Hospital in 1911, citizens complained about the road name, resulting in it being changed to State Street.

Henry Mills Hurd, Eastern Michigan Asylum's first superintendent, was responsible for widespread gains in health care. Restraints were discouraged, and agriculture was used as occupational work therapy. The crops and meat raised on site fed patients and staff, which helped cut costs while providing healthy meals.

At its height, the hospital comprised 800 acres, extending beyond Telegraph Road and to Huron Street, with orchards, pastures, and cropland. By 1973, the name had been changed to Clinton Valley Center. When it closed in 1997, only 307 acres and 200 patients remained. There is no way of measuring the benefit brought to Pontiac and the surrounding communities by the hospital locating here.

The hospital that Elijah Myers, the architect of Michigan's state capitol, designed was one of this nation's preeminent architectural accomplishments. Its network of hollow walls used for warm-air heating and ventilation was a feature that made the buildings ideal for adaptive reuse.

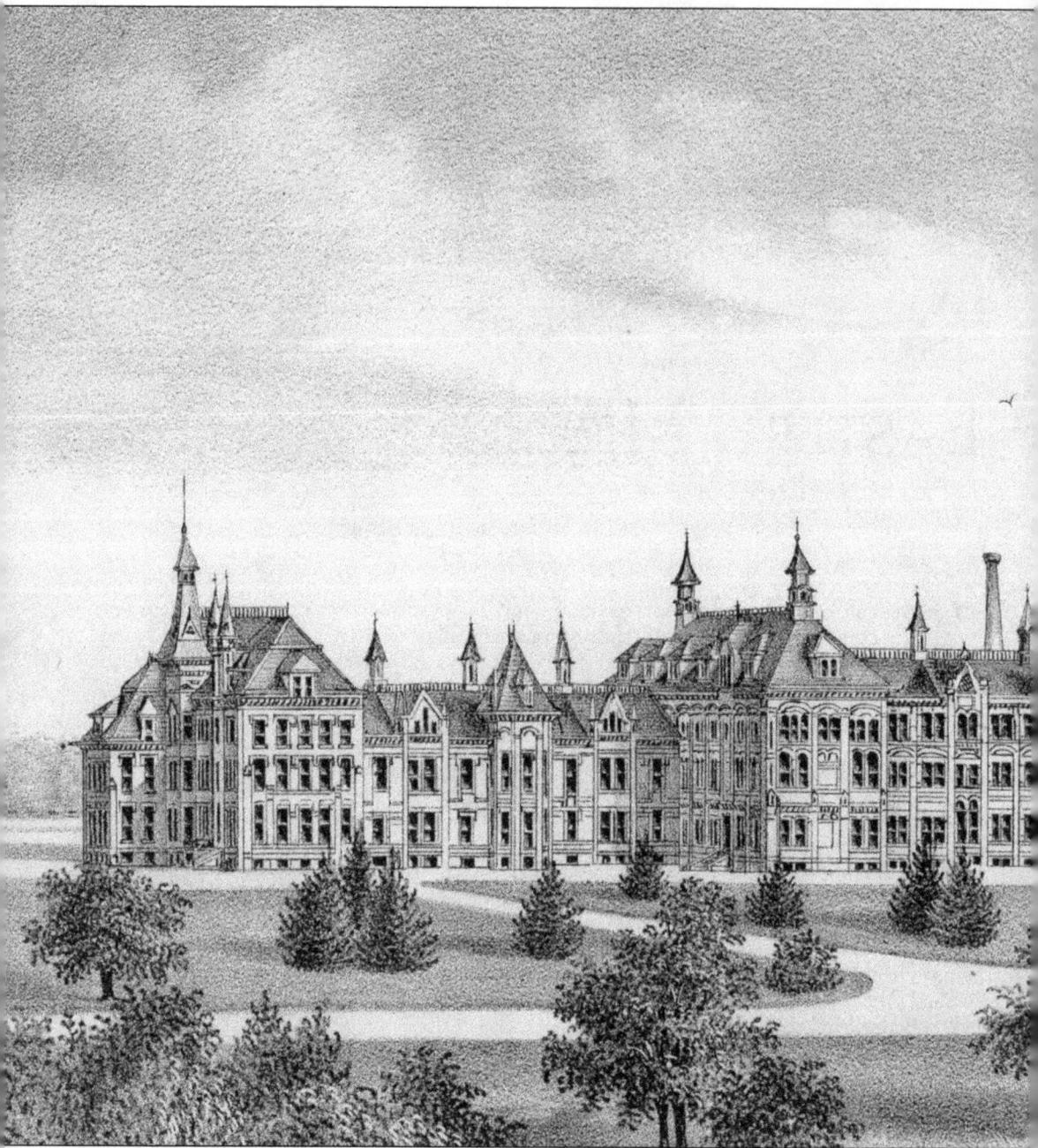

ASYLUM PLAN. When this engraving was printed in *The History of Oakland County 1817–1877*, the new mental health hospital wasn't completed, but it was close enough to include this illustration of the building. Pontiac had won the bid competing against other Eastern Michigan cities, including Detroit, to locate the new asylum in their city. It was a boon to the local economy both during construction and for a century to come. Architect Elijah Myers designed the original building.

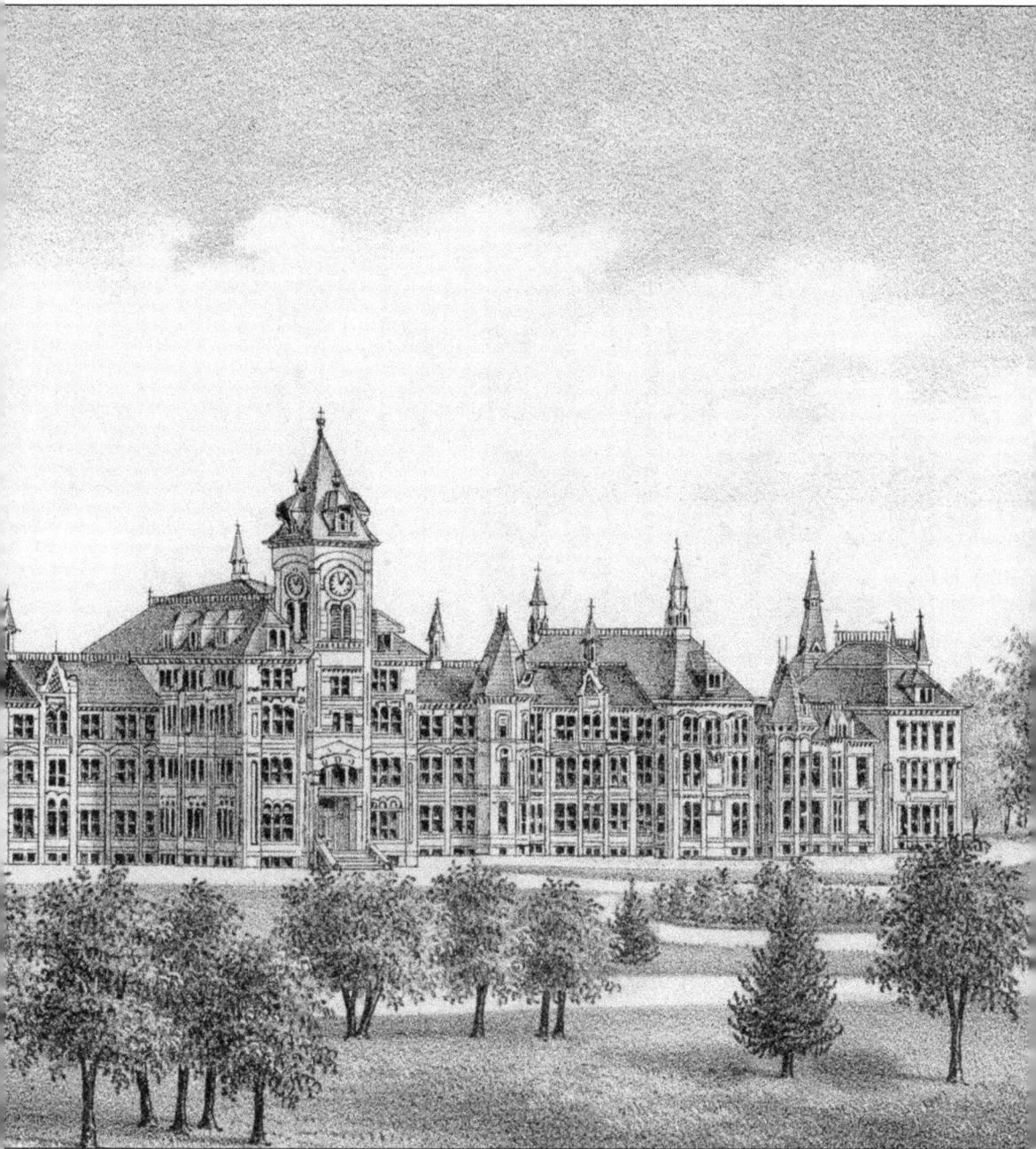

He was also the architect of the Michigan state capitol and designed more state capitol buildings than any other architect of his day. Henry Lord and Charles Palmer of Pontiac were sent to make the final case for the city, when the decision had come down to Detroit and Pontiac. As suggested by the state, Pontiac had included the land for the facility, up to 200 acres, at no cost. (Courtesy of OCPHS.)

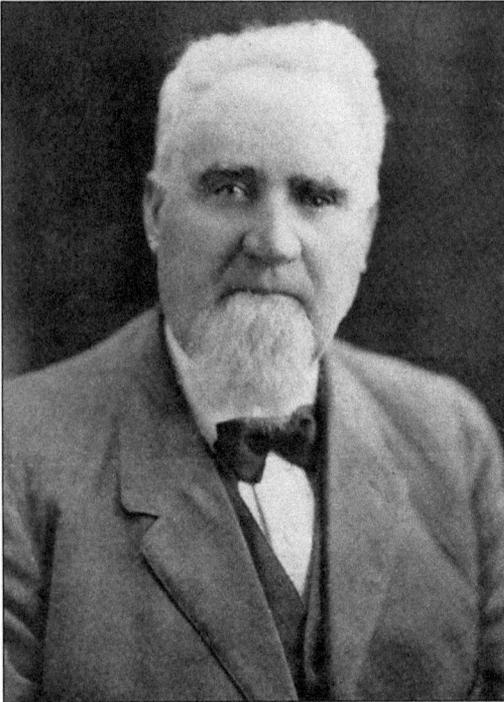

Wm. H. Osmun
Commissioner of Public Improvements

WILLIAM OSMUN. Osmun was a brick maker at the time of the asylum project. He had won the contract to produce the 16 million bricks required for the job. He realized the challenge in making the bricks at his brickyard, far to the east of the site, and decided to move it close by, just east of what is Telegraph Road. He mined the clay and made the bricks at that location over the three-year period the construction took place. (Courtesy of Annalee Kennedy.)

VENTILATION SHAFT. The masonry walls were used as air shafts for heat and circulation of fresh air. The cupolas seen in surplus on the roofs were part of the system. This detail is important when discussing adaptive reuse of historic structures, as it allowed for the installation of all modern mechanicals without changes to walls. (Courtesy of Bruce Annett, www.bbmck.com.)

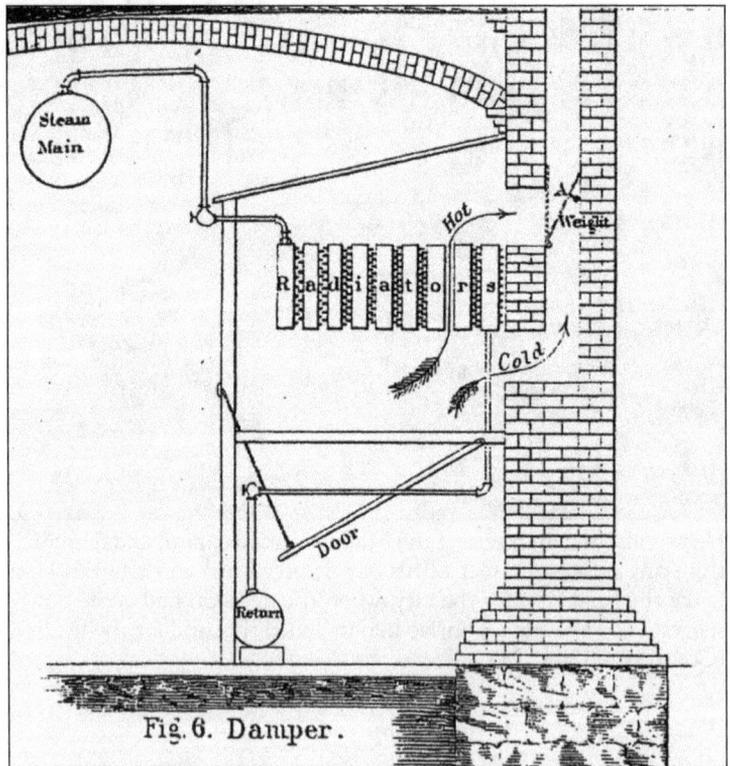

Fig. 6. Damper.

PICNIC NOTICE. From the onset, the philosophy for treating mentally troubled patients here was evident in the natural surroundings, the use of work and agriculture as therapies, and the discouragement of confinement and restraining patients. This picnic notice for July 4, 1893, illustrates that the hospital's outings were inclusive of both patients and staff members. (Courtesy of OCPHS.)

LADIES AT GAZEBO. Gazebos are often seen as a Victorian structure, but this style harkens to the northern woods of Michigan. In contrast to the elegant architecture of Elijah Myers, this structure captures the rawness of the natural surroundings. In this photograph, nurses are on leave from hospital duties and might even be attending the picnic in the notice. (Courtesy of OCPHS.)

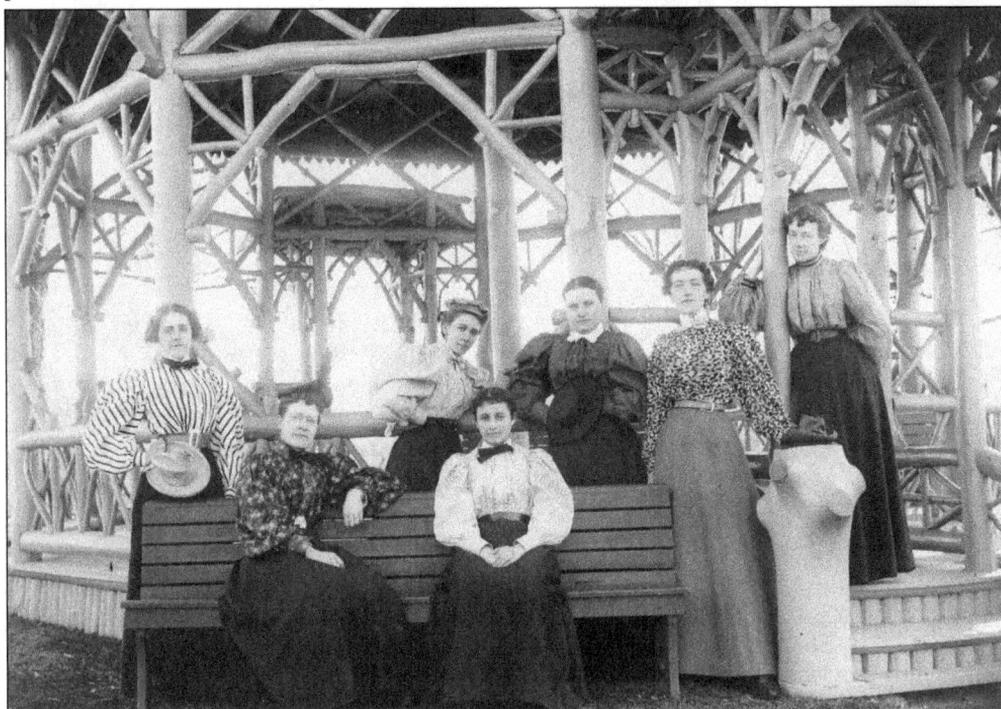

EASTERN MICHIGAN ASYLUM

JULY 4TH, 1893.

1	Tug of War.
	Twelve men on each side selected on ground.
	GEO. P. RITCHIE, / Captains.
	F. C. POTTER, \
2	Wheelbarrow Race.
	Open to patients only.
3	Three-Legged Race.
	1. R. E. CUSHMAN and J. W. CAMERON.
	2. E. A. COFFEY and J. T. BIRD.
	3. L. CANFIELD and I. BLAKE.
	4. E. BATZLAFF and S. PARR.
4	100 Yards Dash.
	1. R. E. CUSHMAN, 5. J. J. WATROUS,
	2. J. W. CAMERON, 6. G. HAMILTON,
	3. H. G. COOK. 7. C. J. HOLSER,
	4. F. V. BROWN. 8. F. GALBRAITH,
	9. E. M. HILTS.
5	Fat Man's Race.
	Open to patients only.
6	Special Challenge, 100 Yards Dash.
	DR. H. C. GUILLOT and L. J. HOLSER.
7	Running Broad Jump.
	1. G. HAMILTON, 3. W. CATHCART,
	2. F. V. BROWN, 4. R. E. CUSHMAN,
	5. J. J. WATROUS. 6. F. GALBRAITH.
8	Potato Race.
	Open to patients only.
9	Bicycle Race.
	1. L. J. HOLSER, 4. R. J. FARMER,
	2. W. H. McCANN, 5. H. D. MULLEN,
	3. O. J. ALLEN, 6. J. D. MULLEN.

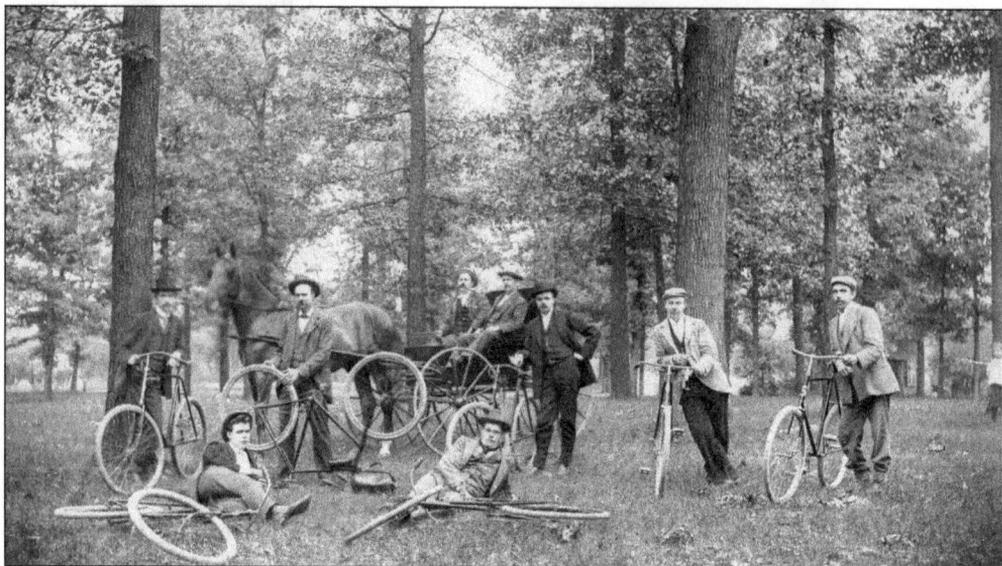

WORKERS ON BIKES. By the beginning of the 20th century, bicycles were a big business. Even though roads were still largely unpaved outside of cities and city roads were paved with cobblestone or brick, bicyclers still took to the streets. Early bikes had shocks in the front and rear to absorb bumps from hard tires. Pneumatic tires and gears came next. These gentlemen might have been in a bike club. There were always bicycle races at the annual picnic. (Courtesy of OCPHS.)

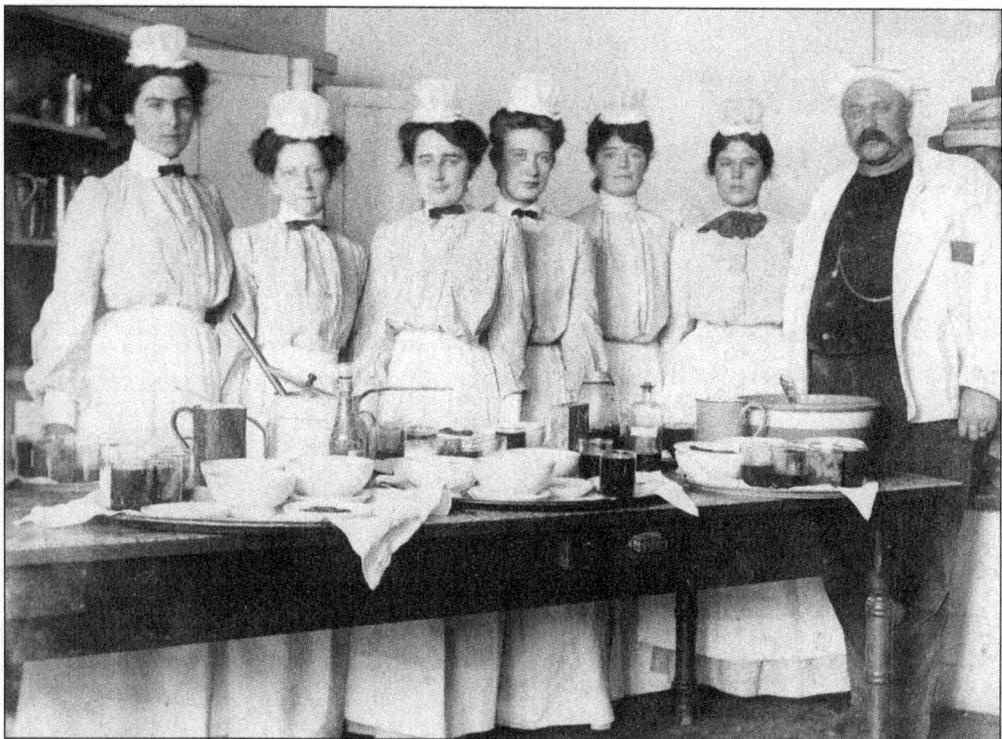

KITCHEN STAFF. The fresh supply of meat and vegetables from the animals and crops raised on-site consistently provided meals of the highest quality. A report from 1889 indicates that there were over 49 categories of crops and livestock. (Courtesy of OCPHS.)

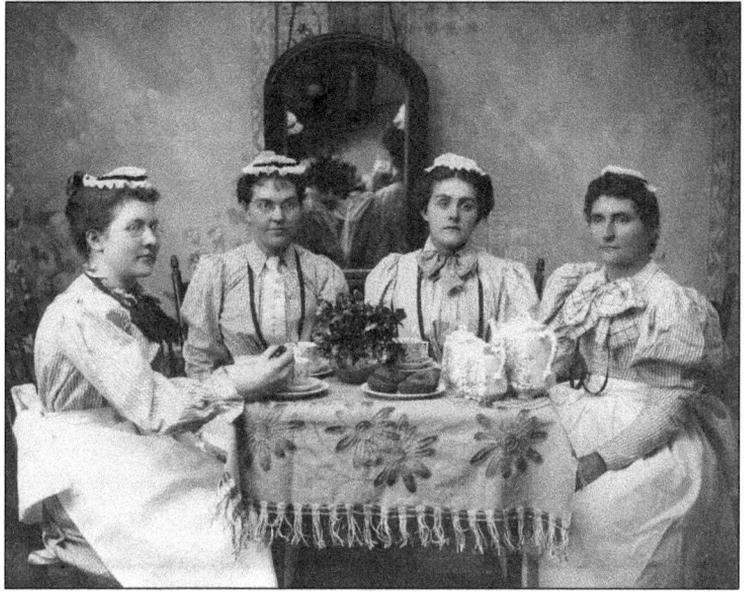

NURSES' TEA.
The quality of the
uniforms at the nurses'
teatime indicates
a well-run and
top-notch institution
that encouraged its
staff to be happy
where they work.
Housing had to be
built both on-site and
off through the years
to accommodate the
large staff of nurses,
orderlies, maintenance
workers, and medical
personnel. (Courtesy
of OCPHS.)

ASYLUM ENTRANCE. From the slate shingles to details on the cupolas and the ornamental ironwork at the peaks, the incredible details and quality of the building cannot be overlooked in this view of one of the entrances to the side of the main entry doors. The brick and stone detail alone is something akin to mansions and castles of royalty. There isn't a space left untouched by careful and thoughtful design. (Courtesy of OCPHS.)

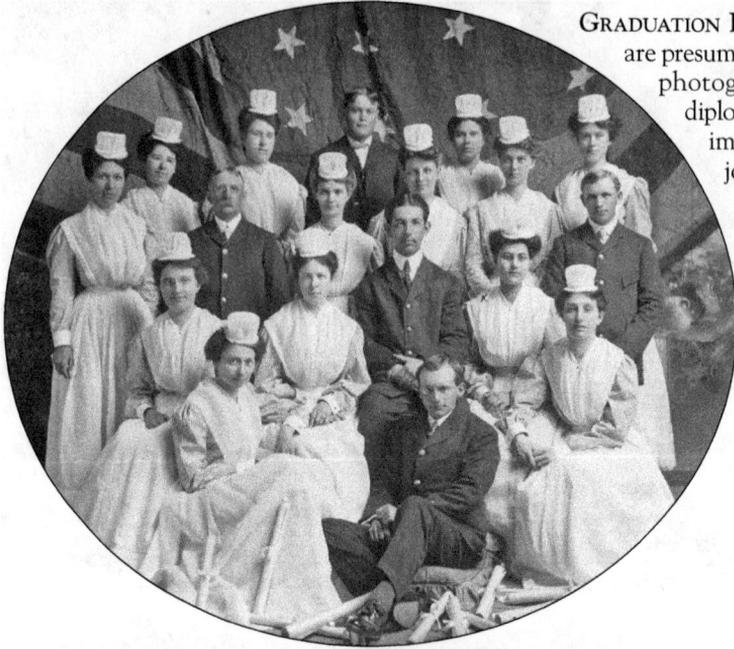

GRADUATION DAY. Nurses and orderlies are presumed to be graduating in this photograph with facsimiles of diplomas scattered in front. The importance of the number of jobs the asylum provided to Pontiac and surrounding communities can't be overstated. (Courtesy of OCPHS.)

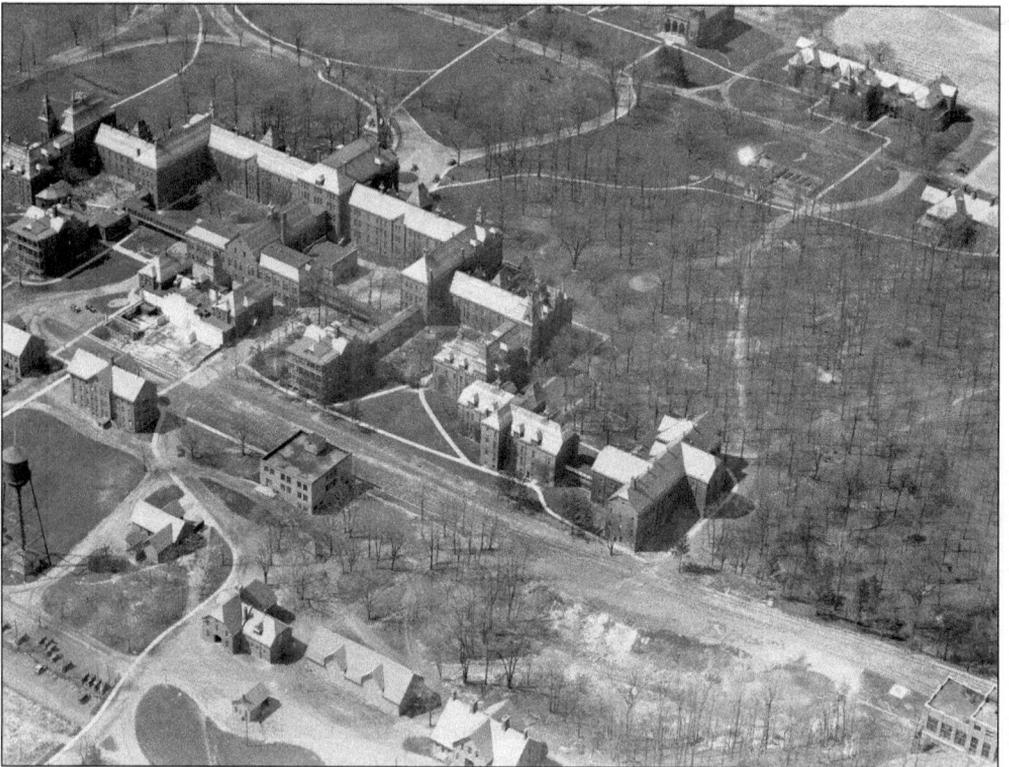

AERIAL VIEW. This 20th-century view is from the back of the main building that shows the extent of growth over more than half a century. The chapel can be seen to the top right center, with two towers. The agricultural areas and buildings are mostly out of view. (Courtesy of Walter P. Reuther Library, WSU.)

60

DAIRY BARN. At its height, there were 800 acres of land used for the campus, animal husbandry, and farming. In 1889, there were 123,842 quarts of milk produced. By the turn of the century, there were over 1,000 patients. The hospital won many awards for its breeding of Pontiac Holstein-Friesian cattle. (Courtesy of Walter P. Reuther Library, WSU.)

ASYLUM COTTAGE. Cottages were incorporated into the care plan to help keep patients of similar disorders together. It also helped manage patients by having smaller groups. In this photograph, the Pontiac Historic District Commission is getting a tour of the buildings by a security officer. Around 1990, the hospital was still open, but the population of staff members and patients was dwindling. (Author's collection.)

ASYLUM ROOFTOPS. This photograph was taken after the hospital had closed. Though it was listed on the National Register of Historic Places, the state decided to demolish the buildings and sell the land to the City of Pontiac. Most of the slate roofs had failed over time, and many buildings had been reroofed to maintain their integrity. (Courtesy of Bruce Annett, www.bbmck.com.)

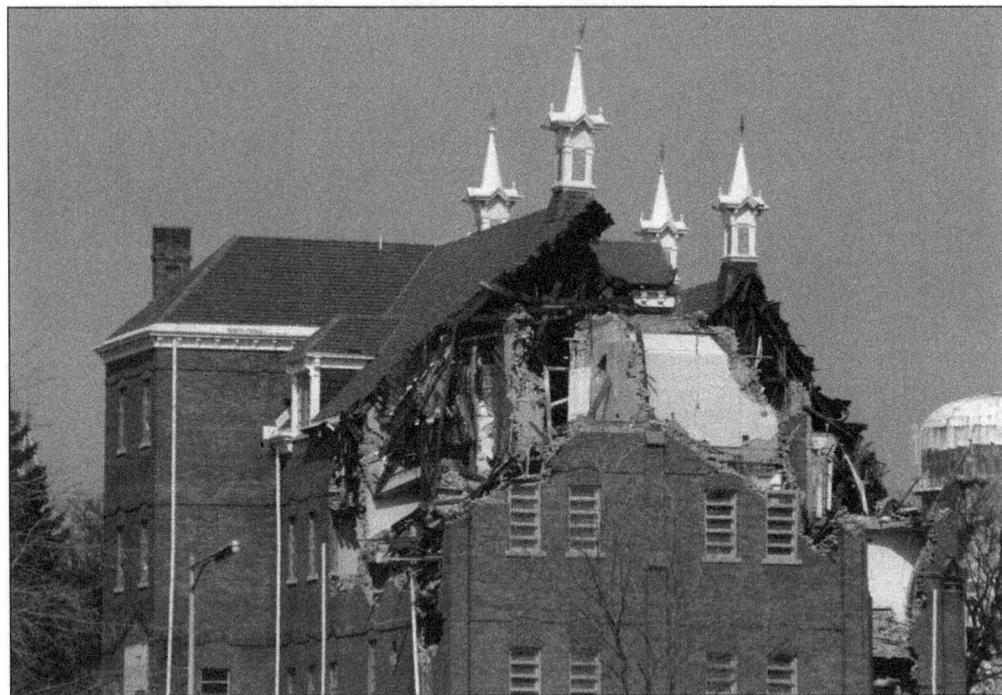

ASYLUM DEMOLITION. Despite an outcry from the community and an appeal to the National Trust, little time was given by the state to offer the campus for sale to private concerns. The campus and its buildings had great potential for practical reuse. For example, Traverse City renovated and converted its old hospital site into a modern village with shops and restaurants but kept its beautiful Victorian architecture intact. (Courtesy of Bruce Annett, www.bbmck.com)

Six

OCCUPATIONS
AND DIVERSIONS

In the first decades of Pontiac, typical occupations for men included lawyer, doctor, surveyor, merchant, architect, banker, tailor, elected positions, farmer, carpenter, miller, blacksmith, brick maker, plasterer, teamster, logger, and shoemaker. For women, typical jobs included homemaker, teacher, nursemaid, cook, housekeeper, gardener, caregiver, seamstress, civic leaders, and landlady. Women were also recognized in many fields like medicine and higher education. By the 1920s, African American doctors and lawyers were opening offices in town.

After the Civil War, Main Street shops sold candy, bicycles, and men's, women's, and children's garments. There were music stores, theaters, restaurants, and hotels, with stables and blacksmiths intermingled. Pharmacies were coming onto the scene. General stores offered a little of everything, including dry goods like sugar, flour, coffee, and beans. There were hardware and sporting goods stores. Builders and land agents had offices around town. Basically everything that was essential was conveniently located to those that lived in town. For example, the train station was close by, and the courthouse was on the corner. By the time automobiles were being sold, dealerships for the various brands sprang up in downtown.

Early on, police and fire departments provided protection for Pontiac. However, most early buildings were extremely vulnerable to fire, which made it challenging to keep a fire from spreading. By the mid-20th century, African Americans and Hispanics were in both the police and fire departments, even though they were few.

Picnics were an affordable diversion for everyone. Music and dance lessons were common. Boys could fish and hunt. By the beginning of the 20th century, a library had opened. Boy Scout and Girl Scout groups began forming. The Pontiac Creative Art Center opened in 1968. By this time, there were all kinds of sports teams for kids and adults to be active in. Pontiac started a network of community and senior centers. Due to difficult financial times, most of these centers have been closed with no hope of them reopening.

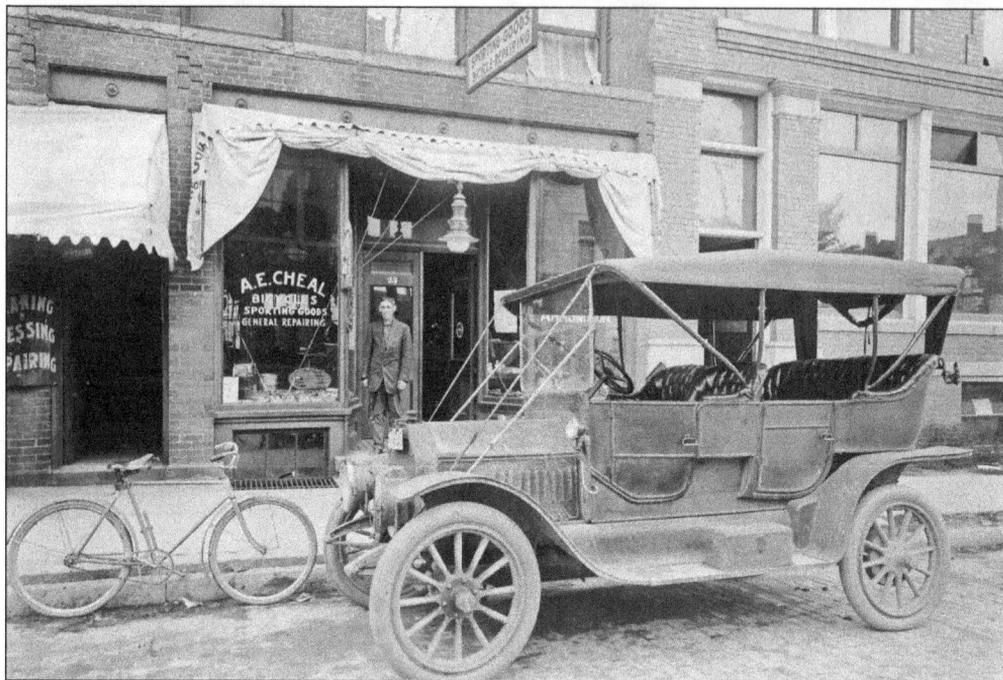

BIKE STORE. A. E. Cheal had a bike and sporting goods store on Saginaw Street. The owner has on his suit coat. The bike is positioned in front of an auto of the day to illustrate some comparison. Brick pavers are working on the street. By the early 1920s, Pontiac had more paved streets than any area in the county, which made it a good place to ride and sell bicycles. (Courtesy of OCPHS.)

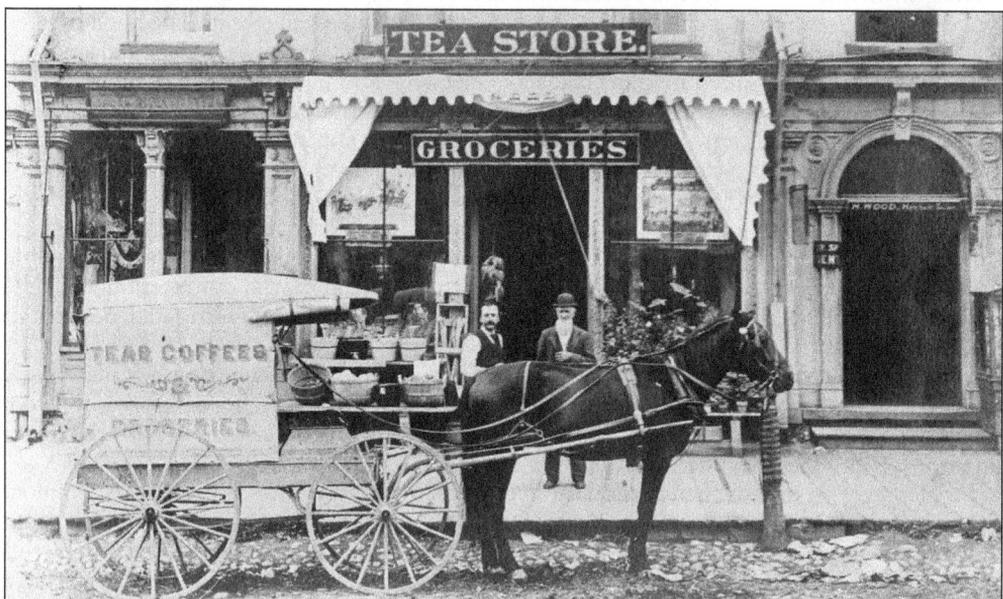

TEA STORE. For someone to put it on the front of his store, it is apparent that tea was a big seller. Catering wagons are not a modern invention or convenience. They have been in business for a long period of time. The sidewalks are wooden, and the street is unpaved. A hitching post stands where one might find a parking meter today. (Courtesy OCPHS.)

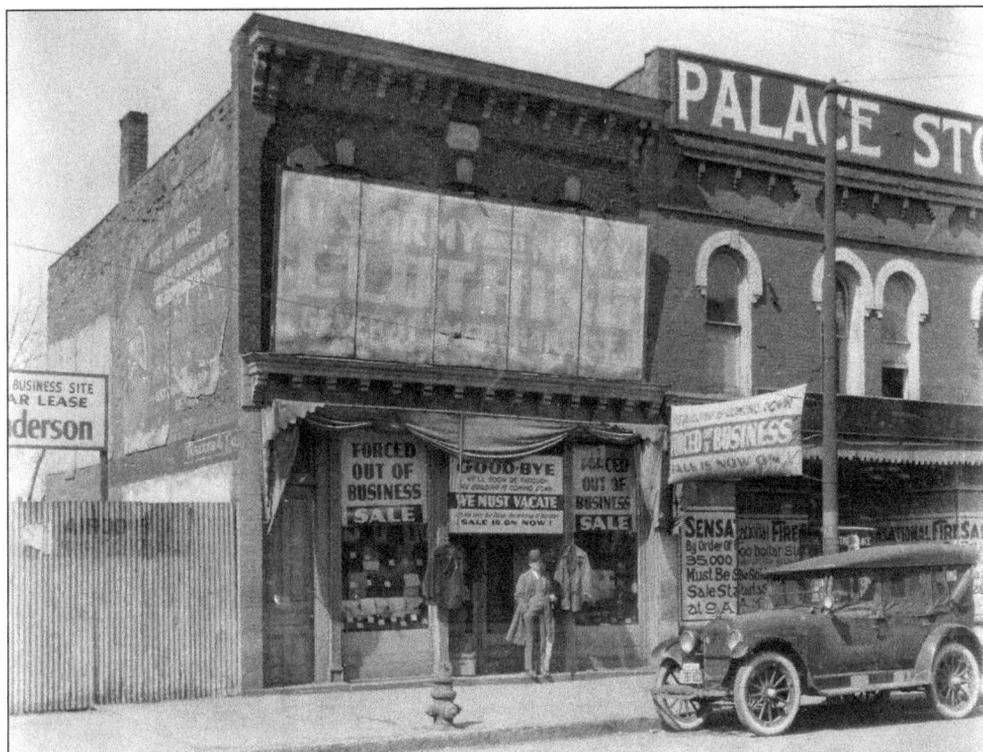

ARMY-NAVY SURPLUS. The sign in the window states that the building is coming down, forced out of business. It appears the building to the left is already closed. Joe's Army Navy was also a fixture on Saginaw Street in the 1950s and 1960s. (Courtesy of OCPHS.)

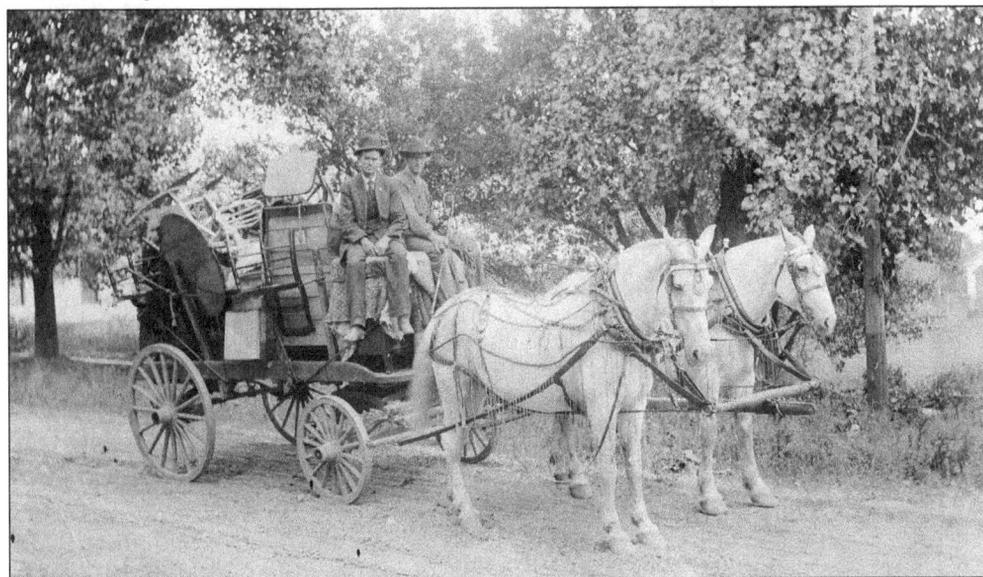

AUSTIN AND MASON MOVERS. This moving company offered a variety of trucking services. This crew is using a chest of drawers as their wagon seat. The furniture in the back is heaped on, with no care for packing or padding, but the horses are adorned with a fringe of some kind, and their tack is of a fine variety. The drivers are even in suits and ties. (Courtesy of OCPHS.)

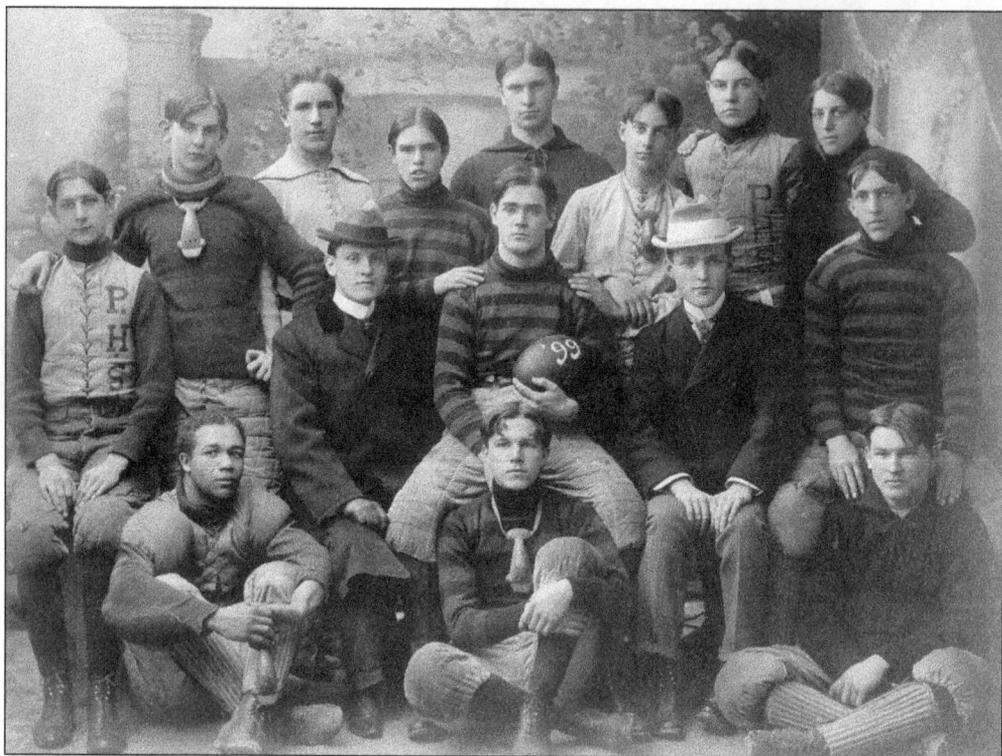

FOOTBALL TEAM. This is the Pontiac High School team of 1899. It is touted as a champion team despite a slow start and a ragged look. The team went on to win the state title, defeating Plainwell in the final game. Their uniforms lacked standardization. Some players had padded shoulders, and some had mouth guards. At this time, helmets were not used in the sport of football. Wilbur Hughes (front row, left) was the first African American to graduate from Pontiac High School. (Courtesy of OCPHS.)

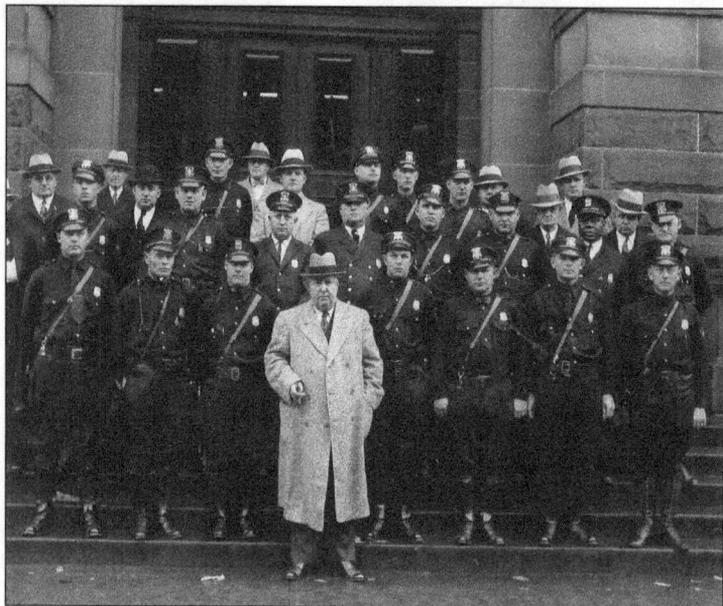

PONTIAC'S FINEST. This photograph shows the Pontiac Police Department in the 1930s. Allen Noble, Pontiac's first African American police officer, is pictured. He graduated from the University of Michigan in 1931. It wasn't until 1952 that Pontiac hired its first Hispanic officer, Rudy Martinez. Martinez went on to retire from the force after a long career. (Courtesy of Pontiac Public Library.)

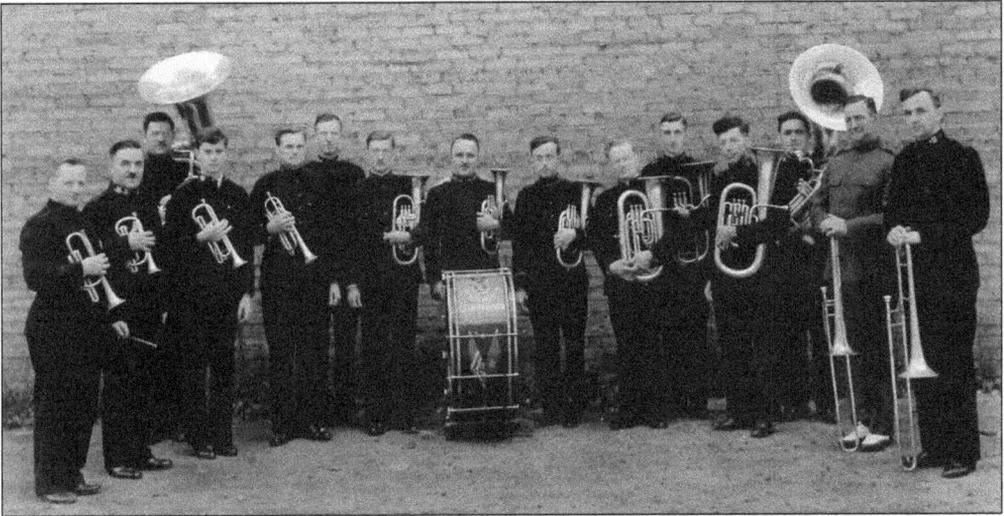

SALVATION ARMY BAND. It has been 120 years since the corps came to Pontiac. The Salvationists are known for taking a message of salvation and redemption to the downtrodden. In Pontiac, its rehabilitation center and retail store are closed today. The photograph on page 76 shows the center before the army occupied it. Built in 1921, its first building still exists at 29 West Lawrence Street. (Courtesy of the Salvation Army.)

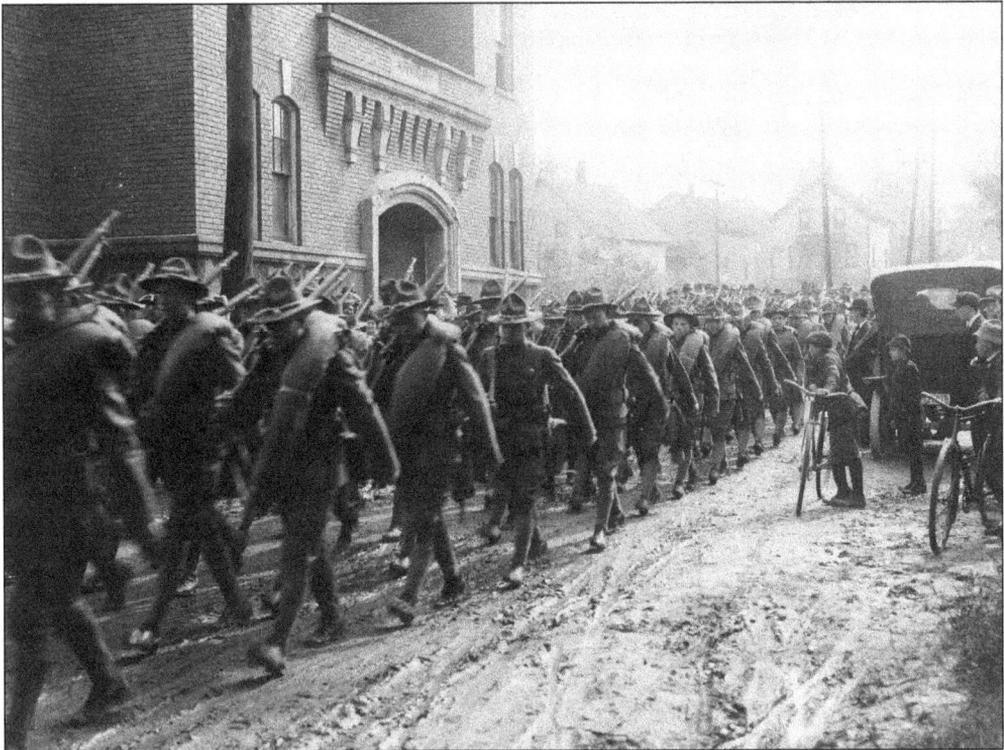

SOLDIERS LEAVING. Leaving the armory on West Pike Street in 1917, the first draft contingent is heading to Grayling before being shipped out to war. The importance of the day can be seen in not only the faces of the soldiers but also in the bystanders. Young boys are looking on in a sense of awe, getting as close as possible to the recruits. (Courtesy of OCPHS.)

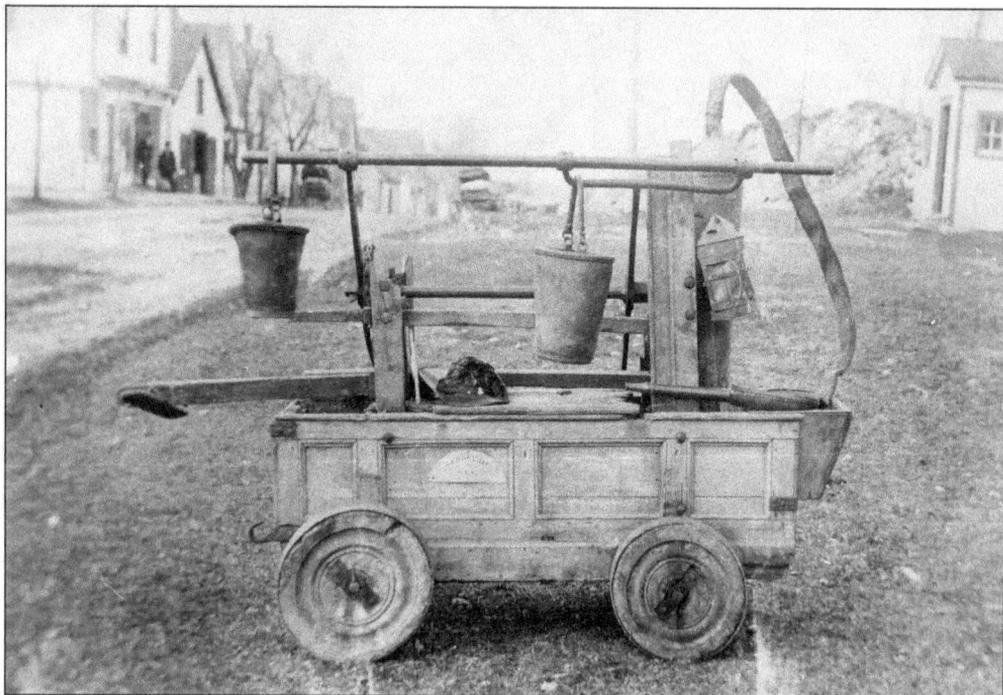

FIRE EQUIPMENT. This early portable pumping station (above) has handles for two men to pump (one on each side), buckets for carrying water, a lantern, and a hook. It appears to be for use in remote locations. The building (below) is Victorian, and at the time it was built, the fire station used horses and wagons. This is Pontiac's main station on Pike Street with two pumpers, a ladder truck, and the chief's car. There are 29 firefighters and a boy pictured. The uniforms have brass buttons that needed to be polished regularly. (Both courtesy of Pontiac Public Library.)

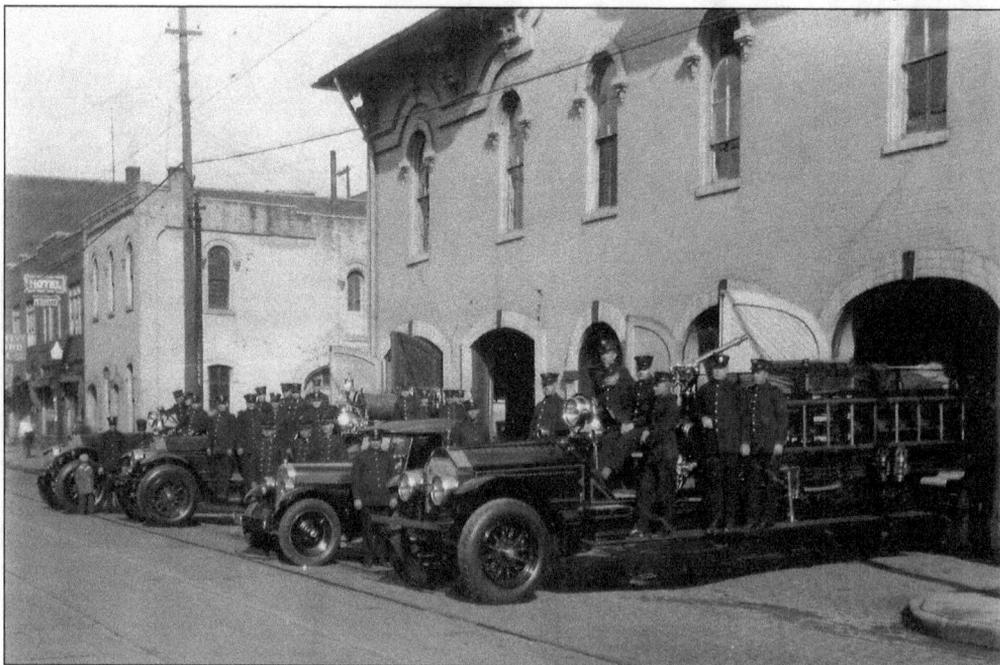

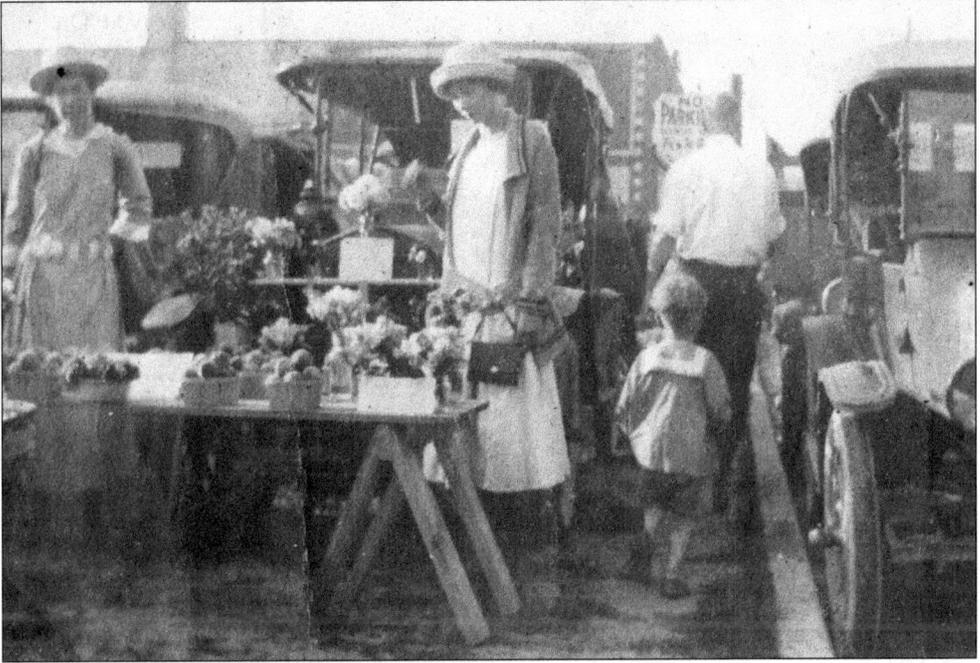

FARMERS MARKET. The county farmers market started in Pontiac on Mill Street in 1923. The farmers had only one bay for their vehicle and table. Geoff Holmwood was present that first year and still takes his goods to market on Saturday. He says that before the county market, vendors came to town and parked on the street to sell their produce. No other photograph of this early market is known to exist. (Courtesy of Geoffrey Holmwood.)

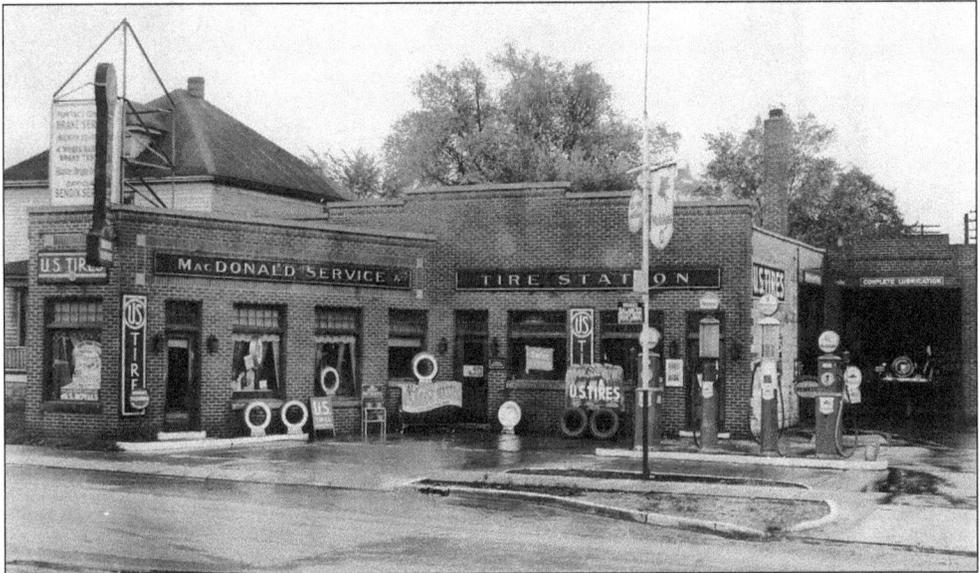

MacDonald's Station. This service station and tire store was owned by Don R. MacDonald. He was a resident of Sylvan Lake. The store was a dealer for U.S. Royal Tires, later known as Uniroyal. The car in the bay is a 1936 Ford. MacDonald was a World War I veteran, one-time mayor of Sylvan Lake, and commodore of the Oakland County Boat Club. He owned a Chris Craft for his personal pleasure. The building is still on the Woodward Loop. (Courtesy of Norm Kasavage.)

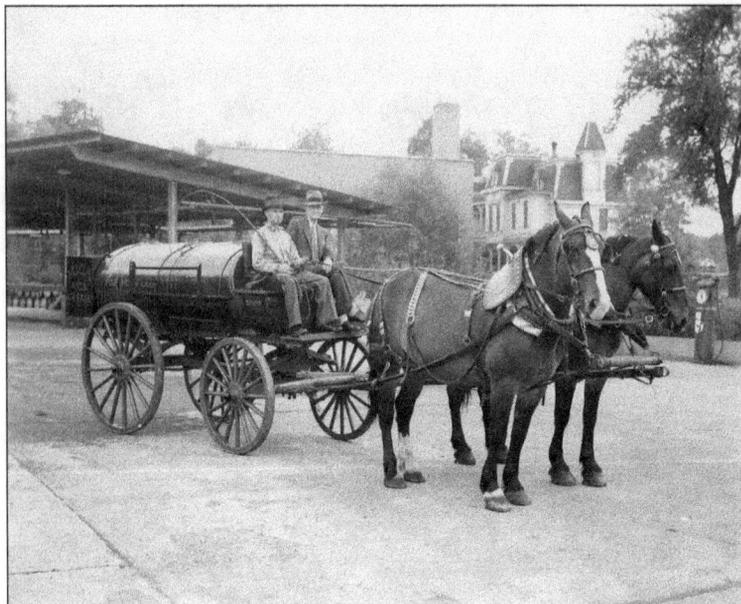

STANDARD OIL TRUCK. Before there were gas-powered trucks, wagons were trucks. The wagon, cutter, and carriage business got going in Pontiac after the Civil War, but it was established beforehand. This is one of the many specialty trucks of the day, just like today's models. (Courtesy of OCPHS.)

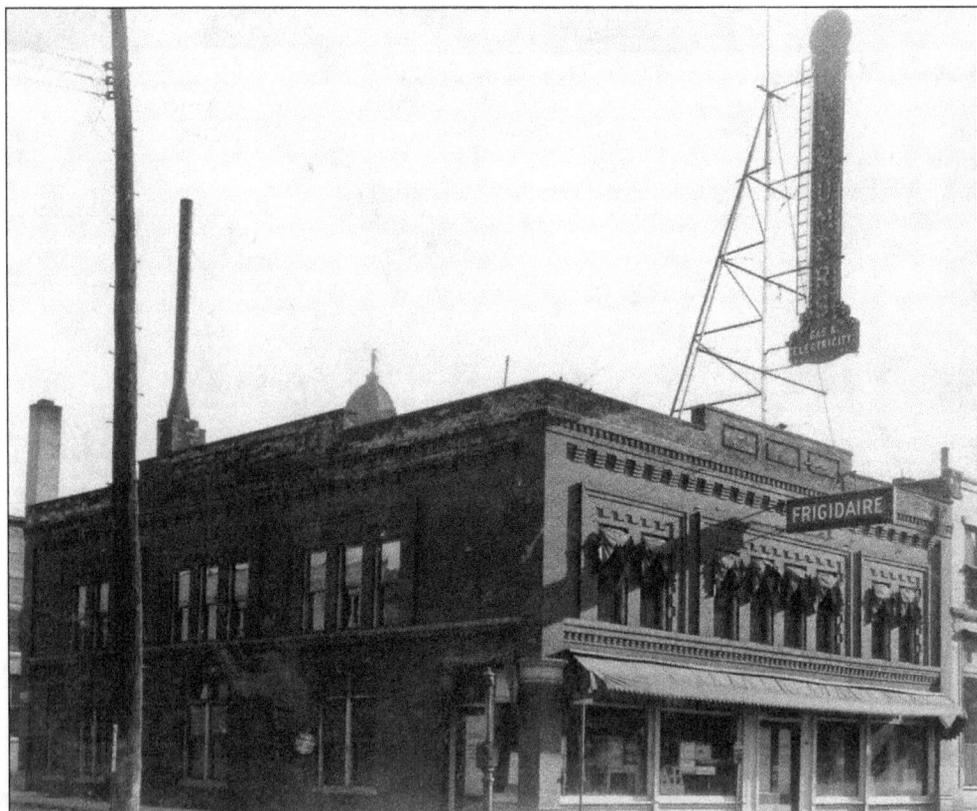

CONSUMER'S POWER STORE. This store is on West Lawrence Street. Consumer's Power was in business well before this store was selling refrigerators and stoves. Frigidaire was an early brand that became so popular that refrigerators were often called Frigidaires. The courthouse dome is in the back center. (Courtesy of Pontiac Public Library.)

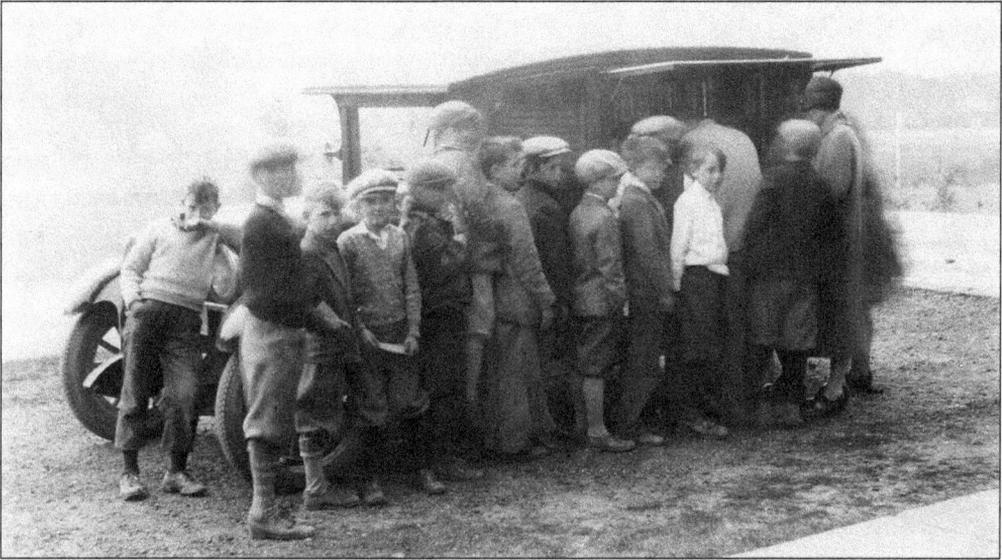

BOOKMOBILE. Waiting patiently and calmly, boys line up to check out books. Books were a luxury many could not afford, especially during the Depression. (Courtesy of OCPHS.)

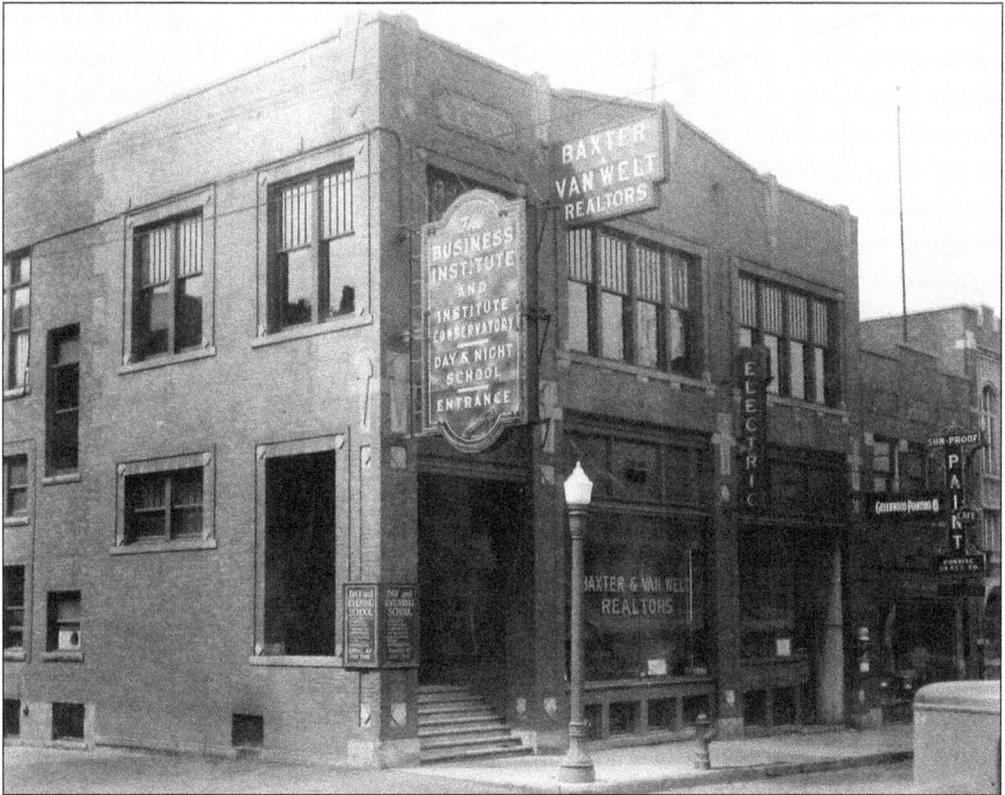

BUSINESS INSTITUTE. This building housed at least three businesses. In 1929, the Institute Conservatory put on its 134th pupil's recital, indicating the length of time it was teaching voice, piano, and other musical skills. The institute was there until General Printing moved in downstairs to sell office supplies and contract printing work. (Courtesy of Pontiac Public Library.)

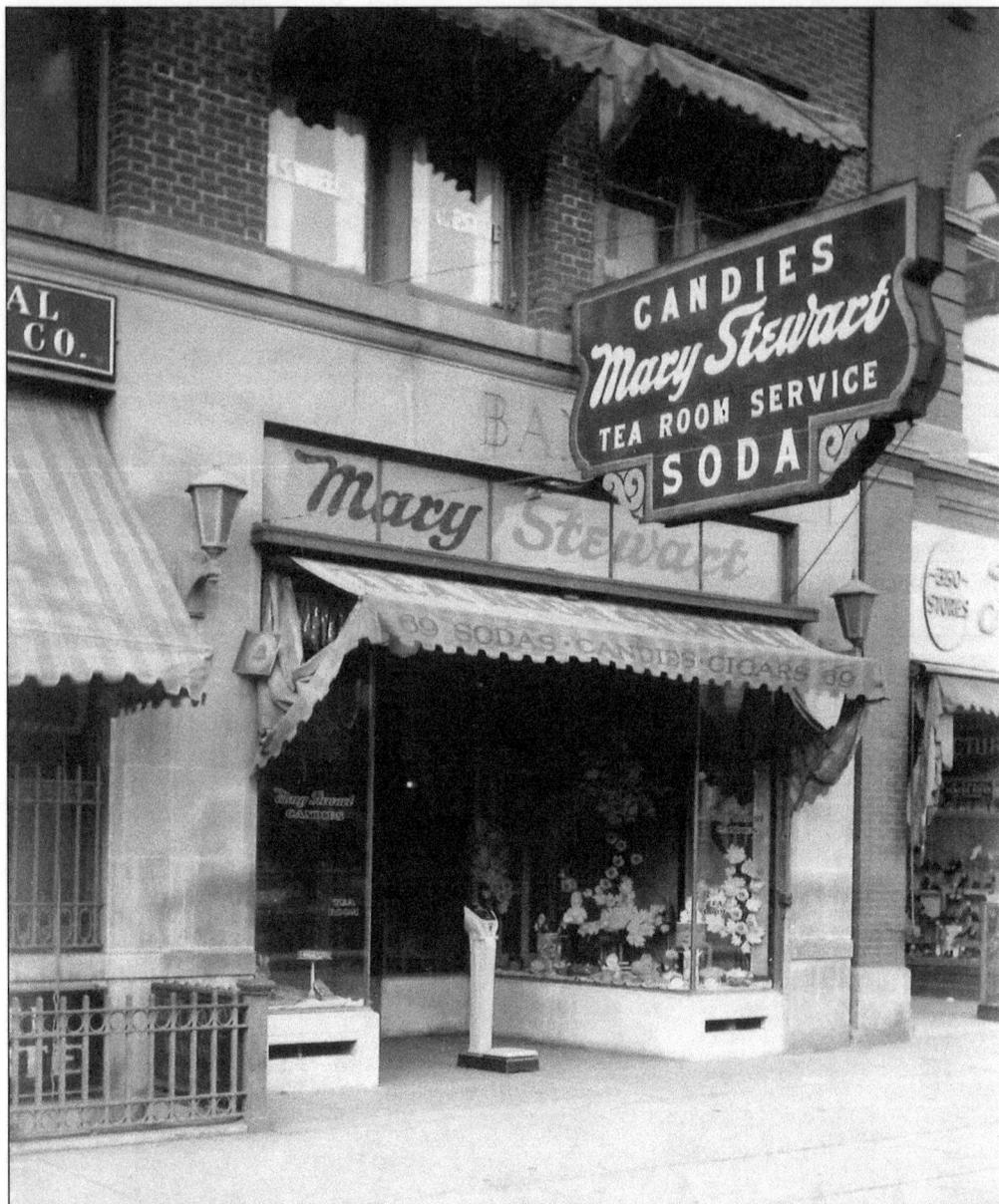

MARY STEWART'S TEA. Over the decades, the popularity of tea in Pontiac seems to indicate the presence of early immigrants from the British Isles. The penny scale by the entrance was a common fixture of the mid-20th century. Most would give a person's weight and a fortune for a penny. The store sold sodas that had become popular as well. (Courtesy of OCPHS.)

WESSEN AND BAGLEY. Known as "The Corner," this was a major business center in the African American community into the 1960s. Pictured in the 1950s, Cooley General Store stands on the corner with the Woodward BBQ down the street. Dr. Howard McNeil had an office on Wessen Street. The Elks had a lodge on Bagley, south of Wessen. There was a poolroom, barbershop, funeral parlor, hotel, and an ice and coal company. (Courtesy of Pontiac Public Library.)

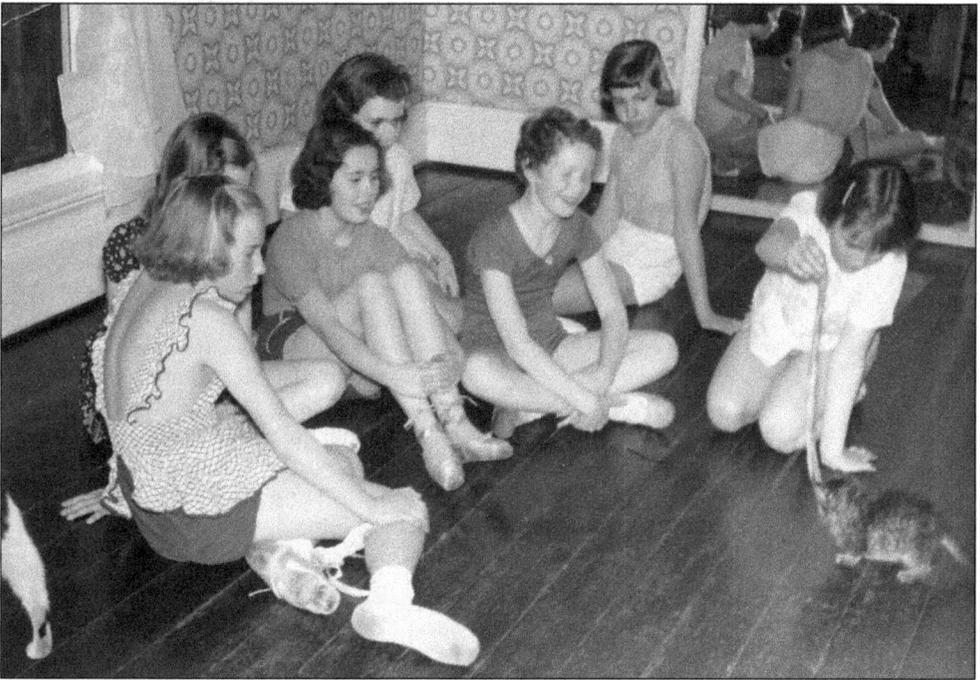

DANCE CLASS. Georgia Hoyt taught music and dance from her home in Pontiac for 65 years. Here are some girls from the middle part of the century playing with some of Hoyt's cats. Recitals were given from time to time in various locations in and out of town. One recital was on the shores of Hammond Lake in the early part of the century. Members of the Detroit Symphony Orchestra came to play at the request Miss Hoyt. (Courtesy of OCPHS.)

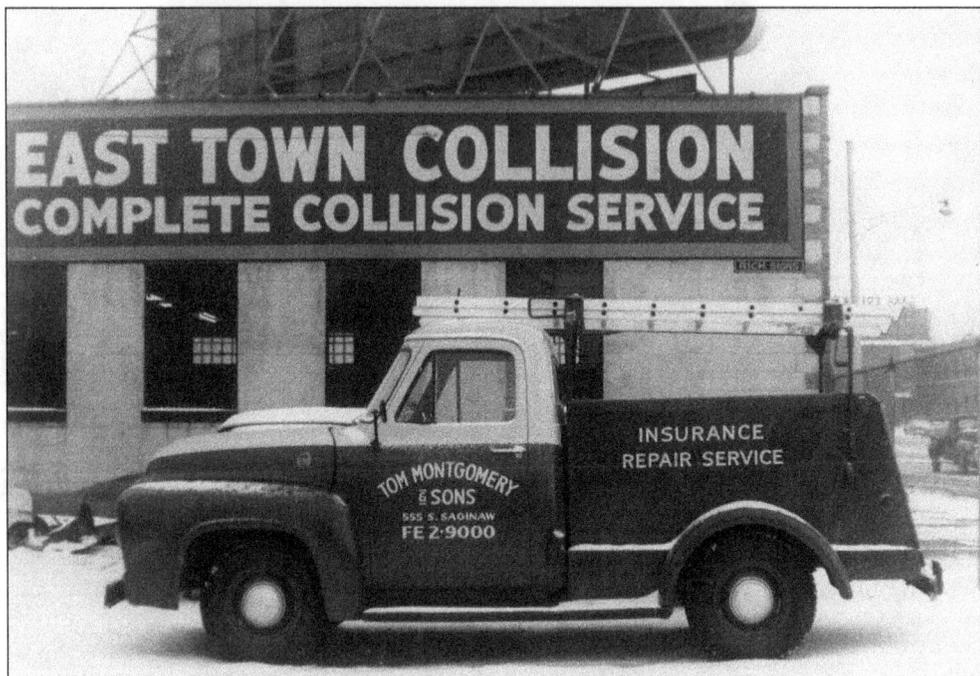

MONTGOMERY TRUCK. The sign on this truck was painted by Rich Sign, which still operates a sign business in Pontiac. Montgomery and Sons started business in town. It has grown to become a major fire and storm contractor in Michigan. A collision service currently operates out of this building on Woodward Avenue, formerly South Saginaw Street, by the railroad tracks. (Courtesy of Rich Sign.)

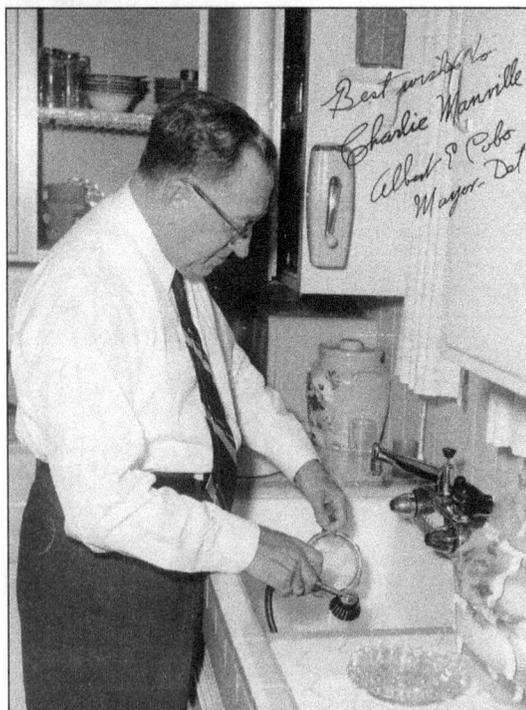

MAYOR COBO. Starting in 1948, the Dishmaster Faucet was made right here in Pontiac for decades on Bagley Street next to the golf course. The building was remodeled after the company moved to Indiana to become part of SilverStream LLC. The mayor of Detroit, Albert E. Cobo, namesake of Cobo Hall, is using his Dishmaster Faucet. He was so impressed with it that he sent the owner of the company, Charlie Manville, an autographed picture. The appliance has been given away on game shows and featured in movies like *Indiana Jones and the Kingdom of the Crystal Skull*. (Courtesy of SilverStream LLC–Dishmaster Faucet.)

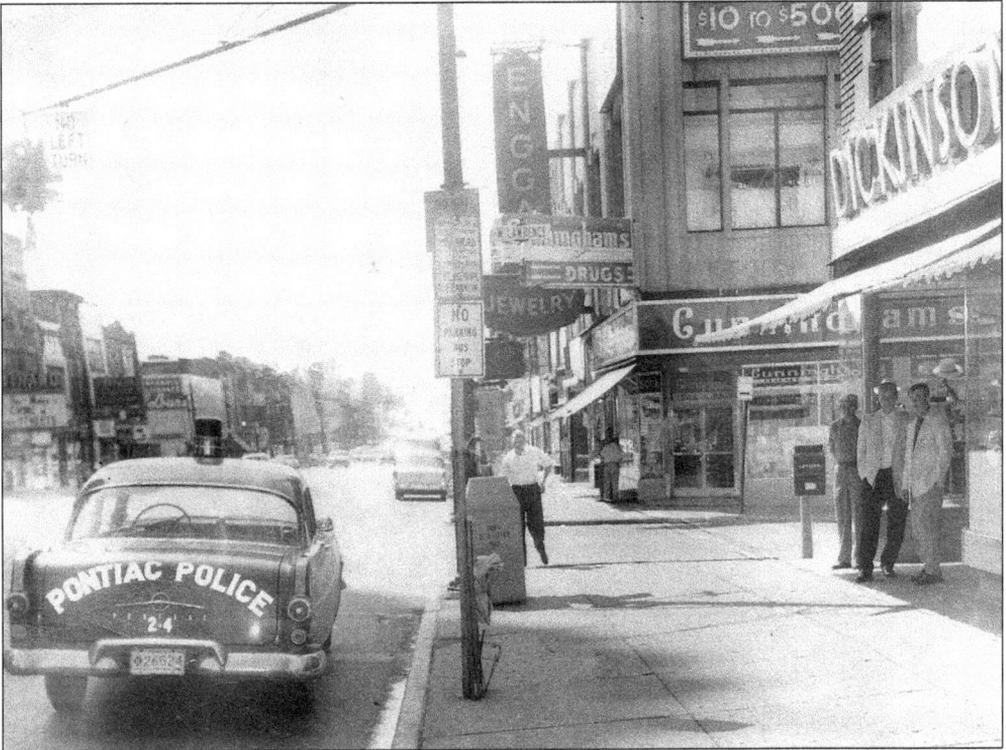

POLICE CAR. It is only appropriate for Pontiac policemen to drive a Pontiac car. And it is only appropriate for the squad car to be parked across the street from the Strand Theater, which is playing *Crime on the Streets*. This was before the urban renewal plan changed the city dramatically. (Courtesy of Service Glass.)

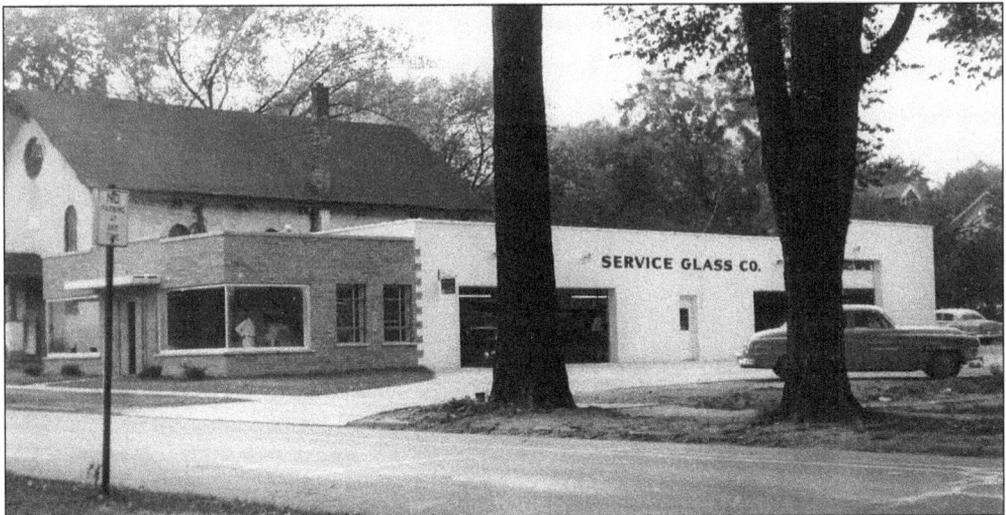

SERVICE GLASS. Richard Shafto became an owner of Service Glass in 1973 after longtime employment there. The company has been a fixture in Pontiac for over half a century. The Clinton River used to run through this area, and the Hinman Estate was just in front of the glass company. Maybe that explains why some years back a major sinkhole opened in the businesses' parking lot. It turned out to be an old cistern, likely the Hinmans'. (Courtesy of Service Glass.)

75

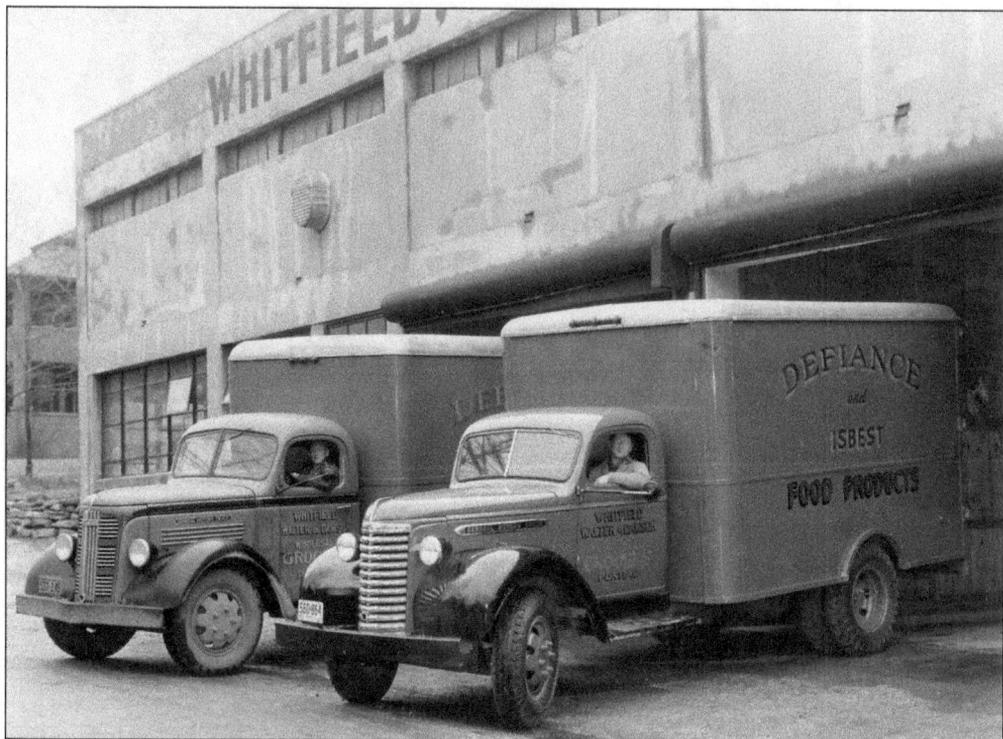

WHITFIELD, WALTER, AND DAWSON. Two owners and a silent partner owned this wholesale grocery business. It was located at 118 West Lawrence Street from 1929 to 1954. Guy Walter's grandson, Guy Duffield, remembers the job of hand-pasting labels on canned goods as a boy. The two brands of the wholesaler were Isbest and Defiance. The trucks are, from left to right, 1937 and 1938 GMC models. (Courtesy of Carol Craven.)

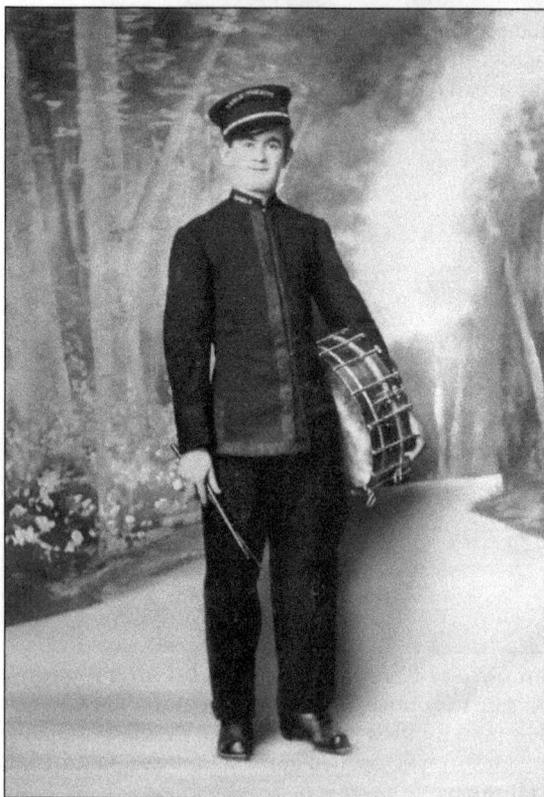

THEATER DRUMMER. Edward Fox worked in the coal mines and learned the drums from Tommy Dorsey's father in Pennsylvania before coming to Pontiac at 19 years old. He played in many Pontiac theater orchestras for vaudeville and silent movies. His hat reads, "Eagle Theater." Talking movies put him out of work, so he became a janitor at the Strand before working in the auto industry. (Courtesy of Richard Thibodeau.)

ART CENTER. After the City of Pontiac opened its new library in 1960, the old Stout Memorial Library became available. Dr. Harold Furlong, an obstetrician and patron of the arts, thought it would make a good art center. Though the building is still owned by the city, the Creative Arts Center has been funded by an endowment of the Furlongs, as well as other charitable contributions. It opened in 1968. (Courtesy of Pontiac Creative Arts Center.)

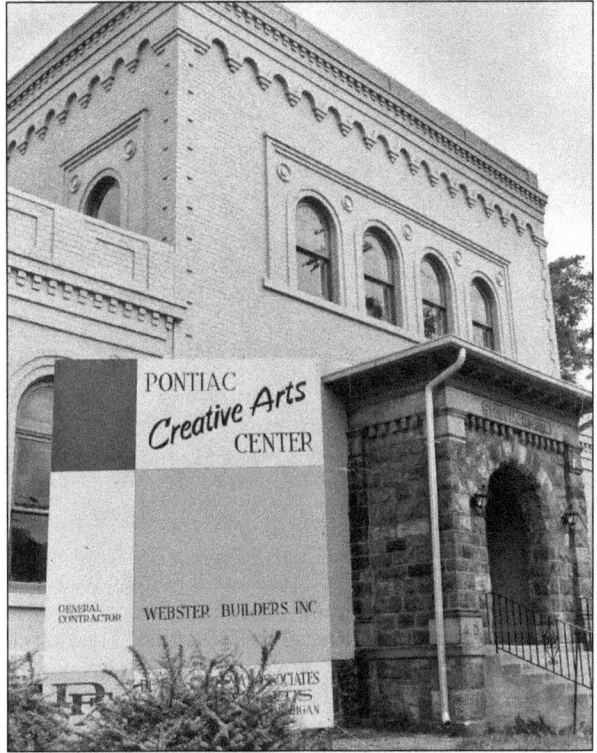

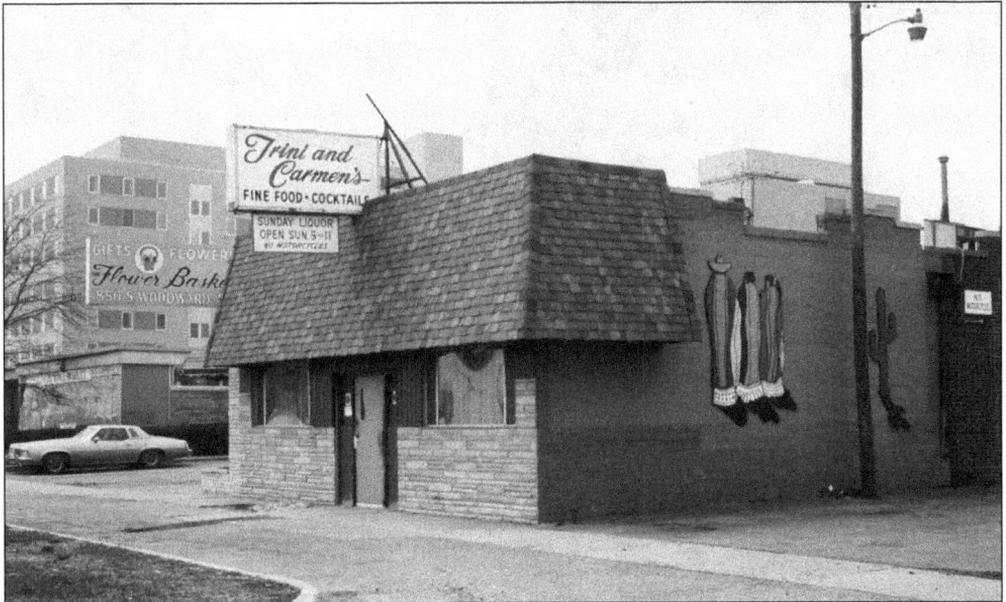

TRINI AND CARMEN'S. Trini and Carmen Martinez opened their restaurant on Woodward Avenue in 1966. They closed two previous establishments to make the move. Carmen says that when they first opened, their menu was meat and potatoes, as the previous owner had served. Their first nachos were chips and jalapenos. The nachos soon evolved, along with the entire menu, which included other Mexican items. St. Joseph Mercy Hospital bought this location many years ago for expansion. (Courtesy of Walter P. Reuther Library, WSU.)

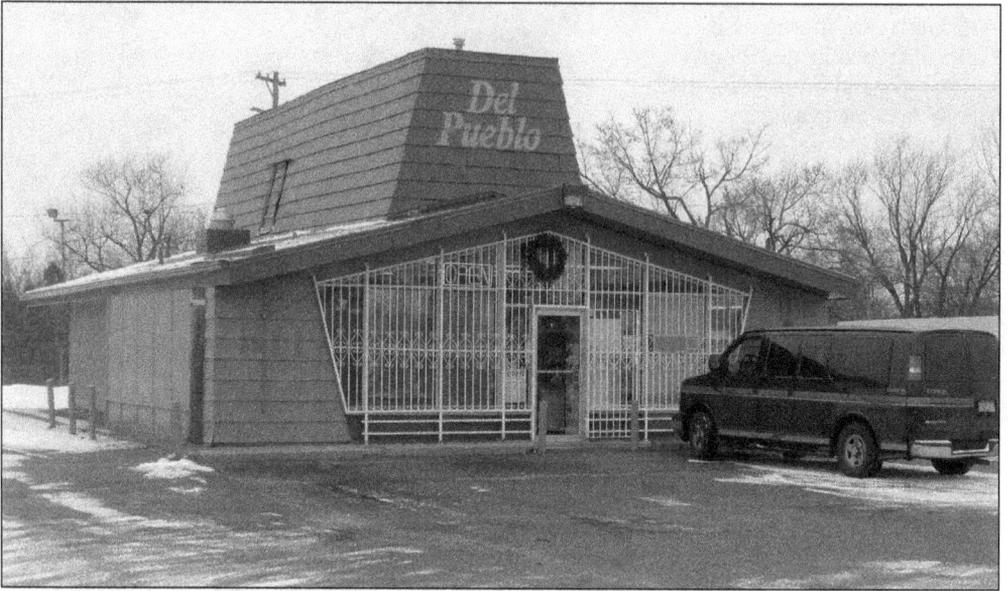

DEL PUEBLO. Del Pueblo sells Mexican grocery items, some of which are made on-site. This is the second location for the store in Pontiac. The first one opened in 1968 on Auburn Avenue. The Perry Street corridor, as well as Baldwin Avenue, has become a common area for Mexican businesses to locate. (Author's collection.)

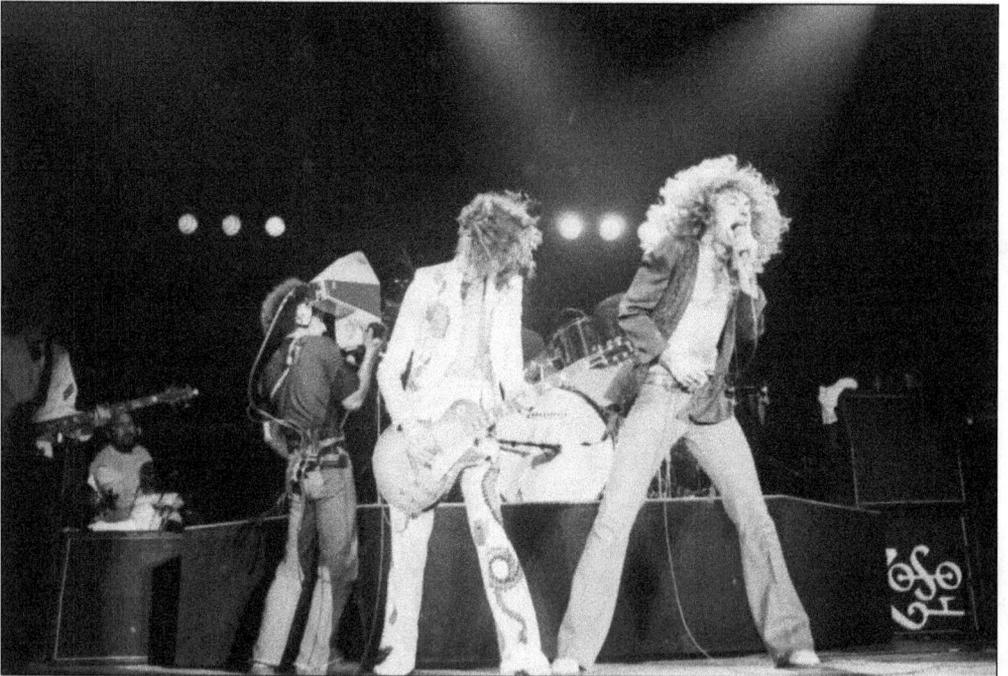

LED ZEPPELIN. One of the side benefits of having an indoor football stadium is the ability to host big-name artists like Michael Jackson and Led Zeppelin that attract large crowds. However, the largest attraction over the life of the arena was not a rock star but a religious leader. In 1987, over 93,000 people showed up to see the pontiff, Pope John Paul II. The rock superstars fell nearly 20,000 fans short of that benchmark. (Courtesy of Walter P. Reuther Library, WSU.)

Seven

RIVERS, ROADS, AND RAILS

The Detroit River provided a port for goods and passengers when Detroit was settled in 1701. Pontiac's location on the Huron at St. Clair River, now the Clinton, virtually insured success as an upstart village because of the waterpower for mills and the water routes to Lake St. Clair. The location on the Saginaw Trail, a Native American trail from Detroit to Saginaw, was most beneficial. Other Native American trails crossed through the new settlement as well.

The Erie Canal was conceived to connect the Atlantic Ocean, by way of the Hudson, with the Great Lakes. It was referred to as "Clinton's Ditch" or "Clinton's Folly." Upon its completion in 1825, it emerged as an engineering masterpiece, credited for Pontiac's surge in growth through the 1830s and 1840s. The success of the Erie Canal spurned Michigan's own plan to create a canal system linking Lake St. Clair to Lake Michigan, passing through Pontiac via the Clinton River. The canal system in Michigan made it only 12 miles before financial collapse. Competition from railroads proved too much.

The railroads began in the late 1830s and grew rapidly. By that time, roads were getting much better, and streetcars also came into being, first horse-drawn and then electric. The interurbans provided mass transit between cities, towns, and countryside for those fortunate enough to be connected to the lines. In 1909, the first mile of concrete road was laid on Woodward Avenue between Six and Seven Mile Roads, the first in the nation. It was widened to a multilane highway in the 1920s and 1930s. By this time, Pontiac was fortunate to have its own network of paved roads compared to outlying areas. While train traffic is a mere shadow of its heyday, freight traffic continues, and plans for high-speed rail passenger service from Detroit to Chicago and beyond are in the process of being finalized. Regional mass transit is also being discussed.

Street names in Pontiac include names of 1812 war veterans, like Commodore Oliver Perry, Capt. James Lawrence, and DeWitt Clinton, but also more contemporary heroes like Dr. Martin Luther King Jr. and Cesar E. Chavez.

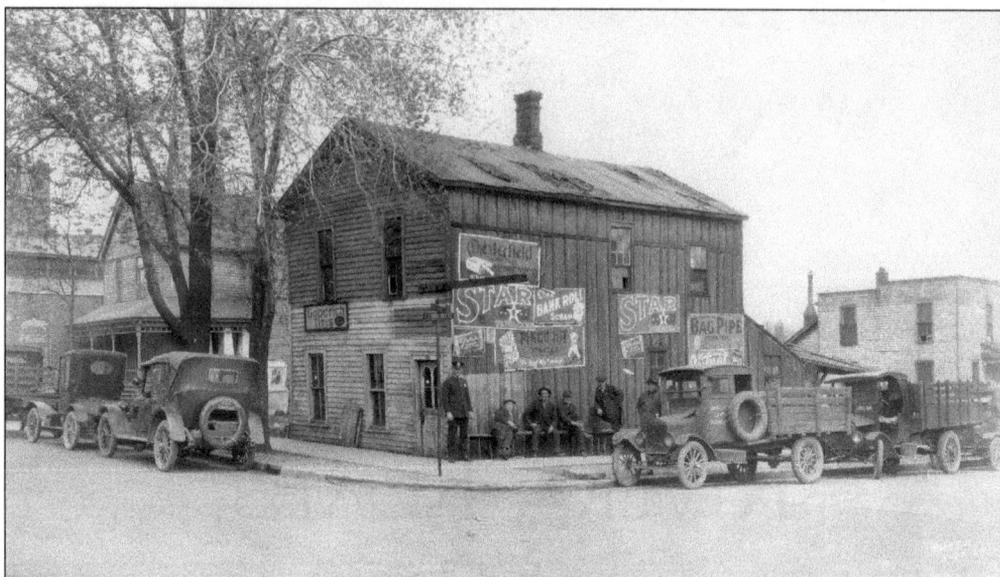

PERRY AND EAST LAWRENCE STREETS. The spare tire cover of the car on the left is advertising Roger's Sporting Goods. The side of the truck on the far right states, "D. W. Kelly Cartage Company." It appears there are five trucks wrapping the corner. The building may be a garage that everyone is hanging around, including the beat cop. There are five or six ads for tobacco on the side of the building, and the roof of the structure is way beyond in need of repair. (Courtesy of Rich Sign.)

BOYS FISHING. Portions of the Clinton River that were not buried are seen east and west of the city today and hardly resemble the natural and wild setting of 100 years ago. People used to take boat tours down sections of the river because of its scenic beauty. These brothers and their dog are spending their summer day sharing a bamboo pole catching fish. (Author's collection.)

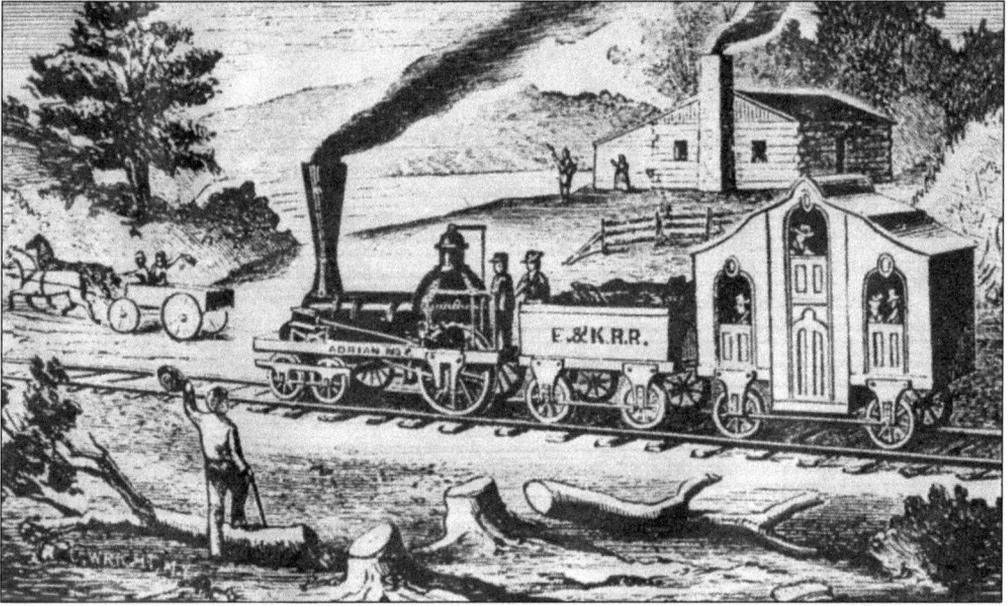

FIRST RAILROAD. The first railroad from Detroit to Pontiac was completed around 1844. The arrival of the railroad was a pivotal event, creating an artery for personal travel and the shipment of all kinds of goods. With its capacity to ship large loads easily, the railroad was transformative—moving societies from the pioneer days into the industrial age. Early steam locomotives were powered by wood, and stockpiles of firewood were replenished at railway stops. (Courtesy of OCPHS.)

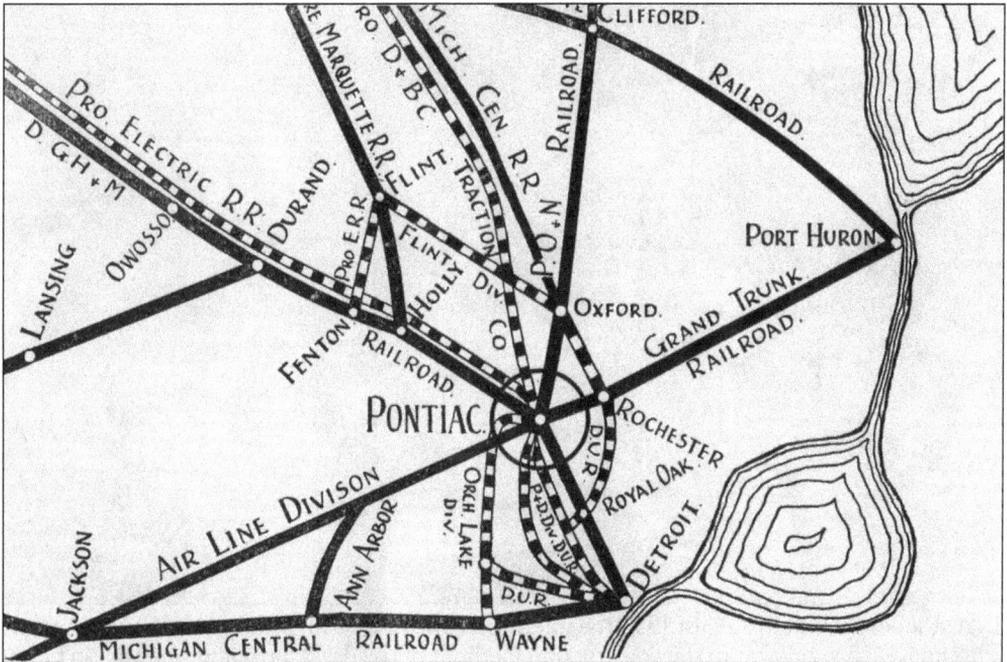

1912 RAILROAD LINES. Pontiac was an important part in the Detroit-area rail system, linking Detroit to Flint, Saginaw, and outlying lake communities. Eventually the automotive industry provided financial support to the railroad. Grand Trunk Railroad, now known as Canadian National, still runs a train yard in Pontiac. (Courtesy of Annalee Kennedy.)

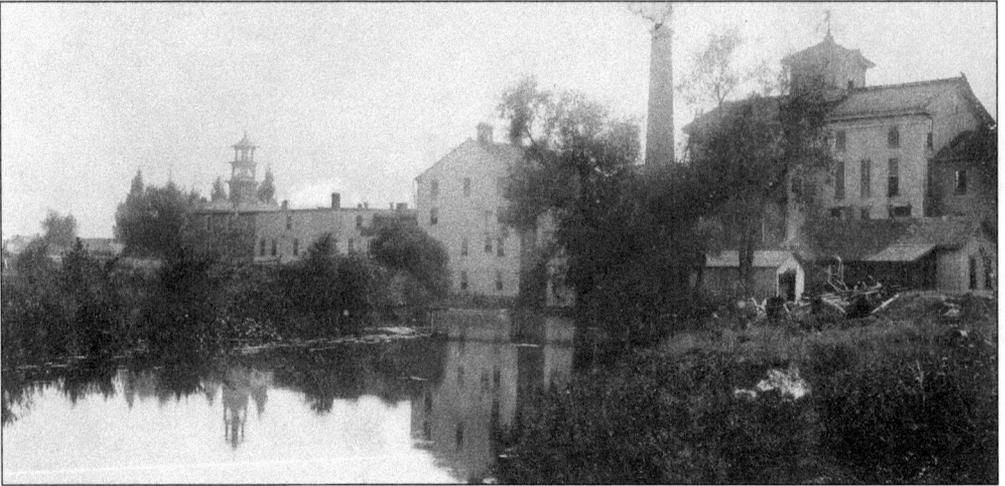

CLINTON MILLS. In one city report, the debris and condition of the old millpond was cited as an eyesore. Milling was the city's earliest industry, beginning with lumber, flour, and wool. Plaster was also made here, as was trim for windows and doors for the finishing in the interiors of houses and buildings. (Courtesy of Burton Collection, Detroit Public Library.)

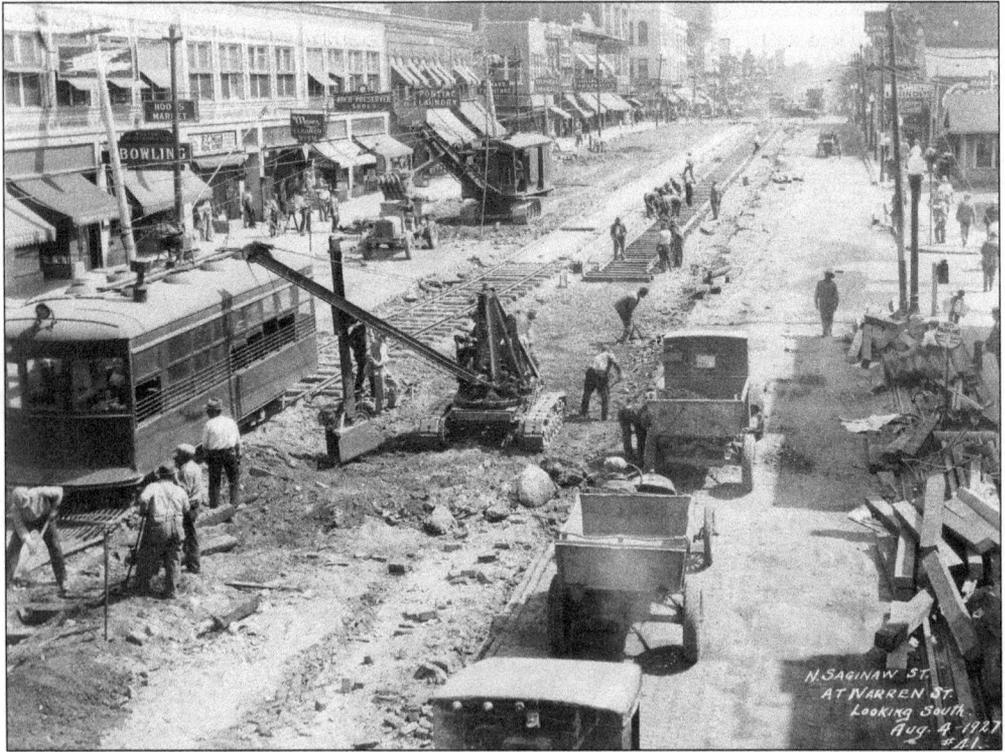

INTERURBAN TRACK. In August 1927, the interurban lines were being expanded through Pontiac. This image is a window into the construction methods of the day. One dump truck doesn't even have a cab. The steam shovel in the distance has a bucket with the teeth facing up and a bottom that opens to empty the load. The smaller tracked machine in the foreground appears to be for compacting the soil. The gang of men at the newly placed track is shifting rails into position and driving spikes. (Courtesy of Pontiac Public Library.)

82

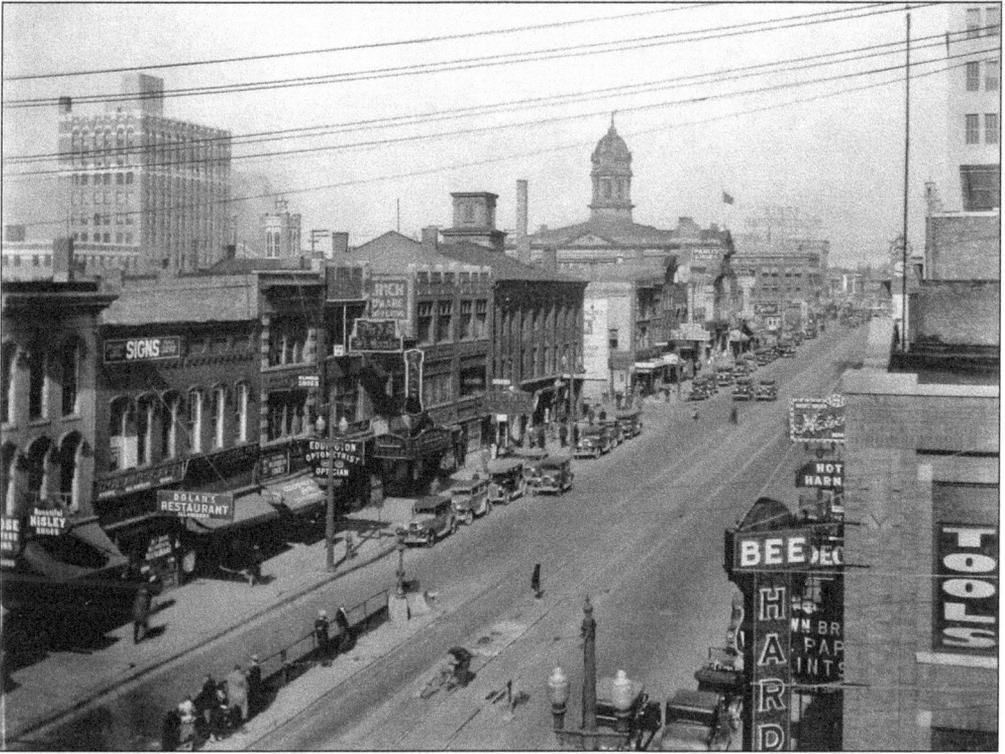

TROLLEY STOP. The streetcar stop on South Saginaw Street is in the center of the road. The schedule must have been frequent and regular, as there is no place for waiting passengers to sit, only a rail to lean on. The street is in its heyday from the looks of the signs, albeit it is right around the time of the Great Depression. There are two hardware stores, several restaurants, an optometrist, and a men's clothing store all located on one block. (Courtesy of Pontiac Public Library.)

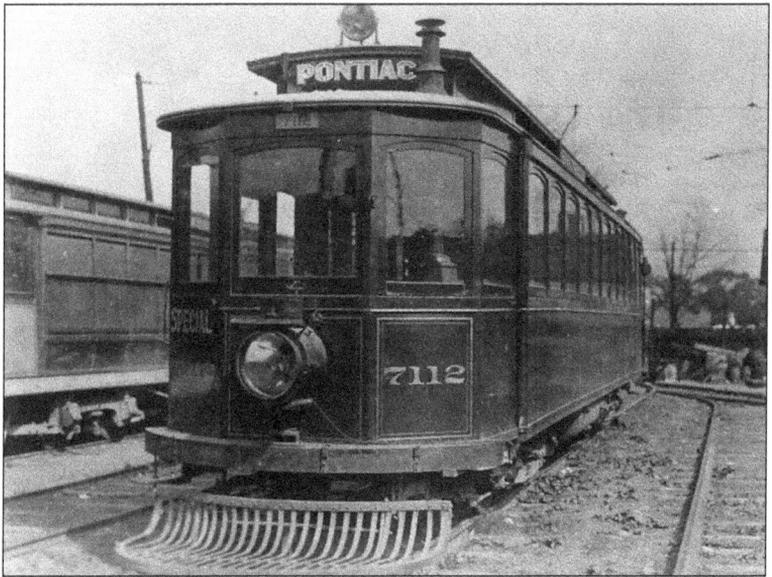

TROLLEY CAR. This is a trolley or streetcar parked in a maintenance area. The trolley lines served many valuable services, including delivering packages and carrying residents from the city to the summer lake spots, particularly Orchard, Sylvan, Pine, and Cass Lakes. (Courtesy of OCPHS.)

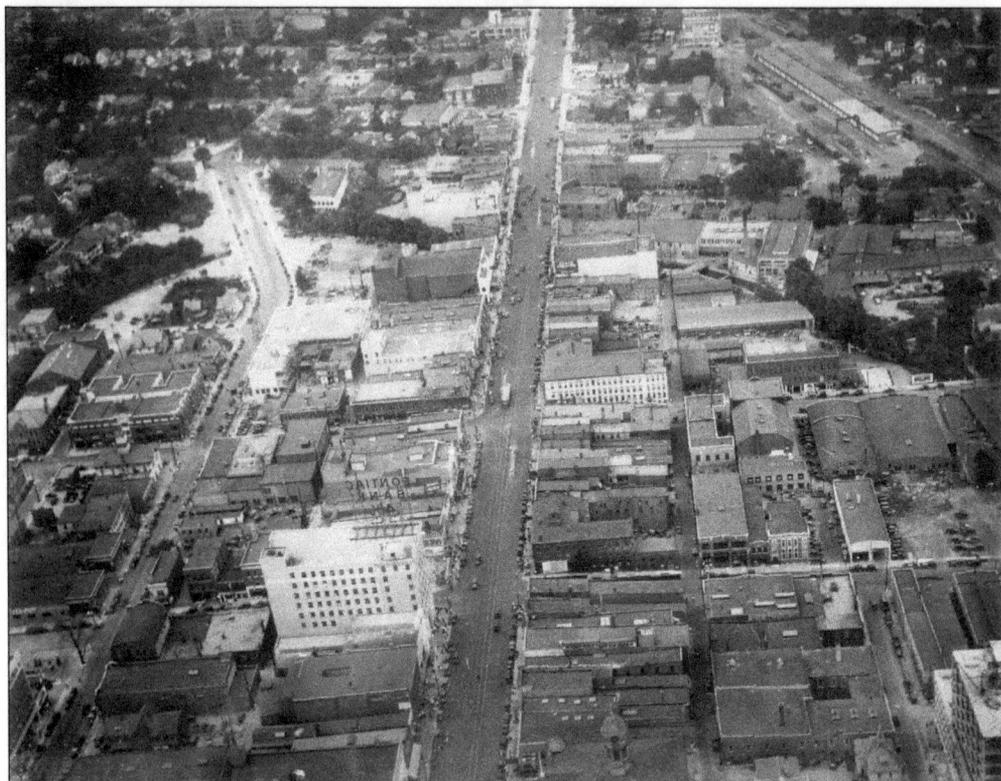

OLD RAIL YARD. This *c*. 1929 aerial photograph looks south down Saginaw Street. The courthouse can barely be seen at the bottom. An old train yard located off Cass Avenue is at the top right. The Clinton River is visible with its tree-lined banks. The number of buildings south of Pike Street is uncountable. Today there are only a few left after the nameless hand of urban renewal in the late 1950s had its way. (Courtesy of Oakland County International Airport.)

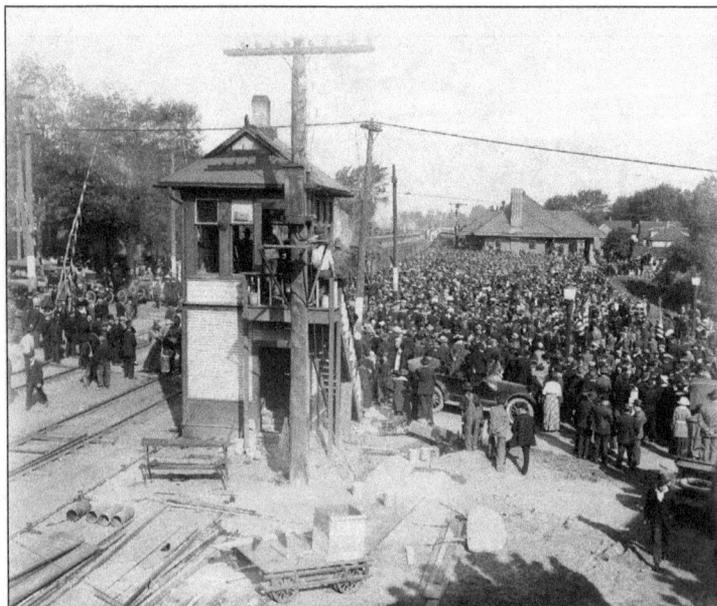

SOLDIERS LEAVING. Soldiers started marching from the armory on Pike Street and got on the train here at Sanderson. On this 1917 day, crowds came out like they did for so many important community watershed events. People are clamoring to be close to the departing soldiers; some are even on the roof of the station. The railroad crossing gate is visible on the left, indicating the early concern for safety. (Courtesy of OCPHS.)

ROAD BUILDING. Swamps were impediments to Michigan's early settlement. The Saginaw Trail from Detroit to Pontiac had to cross a swamp, as did the road from Detroit to Toledo. This photograph was probably taken near Royal Oak, where there was lots of soggy ground. Here Woodward Avenue is being widened from two lanes to multiple lanes. It was a slow and back-breaking task that took several years. These large wheelbarrows run on a track and appeared to be manually powered. (Courtesy of Walter P. Reuther Library, WSU.)

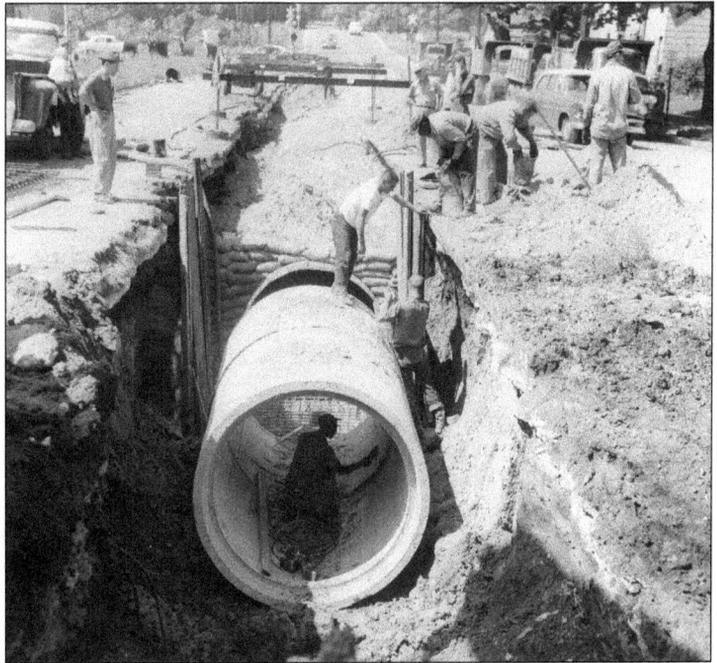

PONTIAC CREEK. The 1950s and 1960s were a time of building, demolition, and change that has come to define the current city of Pontiac. A city with meandering waterways, incomparable historic structures, scenic bridges, and a well-planned streetscape became seemingly overnight a different place entirely. Here is an example of the creek in town being relegated to an underground pipe. (Courtesy of OCPHS.)

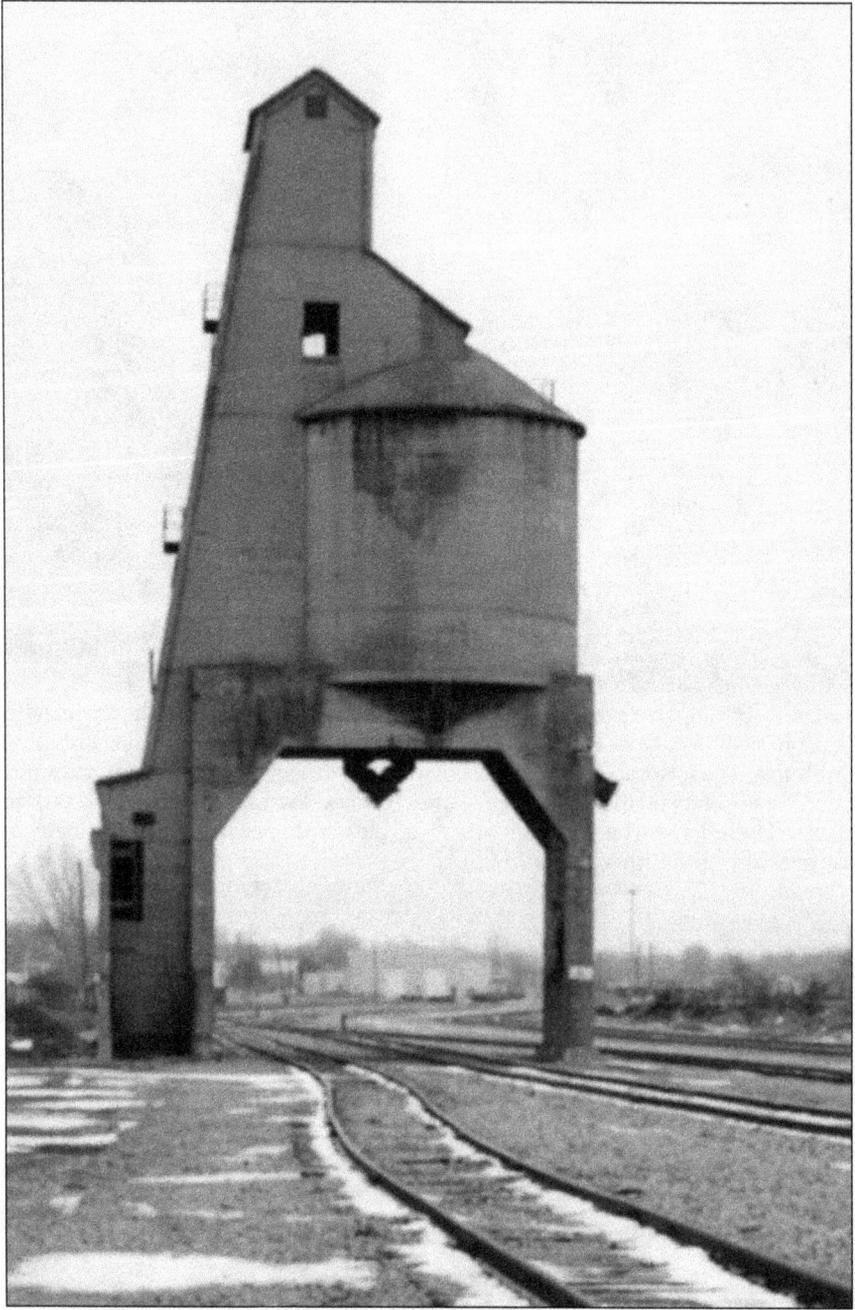

COAL DOCK. This is probably the oldest railroad-related structure in the city. It is in the Canadian National rail yard off of Cesar E. Chavez Avenue. It was used to load the old steam locomotives with coal. It hasn't been used in 50 years, when the steam engines stopped running. Trains also use sand that is dispersed onto the track from the locomotive in front of its wheels to provide traction on steep grades and slick conditions. Train engineers are known for losing their hearing as they get older due to the location of the air horns above the engine cabin. Newer models have positioned their horns further back away from the cabs, which are also quieter and better insulated from the noise. (Courtesy of James Fassinger, www.stillscenes.com.)

Eight

BUGGIES TO BUSES

At the end of the Civil War, a few companies were building wagons, sleighs, and carriages in Pontiac. By the end of the century, business was booming. Names like Pontiac Buggy Company, Pontiac Spring and Wagon Works, Standard Vehicle, and O. J. Beaudette were all poised to build cars.

The Pontiac Buggy Company had scores of models to choose from in its 1904 catalog. In 1907, while still making buggies, Edward Murphy opened the Oakland Motor Car Company in part of the buggy company factory. By 1908, the buggy business was sold off. A year later, the new General Motors owned Oakland.

Before there was Pontiac of General Motors, there was "the Pontiac," manufactured by the Pontiac Vehicle Company, formerly Pontiac Spring and Wagon Works. Albert North and Harry Hamilton had started their wagon and spring works in 1899, but they soon converted to building automobiles and trucks like most other wagon and buggy builders. The Pontiac was their only car model in 1908, but since 1904 they had also been making trucks for the Rapid Vehicle Company of Detroit. The year 1904 was the same year the company had been organized in Detroit by the Grabowsky brothers of Grabowsky Motor Vehicle Company. North and Hamilton did so well in their Pontiac factory building Rapids that they took control of the company. Rapid, the largest truck maker of the day, became the foundation for GMC Truck. General Motors acquired other truck and coach makers in the next several years. Pontiac became General Motors Truck and Coach headquarters. Pontiac was also the capital of bus manufacturing for many years. The bus ridden by Rosa Parks, serial no. 1132, was built in Pontiac.

Pontiac was home to several car makers early on. Welch, Cartercar, Flanders, Friend, Olympian, Monroe, and Oakland were all made here. There were also supporting industries like Baldwin Rubber and the coach builder Beaudette that was absorbed into Fisher Body. Flanders and Whizzer built motorbikes here. UAW Local 594 closed in Pontiac on October 5, 2009. It was the largest truck and bus union local in the world.

MAIL WAGON. Pulling a wagon that was most likely built in Pontiac, it is important to note that the horses were known by citizens as much as the mail carrier. Fritz was one of the better known horses around the turn of the century. This wagon has barely enough room for the driver. Postcards were big business at the time. For a penny, one could send a photograph of a popular site in town. (Courtesy of Pontiac Public Library.)

FIRST PONTIAC. Before Oakland Motor Car introduced its Pontiac model in 1926, there was the Pontiac. Pontiac Spring and Wagon Works, who hadn't been in business but nine years when the model was introduced, manufactured this 1908 model. They started out as a buggy company but quickly switched to automobiles. This car, like some other early models, was driven from the right side. (Courtesy of OCPHS.)

1906 BUGGY CATALOG. The product line catalog for the Pontiac Buggy Company in the early years of the 20th century was impressive. There were scores of models with all kinds of options, including surreys, buggies, and carriages. The company would go on to become Oakland Motor Car while still maintaining the Pontiac Buggy Company for a few years before it was eventually sold off to concentrate on making cars. (Courtesy of OCPHS.)

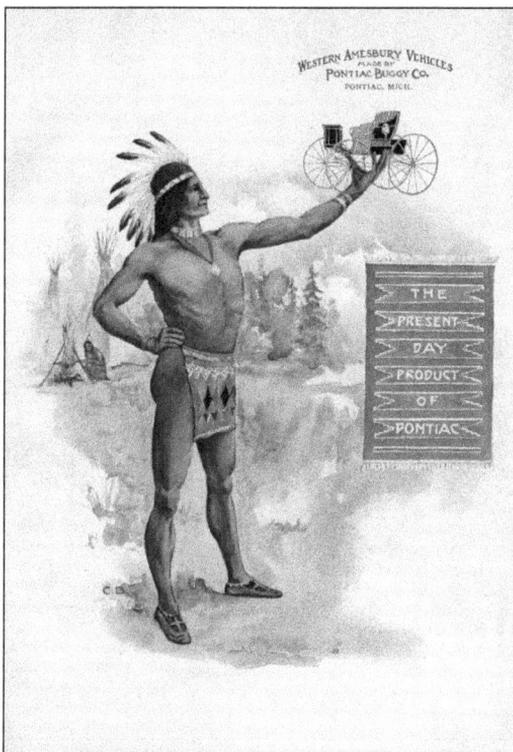

ADLER NO. 100. This 1901 carriage model is a testament to the skills and standards of Edward M. Murphy. He grew his Pontiac Buggy Company into one of the most successful businesses of its kind before the automotive age even got started. Self-oiling, dust-proof axles, cloth or leather upholstery, and screwed rim wheels were a few of the features that set this company's products apart from the rest. (Courtesy of OCPHS.)

Adler. No. 100. Newport Cut-Under Surrey, Extension Top. A Grade.
Admiral. No. 101. Newport Cut-Under Surrey, Canopy Top. A Grade.

Fitted with Pontiac Self-Oiling Dust-Proof Axles. Cleveland quick shifting shaft coupling. Screwed rim wheels. Pullman's open spring cushion. Oil burning lamps and double fenders. Open head springs.

Appropriate for one or two horses. Axles, 1 1-16 in. Band or Sarven wheels, ⅞ or 1 in. tread. Track, 4 ft. 8 in. or 5 ft. Painting—gear, dark green; body, black, with moulding in color. Trimmed in green cloth or leather. Price includes shafts only. Good room under seat for carrying parcels or blankets. Shipping weight, 700 lbs.
EXTRAS—Leather trimming; pole.

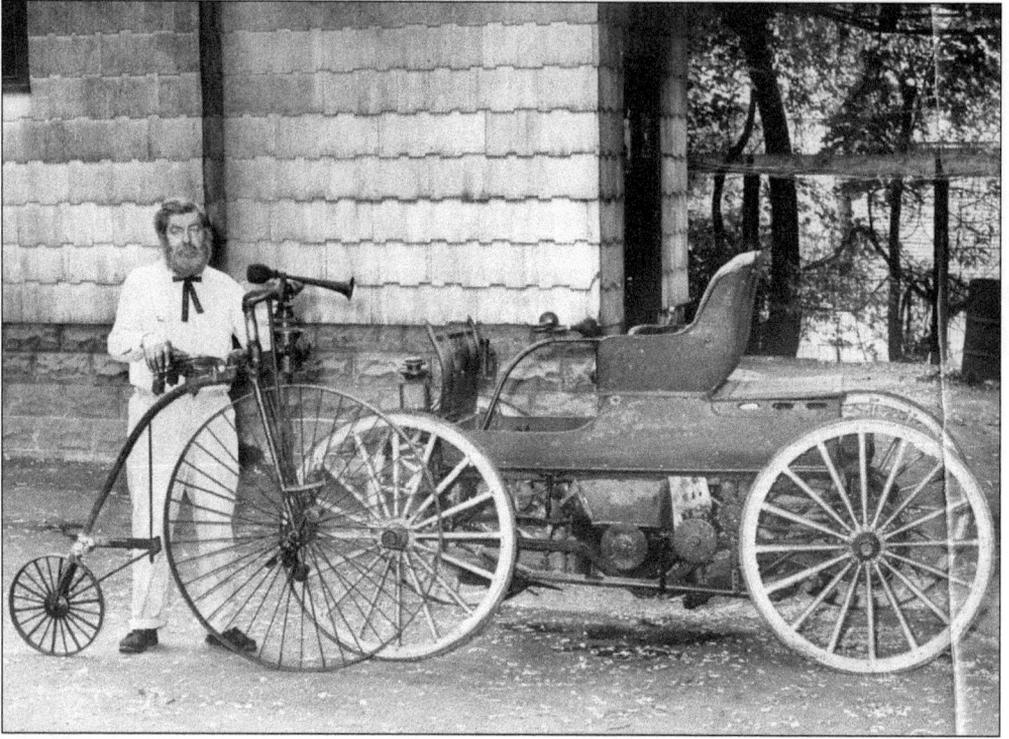

HIGH BICYCLE. This early bicycle and auto are compared during the festivities of the 1961 centennial celebration in Pontiac. The centennial celebrated the village becoming a city, not its founding. Some of these early bicycles had front wheels as large as 5 feet, 6 inches to 6 feet. Not everyone could reach the pedals to ride one. It is not known if there were any bicycle manufacturers in Pontiac, but with all the other vehicles being made here, it is hard to believe there weren't one or two makers. (Courtesy of the *Oakland Press*.)

MOTOR BUILDING. GMC was one of the largest employers in Pontiac for many years. These are truck engines that are likely going into a medium- to heavy-duty truck due to the transmission levers protruding from them. GMC used both gas and diesel engines, with diesels entering the industry in the late 1920s. (Courtesy of OCPHS.)

CARTERCAR. Based in Pontiac from 1907 to 1915, this auto brand was part of GM for six of those years. They were best known for their friction-drive transmission, causing Durant to buy the company. It was discontinued due to poor sales. (Courtesy of OCPHS.)

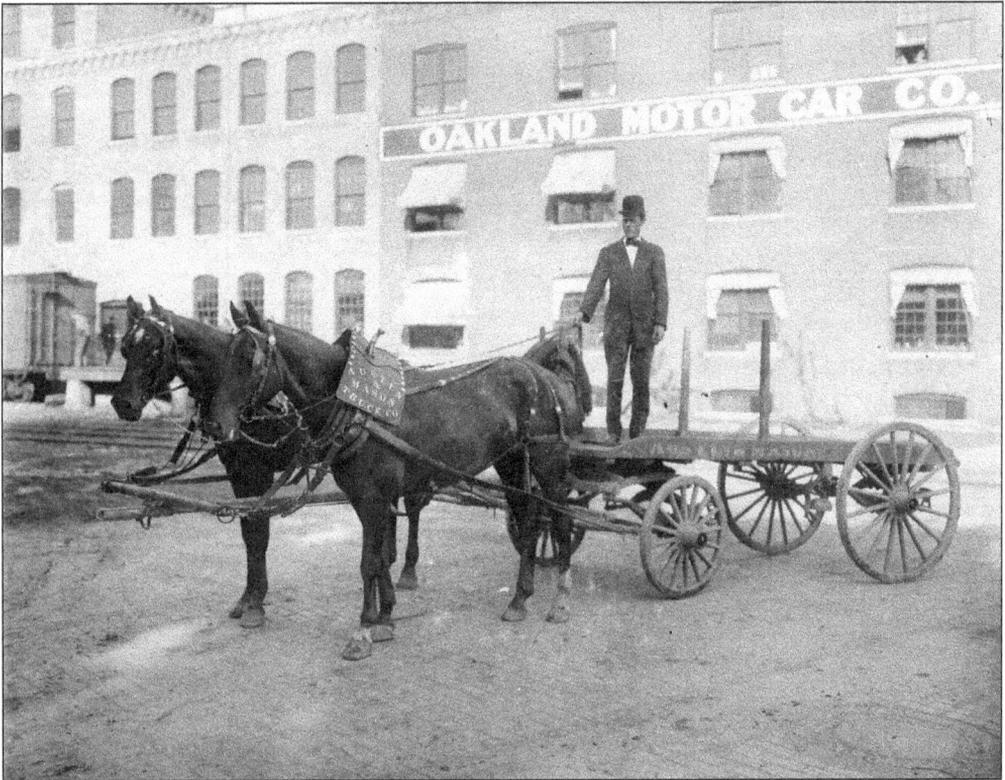

OAKLAND FACTORY. Before trucks had engines, they had horses. This truck, owned by Austin and Mason Truck Company, illustrates the point that the truck industry was much slower to take off than the auto business. Reasons cited are that farmers and builders didn't believe a gas-powered vehicle could do the work. Early trucks did have very small engines. (Courtesy of OCPHS.)

TRUCK OR TRAILER? Based on the truck in front, this picture dates to around 1910–1915. The vehicle in the rear has three wheels, a brake, and a driver's seat. But is it a trailer hooked to the truck in front, or is there an engine beneath the seat out of sight? The tires on the front vehicle

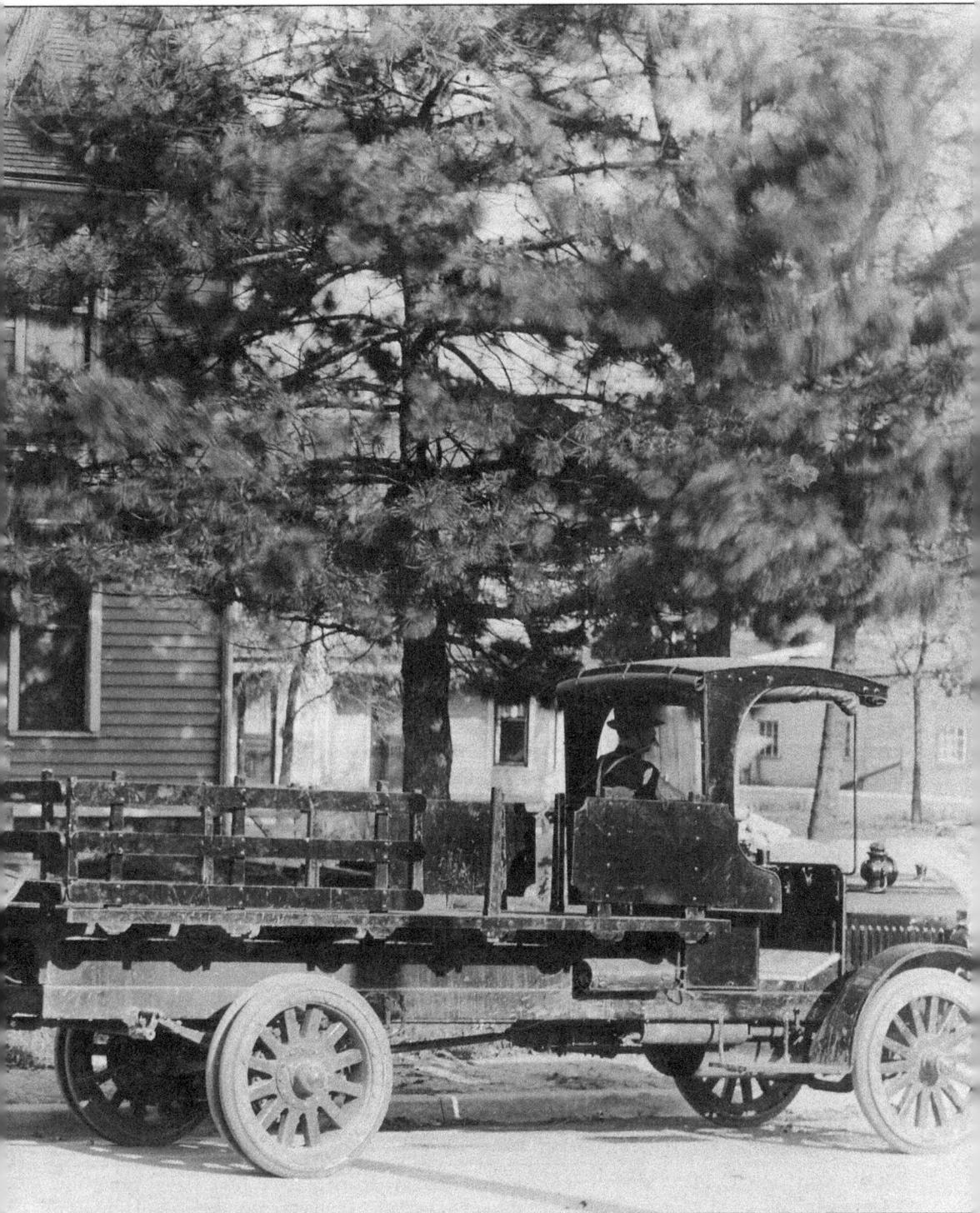

appear to have wide channels for riding on the railroad track. The rear vehicle has an suspension system that looks like its designed for a fragile payload, and the sides look like the panels enclose the cargo box up to the roofline. (Courtesy of OCPHS.)

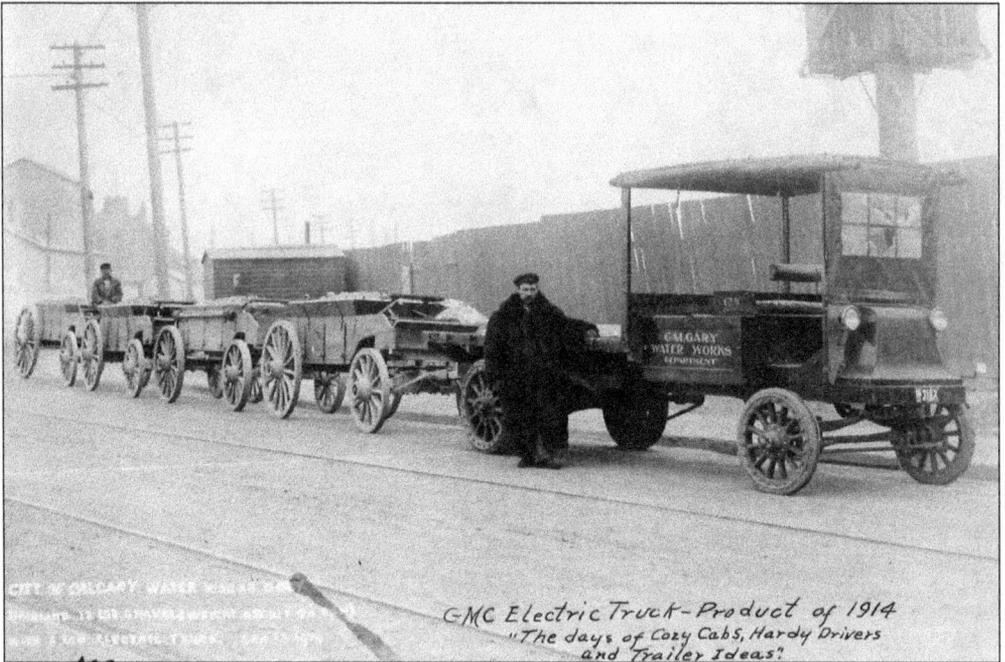

GMC Electric Truck – Product of 1914
"The days of Cozy Cabs, Hardy Drivers and Trailer Ideas".

ELECTRIC TRUCK. Before Prius, there was the three-ton GMC Electric Truck. It worked in cold climates, as seen here in Calgary on January 15, 1914. The trailers contain 20 tons of gravel. The curtains around the driver's compartment convert it to a "cozy cab." GMC manufactured electric trucks from 1911 to 1915. They were the light-duty line. (Courtesy of Pontiac Public Library.)

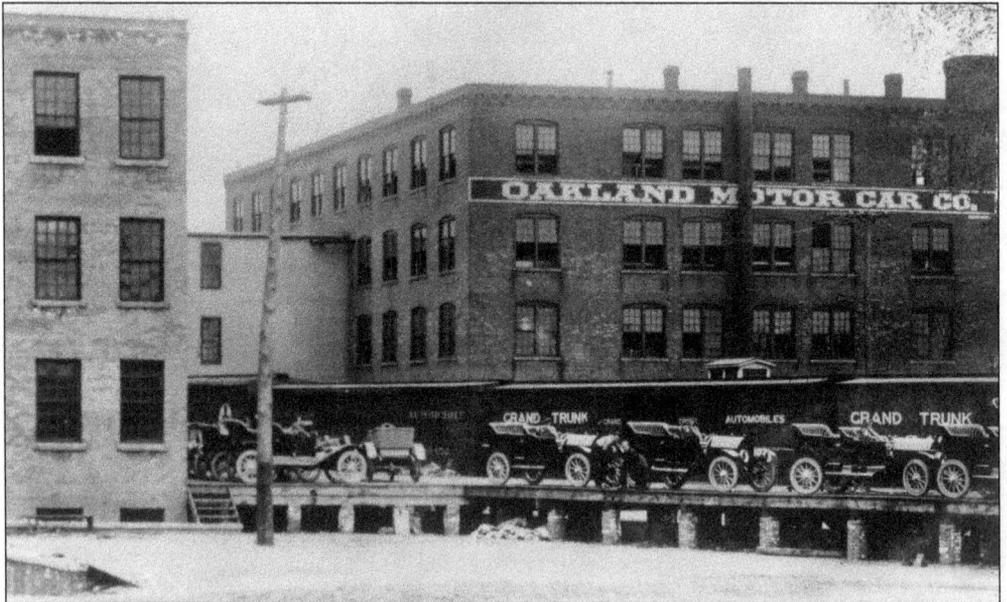

OAKLAND CARS. Oakland Motor Car Company began in a space of the Pontiac Buggy Company, owned by Edward M. Murphy. When cars started to become popular, he decided to build his own model. He hired Alanson Brush to design his new car. Brush had been Henry Leland's engineer for Cadillac Automobile Company. If there is one car brand that is truly an original of the city of Pontiac, it is the Oakland that evolved into Pontiac. (Courtesy of OCPHS.)

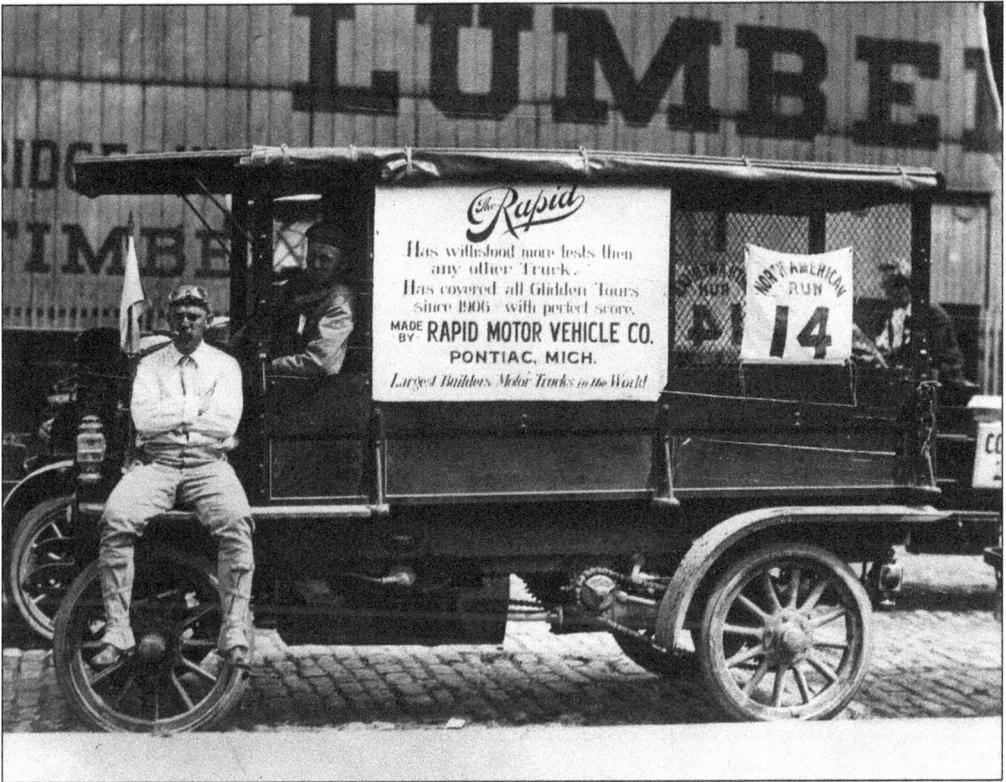

RAPID TRUCK WINNER. If there is one truck brand that is Pontiac's own, it's Rapid. Though it was started in Detroit by the Grabowsky brothers, Rapid became a viable vehicle line after Albert North and his partner, Harry Hamilton of the Pontiac Spring and Wagon Works company, began building Rapid trucks here in 1904. They were so successful that they bought out the brothers from Detroit. It became the largest truck manufacturer in the world at the time of this photograph. GM bought the company, and the trucks became the foundation for GMC trucks. (Courtesy of OCPHS.)

RAPID DESIGN ROOM. Every gear and casting was drawn by hand in rooms just like this for the first 80 years of the automobile industry until the arrival of computers and CAD systems. Now all of the components that go into auto and truck building are programmed on computer software. (Courtesy of OCPHS.)

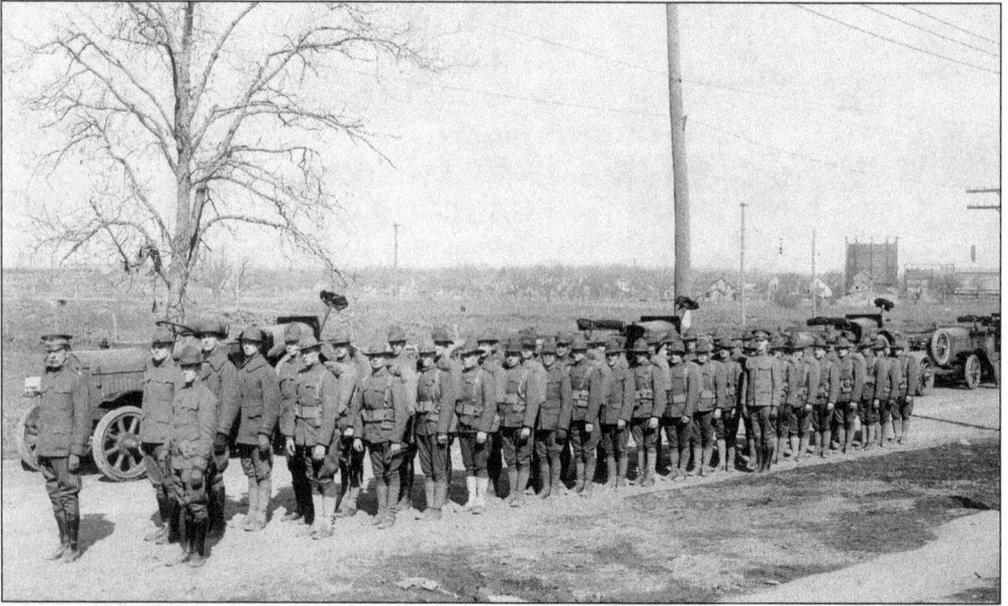

RUSSIA DEPLOYMENT. These soldiers and 20 GMC trucks are likely part of the Polar Bear Expedition, as the photograph is labeled, "Soldiers to Russia." The expeditionary force landed in the fall of 1918 under the orders of Pres. Woodrow Wilson. The U.S. Army's 85th Division left Camp Custer, Michigan, for the Western Front in France before shipping to Russia. (Courtesy of OCPHS.)

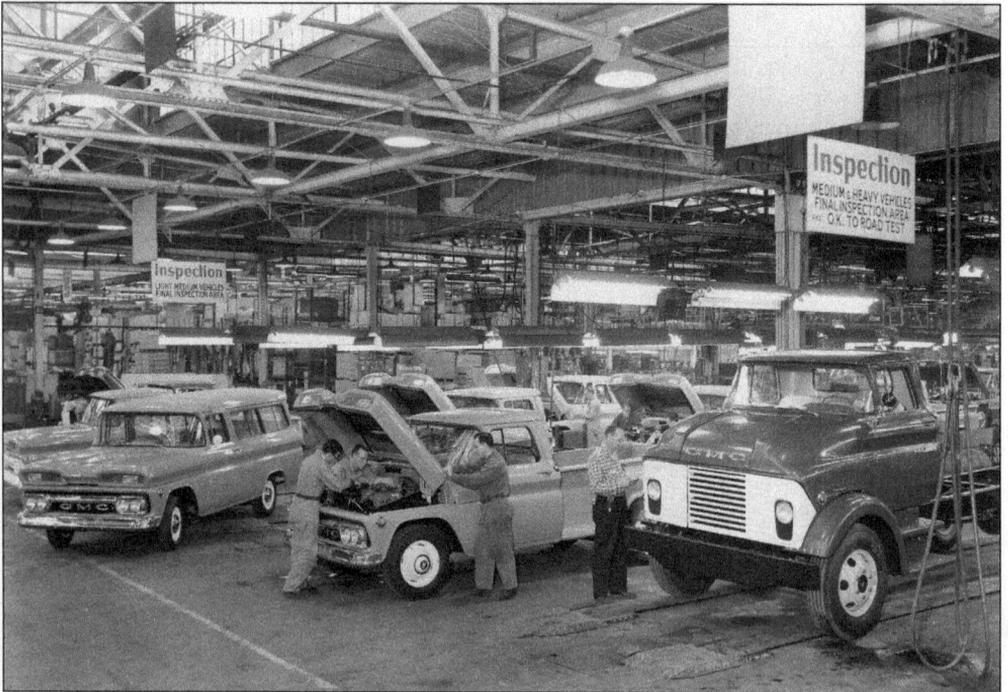

INSPECTION POINT. GMC made light-, medium-, and heavy-duty trucks in its prime at its plants on South Boulevard. Trucks are being inspected before delivery to dealers. Fifty years ago, customers could buy vehicles directly from the factory; GMC had such a place in Pontiac. Its service center was open seven days a week, 24 hours a day. (Courtesy of OCPHS.)

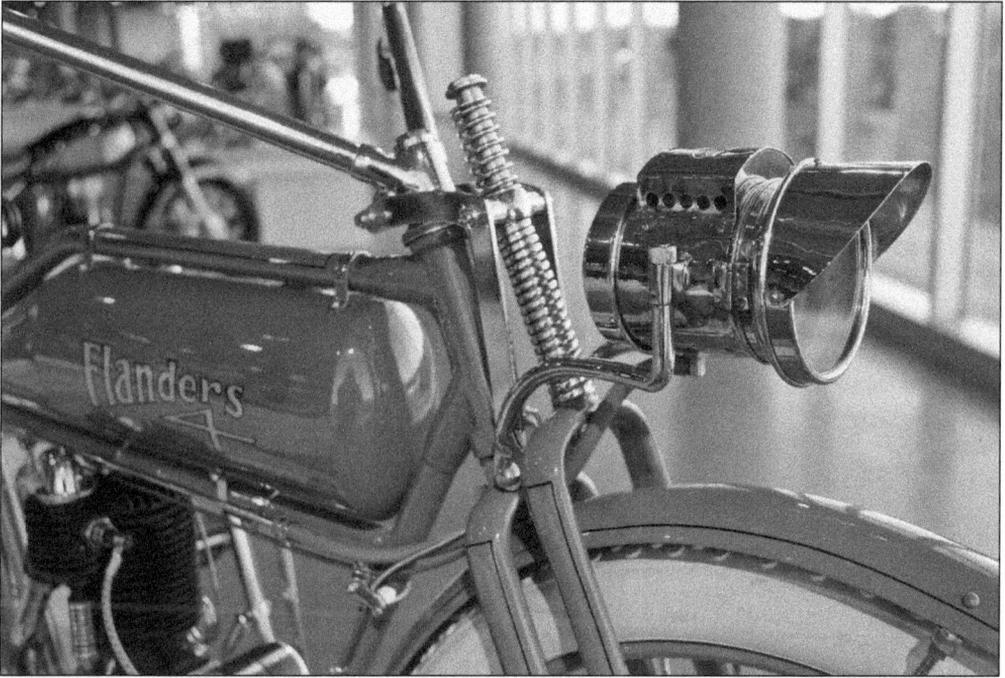

FLANDERS BIKE. Flanders Manufacturing Company in Pontiac was a consolidation of several companies, including the Pontiac Motorcycle Company. This Flanders 4 motorbike had four horsepower, was capable of going 50 miles per hour, and had an acetylene lamp for night driving. For a short time, the other motorbike made in Pontiac was the Whizzer. (Courtesy of Jordan Vittitow.)

PARADE OF PROGRESS. GM's Parade of Progress program began at the Chicago World's Fair of 1933 and showed innovations of science and technology to the public. Because only a limited number of people could attend the fair, GM decided to take the show to the people. It had three tours, two before World War II and one after. Pictured is a Futureliner, which was built in 1940. It is exhibited here at the 2009 Dream Cruise in Pontiac. (Courtesy of Rodney Gay.)

WAR MACHINE. Pontiac was responsible for the massive manufacturing of army vehicles and armament. GMC turned the largest truck and coach facilities in the world to the war effort overnight. Without the resources of such companies, World War II would have had a much different outcome. (Courtesy of OCPHS.)

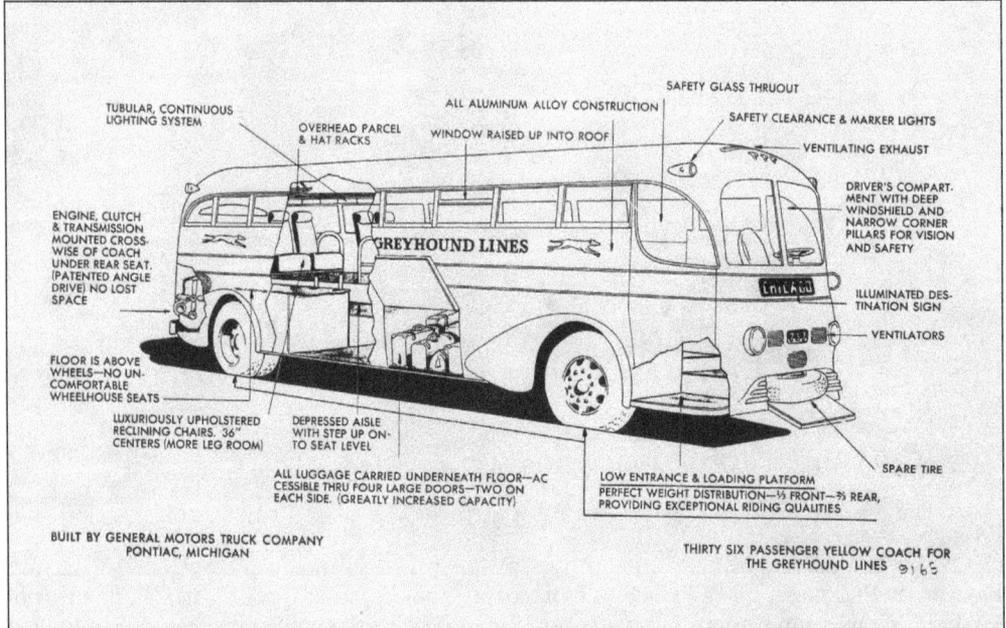

BUS ANATOMY. Bus building was big business in Pontiac, and GMC's headquarters for truck and bus manufacturing was located there. Buses were a part of the GM family of products for years. The RTS was the last bus built by GM and consequently in Pontiac. (Courtesy of OCPHS.)

SEDAN DELIVERY. This is a 1952 two-door Pontiac delivery wagon with a single rear door. The company Rich Sign did the lettering. It has been in the business here for over 100 years. Early on, the sign lettering was done inside the factory, so a local sign painter could paint a sign for a business that might be across the country. (Courtesy of Rich Sign.)

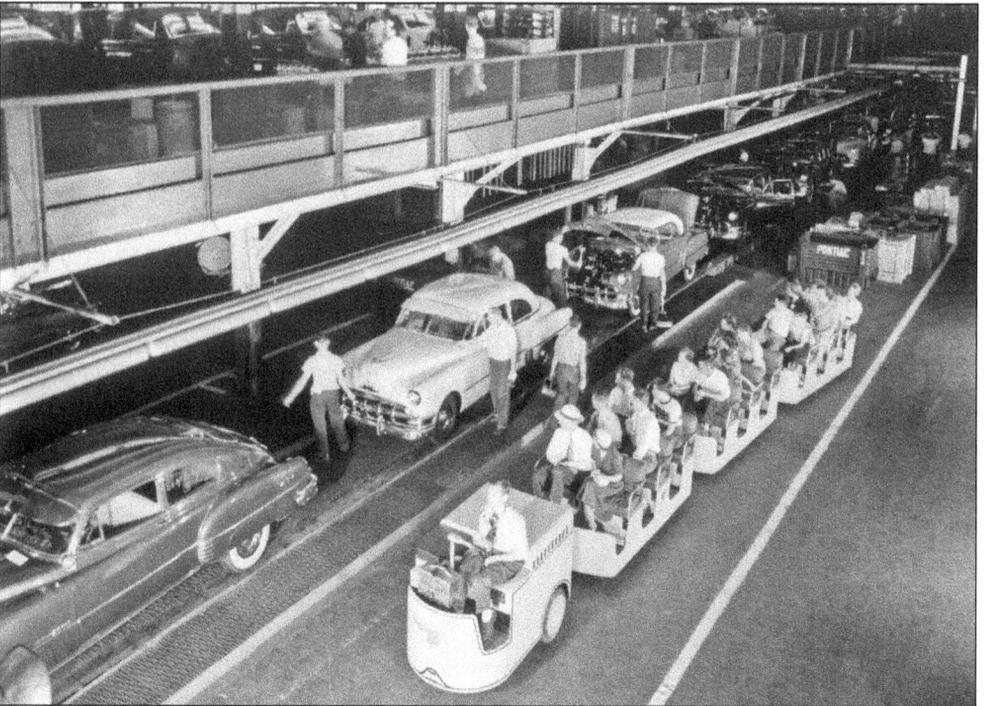

PLANT TOUR. This is an early-1950s scene of a car factory, which was right around the same time Johnny Cash worked at Pontiac Motors, albeit for only a month. He was an example of the great number of people that came to the city looking for a job with good pay and benefits because of the union. (©2010 GM Corporation, used with permission GM Media Archive.)

POWER PLANT. This building was originally the power plant for Rapid Truck, and in 1912 the City of Pontiac made it a power station. Since 1994, it has been Planet Rock climbing gym with walls 55 feet high. It is a great example of adaptive reuse of a historic structure. (Author's collection.)

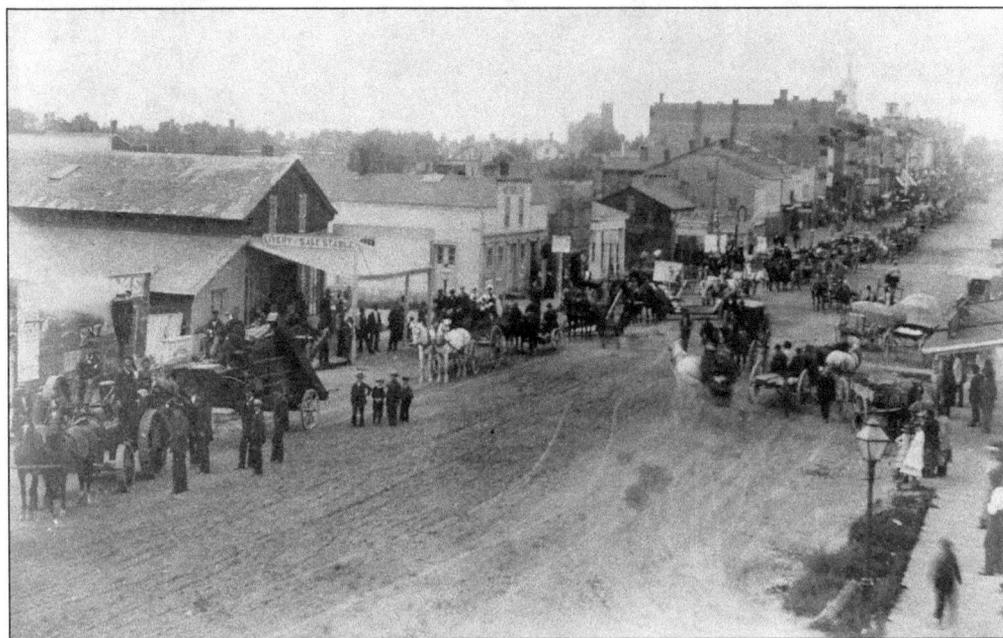

STEAM POWER. The Ladies Cornet Band of Caro provided the music for this event. C. B. Whitman supplied $16,000 in new farm implements and machinery to be sold on this summer day of June 21, 1882. By the time all of the area farmers had taken delivery of their new equipment, L. M. Smith began a parade of horses, wagons, dressed up farm folk, and newfangled contraptions that stretched a mile. The photographer, Mr. Taylor, set up his camera here at the corner of Auburn Road and South Saginaw Street looking north. (Courtesy of Pontiac Public Library.)

Nine

THE CITY OF PONTIAC
MUNICIPAL AIRPORT

The City of Pontiac Municipal Airport began in 1927, which was right after Charles Lindbergh had crossed the Atlantic. The location for the airport was chosen based on several criteria; being west of the industrial smoke stacks of Pontiac was among them. It ultimately proved ideal for air traffic. Located at the corner of what are now Highland and Airport Roads, a parcel of 160 acres was purchased from the Beatty family, with an additional 80 acres added soon after. Construction began, and the airport opened in late 1928, accommodating the needs of local businesses to take to the air. Airmail service began right away, on November 27, 1928, in a Stinson-Detroit Monoplane. Thompson Aeronautical Corporation was awarded the contract. The airport was dedicated the following year at the first Michigan Air Tour, conceived to promote aviation throughout the state.

The airport was certified by the Commerce Department with its highest designation in 1930. It was also the first to receive an "Airport for Landplanes" certificate, calling pilots' attention to the ideal layout and first-rate facilities.

In April 1941, Japanese and Japanese Americans were forbidden to fly on passenger planes arriving and departing in Pontiac. With World War II, there came a heavy involvement of the Pontiac industrial machine, and as a result the airport became a link in that chain, working closely with the U.S. Army Air Corps.

Runways were unpaved until the 1950s, when improvements began to keep up with the need for larger planes. A control tower and terminal were added around 1960. In 1967, the Pontiac Municipal Airport was having difficulty coming up with funding to expand airport approaches on the eastern end. As a result, an agreement was reached to transfer ownership to the county, which was better equipped to handle these critical improvements.

The new Oakland County International Airport continued its growth. It is currently ranked as the sixth-largest general aviation airport in the country, with an average of 333,000 takeoffs and landings each year.

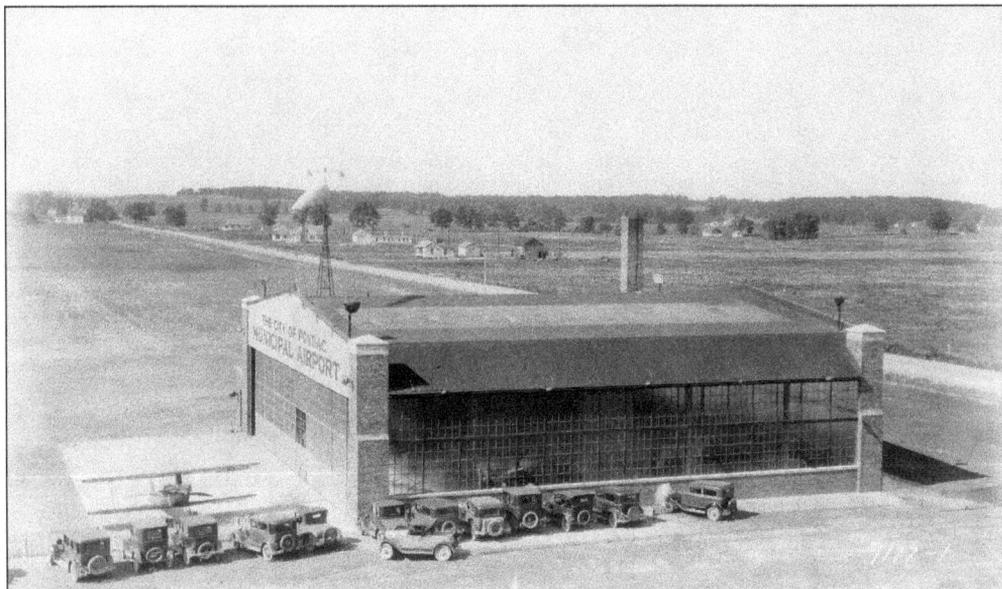

FIRST HANGAR. In the fall of 1928, the hangar for Pontiac's first airport was completed. The automotive industry nearby needed an airport to stay competitive. Pontiac's expectations were also high for getting into the plane building business, seen as not so different from building cars and trucks. (Courtesy of Oakland County International Airport.)

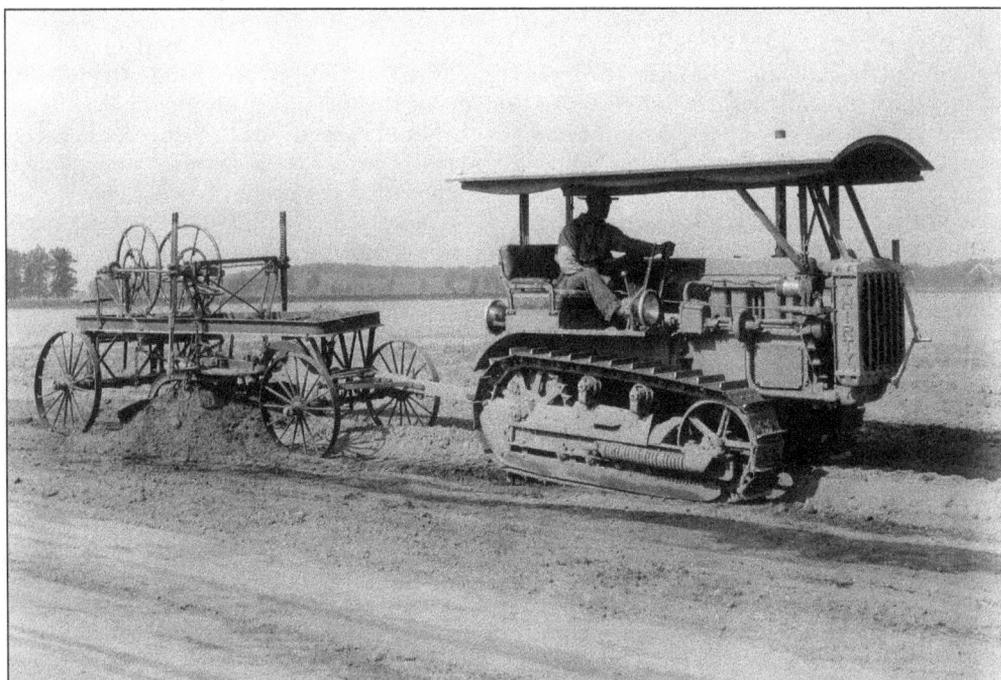

FIRST RUNWAY. The airport converted farmland into grass runways. A 30-horsepower Caterpillar Model 30 tractor is pulling a grader to create the smooth landing surface, which is just one part of the runway building process. Later runways would be covered with cinder and gravel to prevent muddy conditions before ultimately being paved in the 1950s. (Courtesy of Oakland County International Airport.)

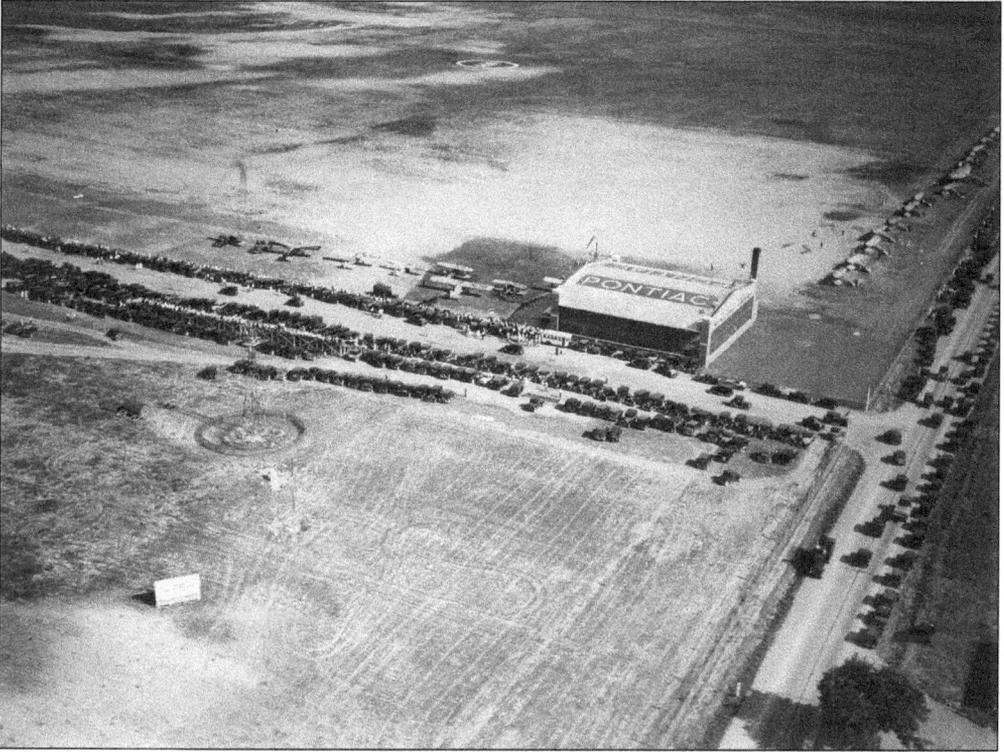

AERIAL VIEW. During the first Michigan Air Tour, planes line up along the right edge of the airport and in front of the hangar. There is even a bus parked amidst the crowd. The circle in the grass on the left is the tower with the airport landing light. The circle out in the distance is the letter E for direction on the landing field. (Courtesy of Oakland County International Airport.)

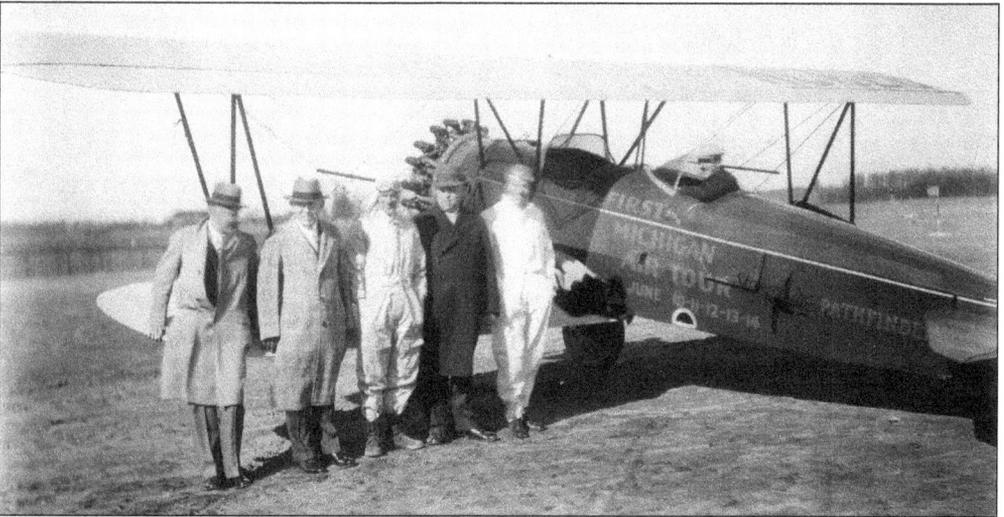

AIR TOUR. Aviation was still very new in the late 1920s, and its benefits needed to be taught to an uneducated public. The Michigan Air Tour was organized to travel around the state educating communities about the aviation industry. Gov. Murray Van Wagoner of Pontiac flew in that first air tour. The Michigan Air Tour celebrates its 81st anniversary in 2010. (Courtesy of Oakland County International Airport.)

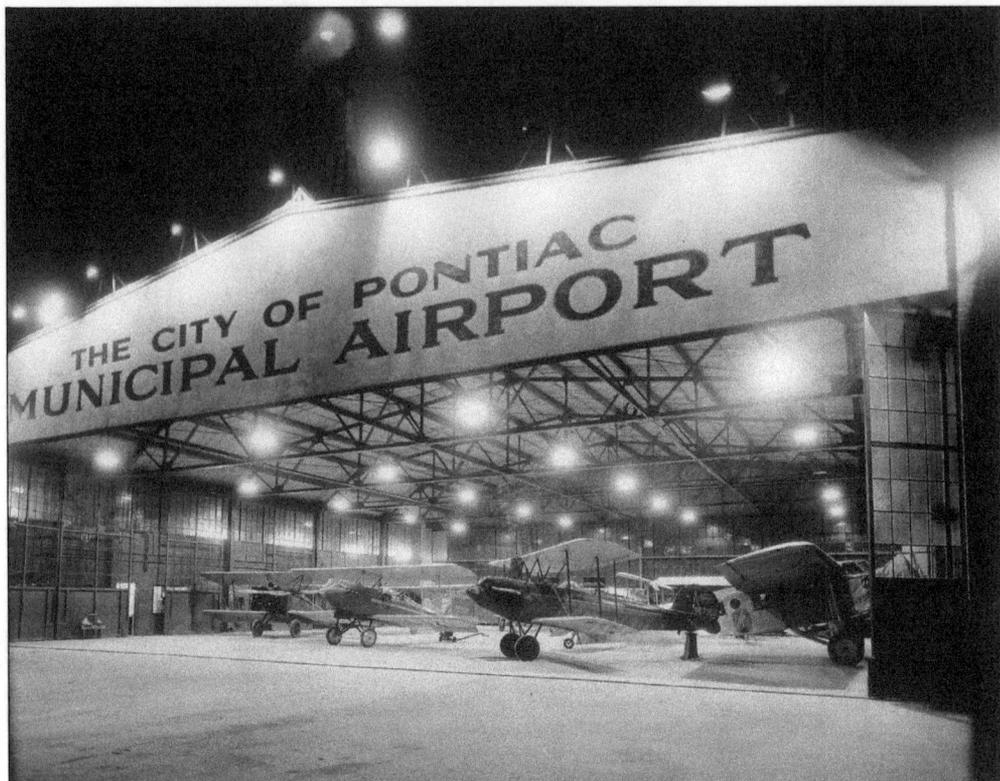

NIGHT HANGAR. This night view highlights the size of the first hangar. There are at least six planes inside, including a Stinson-Detroit Monoplane that was used by Thompson Aeronautics for the first airmail contract that was awarded to them in late 1928. Also located in the hangar was the Detroiter, which was first to offer a heated cabin, not to mention being enclosed. It had an electric start, which eliminated hand propping. The plane was built in Northville, Michigan. (Courtesy of Oakland County International Airport.)

AIRPORT OFFICE. There was no tower or administration building, just a hangar with an office. This pilot is checking in before or after a flight. The open-air planes from the early days required pilots to dress warmly. They flew these planes virtually all year. An engine cowl from a plane hangs on the wall. (Courtesy of Oakland International Airport.)

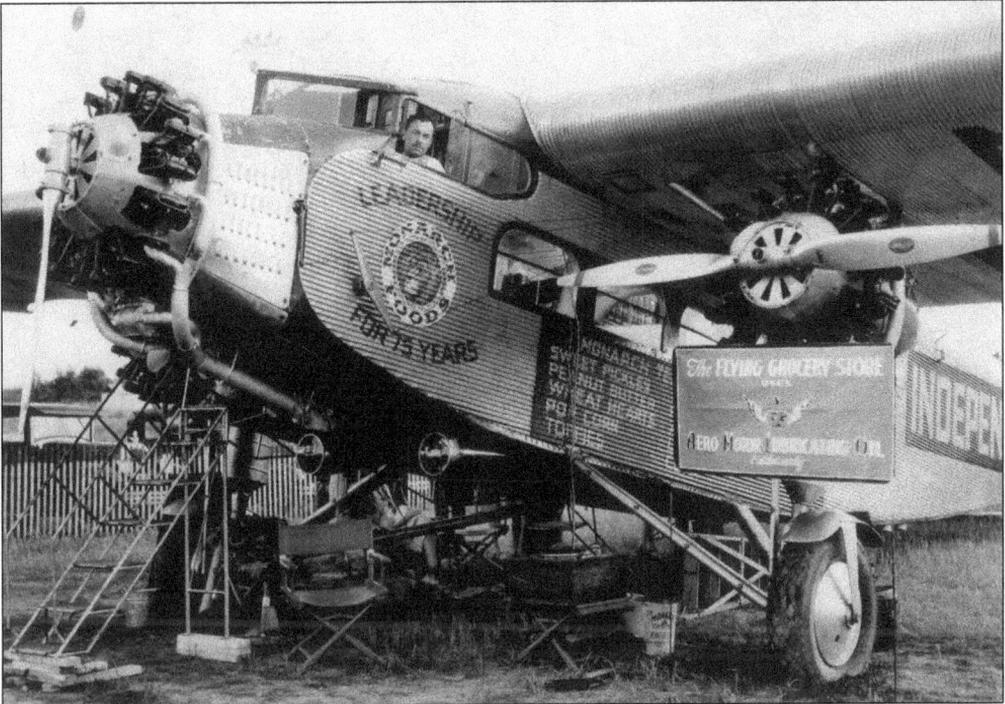

FORD TRI-MOTOR. This is a photograph not only of the well-known plane by Henry Ford, but one of a flying grocery store. The plane had three motors, not by Ford, and a corrugated aluminum fuselage. It was manufactured between 1926 and 1933. It started transcontinental air service in 1929. Roads were still in questionable shape in these years, especially in outlying areas. (Courtesy of Oakland County International Airport.)

WICKER SEATS. This is the interior of a Tri-Motor used for passenger service; the seats are wicker. Without sacrificing too much comfort, keeping weight to a minimum was important in designing an aircraft. (Courtesy of Oakland County International Airport.)

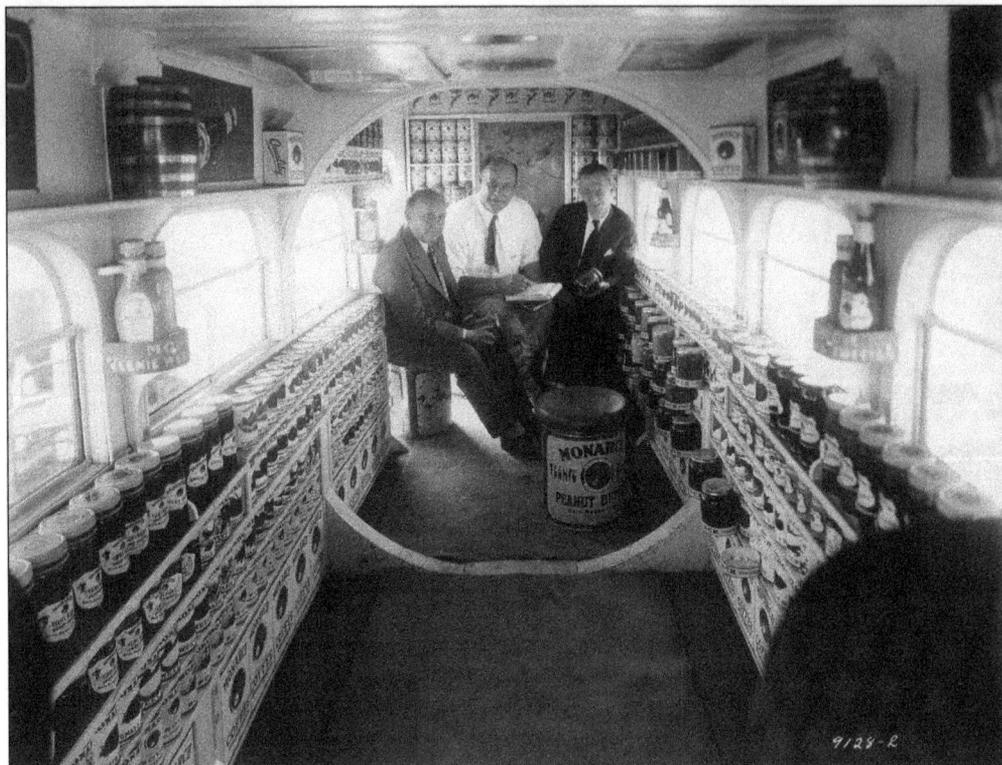

GROCERY AISLE. This is the interior of the flying grocery store. The company managing this air store is Monarch Foods. Sweet pickles, peanut butter, wheat hearts, popcorn, and toffees are a few of the items offered up from this plane. Unfortunately the concept of the flying grocery did not catch on. (Courtesy of Oakland County International Airport.)

AIR TAXI. Pete and Wayne had an air taxi business out of the new Pontiac Airport. In March 1929, they are dressed for a late winter flight, most likely in a Waco plane. (Courtesy of OCPHS.)

FLIER. In the early days, there were only open-cockpit planes. They were biplanes with an over and under wing. To make money, fliers used to travel from town to town giving joy rides. They would attract customers by flying low, causing the citizens of a small town to follow them to a nearby field. According to a PBS television program on aviation, on one occasion a young flier took a lady on board for her first trip into the blue. They took off and were flying about without any problems. The pilot then turned to see the lady passenger climb out of her seat and onto the wing, hanging on for dear life. The pilot screamed, "What are you doing? Get back in here." The passenger called back, "But there's a mouse in there." And so went the adventures of young fliers in the early years of aviation. (Courtesy of Pontiac Public Library.)

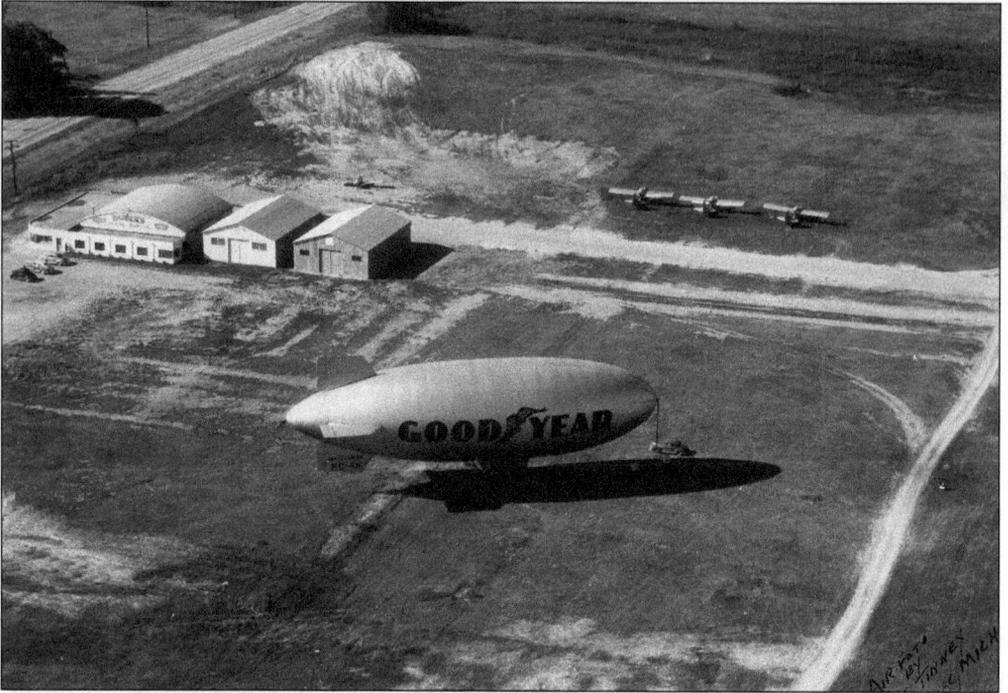

GOODYEAR BLIMP. In 1925, the Goodyear Tire and Rubber Company started flying its famous blimps. The airship shown here is the *Mayflower* and was in service by 1930. Goodyear was the first airship company to use helium. The building in the background is Barber's Flying School. Kenny Barber bought a biplane in a box for $300. He took it home, put it together, and taught himself how to fly. (Courtesy of Oakland County International Airport.)

WACO PILOT. Women were early aviators too. Amelia Earhart paralleled Charles Lindbergh, setting several records of her own. The plane shown is a Waco, made by Waco Aircraft Company of Troy, Ohio. The largest manufacturer of civilian aircraft in the United States from the late 1920s to the mid-1930s, Waco Aircraft Company also manufactured most of the gliders used in World War II. (Courtesy of Oakland County International Airport.)

AIRPORT BILLBOARD. By today's standards, this is a classy billboard. It has wood trim and columns with lattice on the bottom. This ad also gives the passerby some idea of the caliber of Pontiac's new airport. (Courtesy of Oakland County International Airport.)

WING REPAIR. Hangar Two was where repairs were made regularly. Fabric-covered wings had to be replaced every few years. These wings may be in the process of such a replacement. Planes are still manufactured with fabric-covered wings or fiberglass. (Courtesy of Oakland County International Airport.)

REFUELING. On the backs of the coveralls, it reads Pontiac Municipal Airport, which is a shortened version of the official name. Eventually the shortened version stuck. The fuel tanks were in the ground, making this airport as modern as any. The men are refueling the *Silver Eagle*. (Courtesy of Oakland County International Airport.)

GLIDER PILOT. This was an early glider just after landing. The first planes designed by the Wrights and others were gliders. It is said to be the purest form of flight. Capt. Chesley "Sully" Sullenberger III of the Hudson River landing fame got his glider pilot's license at age 14. Unfortunately air traffic at this airport today is far too busy for gliders. (Courtesy of Oakland County International Airport.)

GLIDER FLIGHT. A glider is taking flight after the tow plane kicks up a good amount of dust. Gliders were used in the invasion of Normandy to ferry supplies such as jeeps, heavy guns, and troops to France. There was a high casualty rate amongst soldiers in these planes known as "flying coffins." (Courtesy of Oakland County International Airport.)

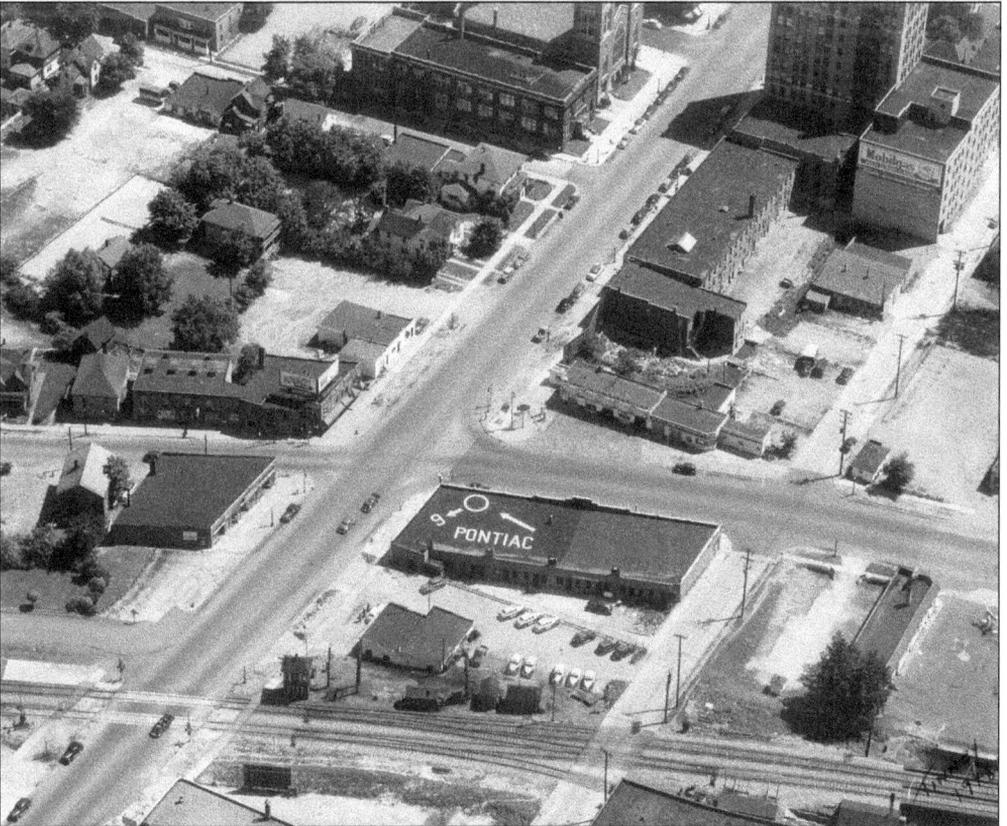

PONTIAC PAINT. In 1948, an air marker is located on the roof of the Pontiac Paint Company. There are still many houses in the downtown area at this time. Ten years after this photograph was taken, many buildings would disappear as Wide Track Drive was developed. (Courtesy of Oakland County International Airport.)

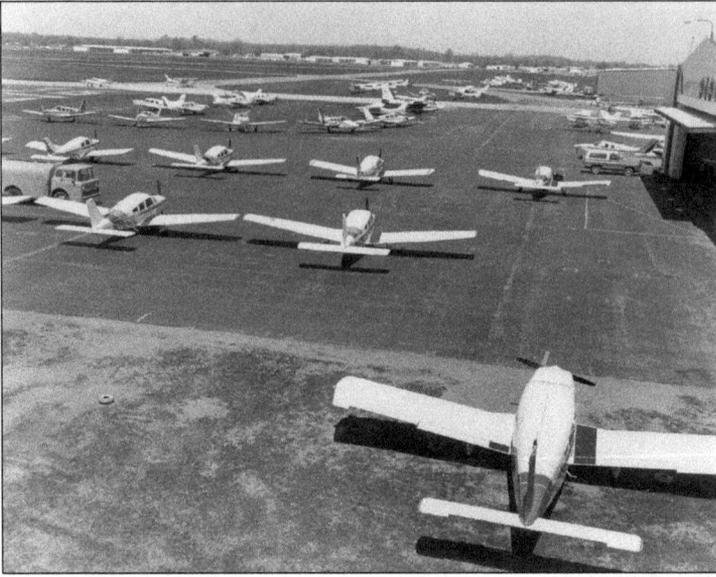

PLANES ON TARMAC. Even though there are numerous planes with wings over the fuselage at this time in the 1970s, there are no planes here on the tarmac with two wings. (Courtesy of Oakland County International Airport.)

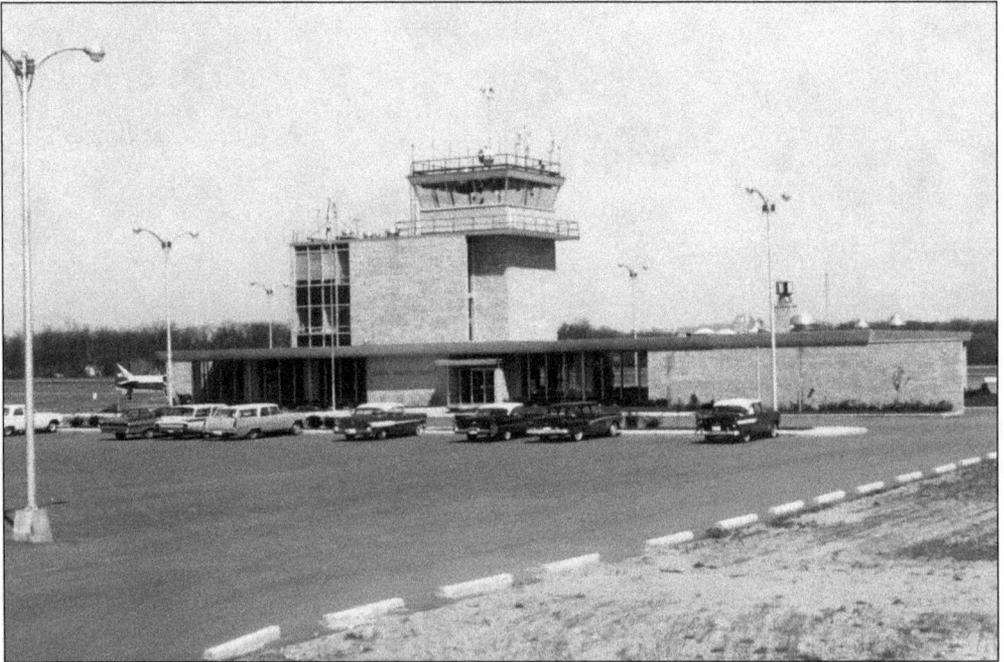

FIRST TOWER. This tower was erected in 1960 and later replaced in 1995. The addition of a tower to the airport transformed it into a sophisticated modern-day facility. Some confusion existed for a while after the first tower went up. Older pilots were used to taking off and landing when they wanted, without having to ask permission. When the first tower was built, jets for private and corporate use were uncommon. Today they are a large part of the airport's business. (Courtesy of Oakland County International Airport.)

Ten

CITIZENS AND GATHERINGS

Citizens of Pontiac come from strong stock. In the beginning, it took untold stamina to live in a remote wilderness and stake claim for a new homestead. Previously enslaved African Americans, some of whom even escaped through the Underground Railroad, were especially strong. The village started as a community of white settlers and very few African Americans. Its cultural makeup changed with the increased influx of immigrants and African Americans, especially right before and after the Civil War. The citizenship varied widely by income, education levels, languages, and dialects. Initially many new residents came from the Northeast, but then this shifted to the South. By the beginning of the 20th century, people were coming to Pontiac from the Southwest. Protestants, Catholics, and Jews all came to Pontiac and intermingled. The city has made its contribution in the way of athletes, artists, educators, war heroes, politicians, business tycoons, and even an astronaut. Currently Pontiac's population is predominately African American, Caucasian, and Hispanic.

From the beginning, Pontiac has been a gathering place. With the county seat located here, there have been many public functions. The city was filled with religious congregations from early on. Baptists, Presbyterians, Congregationalists, Episcopalians, and Methodists all worshipped here. The Catholic Church had its first county congregation in Pontiac, and the first county chapel still stands in White Lake. Newman African Methodist Episcopal Church was organized here in 1861. Trinity Baptist built its first church in 1918. St. Joseph's Parish originally served Polish Catholics, but now masses are more commonly spoken in Spanish. There was also a Jewish synagogue and community center at one time.

Pontiac has been home to the county fair, state fair, a Masonic Temple, the Detroit Lions, the Detroit Pistons, mega-concerts, tractor pulls, and home shows. It has had visits by the likes of Alexis de Tocqueville, Abraham Lincoln, John F. Kennedy, Martin Luther King, Muhammad Ali, and Pope John Paul II.

The city is a place of caring citizens. There are many dedicated, helpful organizations like the Lighthouse of Oakland County, Catholic Social Services, Hispanic Outreach, Youth Assistance, the Michigan Animal Rescue League, Pontiac Rescue Mission, the Salvation Army, Baldwin Center, Bound Together, and two senior centers.

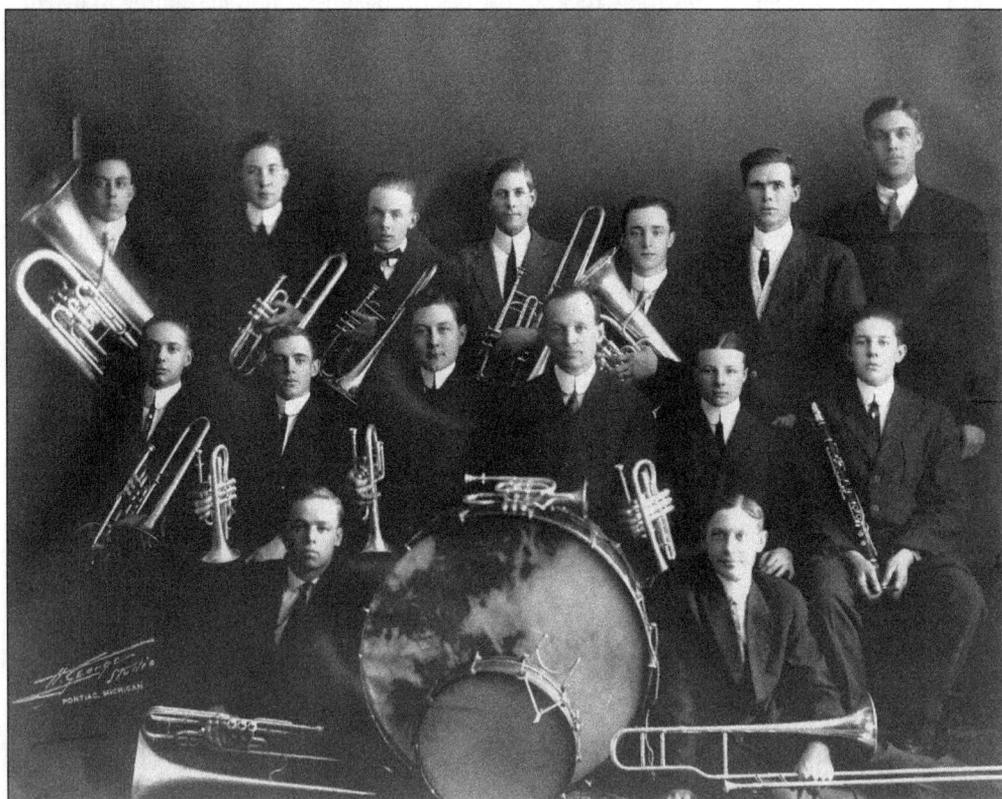

BRASS BAND. This is the school picture of Pontiac High School from 1912. The band is not a marching band. Their attire of dark suits with white shirts while holding brass instruments, set against a dark background, makes for a striking photograph. (Courtesy of OCPHS.)

LETTER CARRIER. Born in 1890 on a farm in New Hudson, Michigan, Earl Parker was a mailman in Pontiac for 18 years. He was a graduate of the Business College of Lansing. He and his wife, Elanora, lived on Glendale Avenue. Earl's grandson, Dave Parker, was a city employee in Pontiac for many years. Dave's other grandfather, George Stockwell, was Pontiac's postmaster and the last one appointed by Pres. Harry Truman. (Courtesy of Dave and Debbie Parker.)

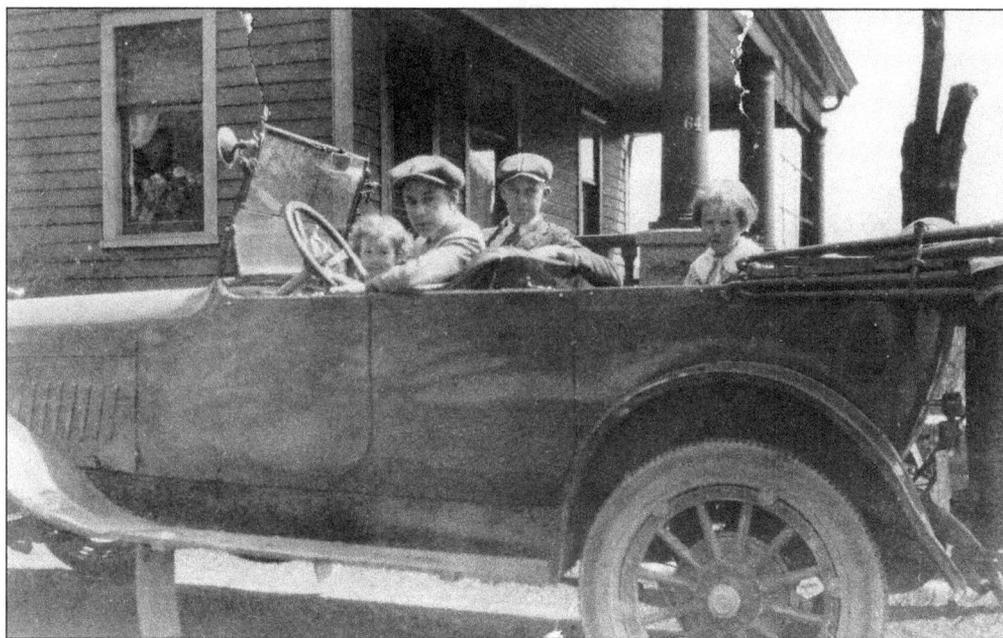

FAMILY CAR. Annalee Kennedy, in the front seat with her uncles, is having her picture taken. She is now a retired schoolteacher from Pontiac's Central Elementary School and Daniel Whitfield School. Her family built many of the commercial buildings and houses throughout the city. She has been active in the Oakland County Pioneer and Historical Society for many years. (Courtesy of Annalee Kennedy.)

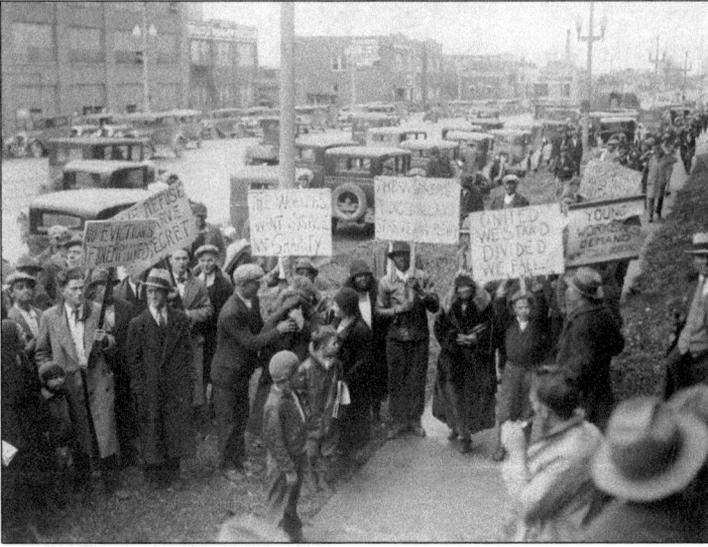

HARD TIMES. In downtown Pontiac during the Depression, the "Communists Hunger Strike" took form. The Communist and Socialist parties gained popularity during the Great Depression because of the serious need to make things better, especially for the young and old. One sign in the background reads, "They shall not starve our children." (Courtesy of Walter P. Reuther Library, WSU.)

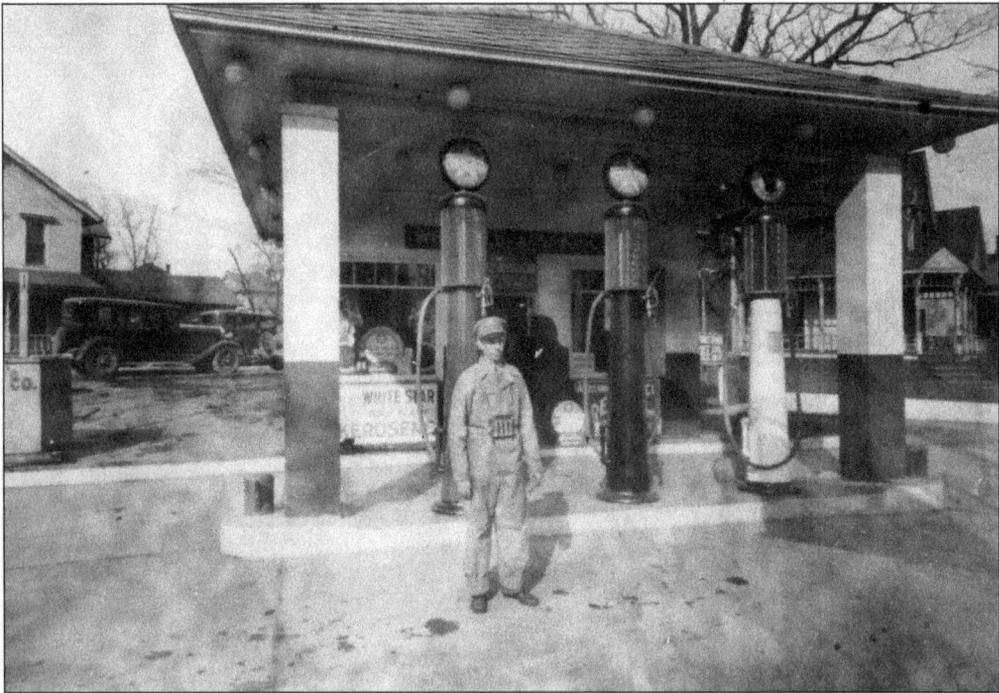

OLD STATION. James Spark was a service station owner in Pontiac for many years. He is wearing a little coin changer, which was used to give change back to customers. He and his partner, Thomas Whitfield, had two Mobil stations in Pontiac. James married Helen Hendry in 1933. They lived in Sylvan Village the latter half of their lives. Mrs. Spark taught elementary school grades at Covert School in Waterford and Daniel Whitfield School in Pontiac. (Courtesy of Helen Jane Peters.)

116

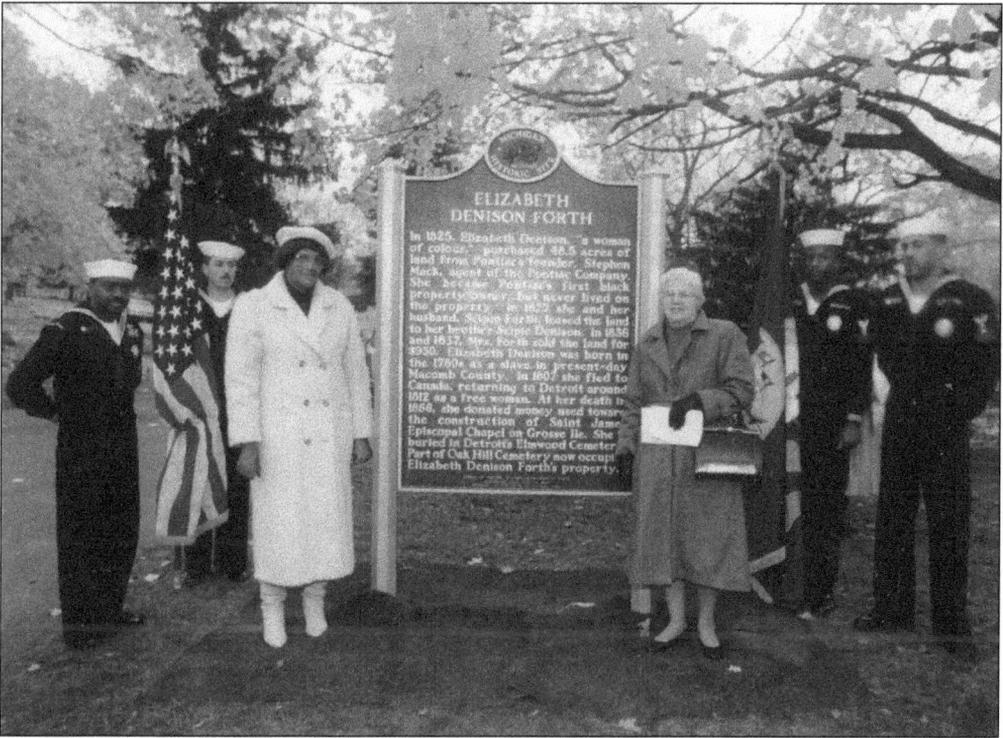

DENISON MARKER. The occasion of this gathering is the dedication of the historical marker designating this site on the National Trust's List of Historic Places. Elizabeth Denison Forth, an African American, purchased 48.5 acres of land in Pontiac in 1825 that is now partly in Oak Hill Cemetery. She was born enslaved before this territory disavowed slavery. Dressed in white, Cora Bradshaw, a Pontiac schoolteacher, spearheaded the campaign to have this marker placed. (Courtesy of Cora Bradshaw.)

MEMORIAL STADIUM, 1941–1945. This stadium was dedicated in 1946 "to the men and women of Pontiac who served their country in this war, and in grateful memory of those who made the supreme gift." The running track on the top right is named for Richard Craig. (Courtesy of Pontiac Public Library.)

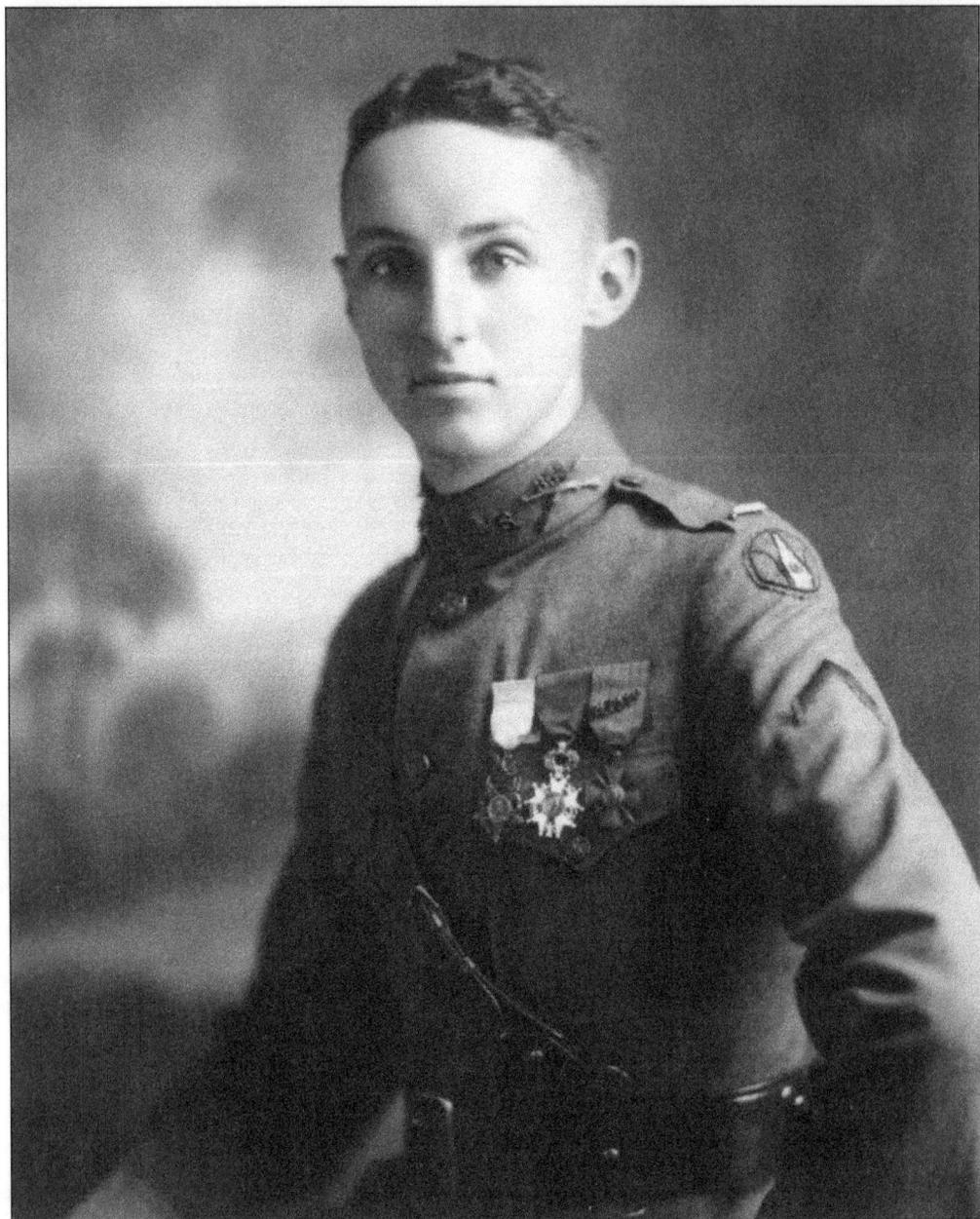

HONORED SOLDIER. Dr. Harold Furlong was a longtime physician and obstetrician in Pontiac before his retirement. He was also a first lieutenant of the U.S. Army, serving in the 353rd Infantry, 89th Division during World War I. On November 1, 1918, he received the Congressional Medal of Honor. Immediately after the opening of the attack in the Bois-De-Bantheville, Lieutenant Furlong moved out in advance of the line with great courage and coolness, crossing an open space several hundred yards wide. Taking up a position behind the line of machine guns, he closed in on them. He killed a number of the enemy with his rifle, put four machine-gun nests out of action, and drove 20 German prisoners into U.S. lines. He is also responsible for establishing the Pontiac Creative Arts Center, leaving an endowment to help fund its ongoing needs. (Courtesy of Michigan's Own Military and Space Museum.)

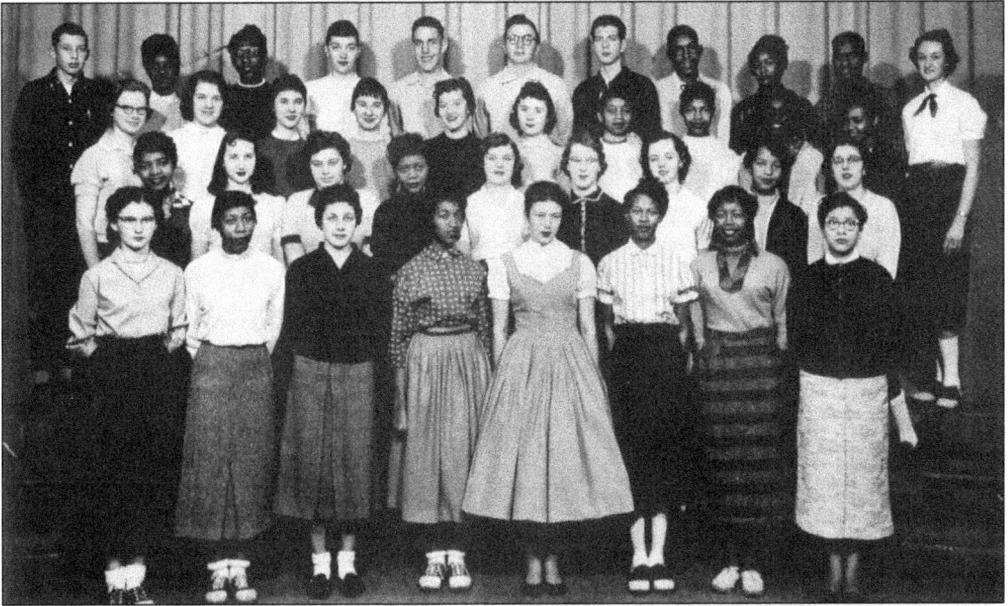

LIBRARY AIDES. With the help of 40 Pontiac High School students in 1957, the school's library was maintained. Some of the volunteers' tasks included checking out books, shelving returned books, and keystoning magazines. The librarians were Viola Fitch and Russell Buller. (Author's collection.)

LIBRARY GROUND-BREAKING. The current Pontiac Public Library started with this ceremony some 50 years ago. It was part of the plan for a new civic center, which was to come after the new city hall. The statue of Chief Pontiac is a familiar representation of him, though no real image exists of the Ottawa chief. When it was built, the library was one of the best in the county. (Courtesy of OCPHS.)

PUTTER. Nick Shorter was on the Pontiac High School golf team in 1957. In that year, the boys also had teams for football, baseball, basketball, fencing, swimming, tennis, track and field, cross country, and wrestling. The girls had teams for synchronized swimming and the girls' recreation association, which offered activities in basketball, tennis, volleyball, golf, badminton, bowling, tumbling, and ping-pong. (Author's collection.)

120

DANCE INSTRUCTOR. Georgia Hoyt was born in 1878 in Pontiac. Her parents, George Hoyt and Caroline Wilcox Hoyt, were both music teachers; Mr. Hoyt was a highly regarded professor. Georgia was a cofounder of two animal rights groups, one being the Animal Rescue League, which is still open. She and her family taught music from their home for over 100 years. (Courtesy of OCPHS.)

1961 PONTIAC. In 1961 or before, someone had the idea to celebrate the city's 100th birthday. The centennial was no small one. The celebration didn't honor the city's founding but the incorporation of the village as a city. This parade shows a brand-new 1961 Pontiac coming down Saginaw Street, the city's main north-south artery. (Courtesy of Bruce Annett, www.bbmck.com.)

BRUSH BROTHERS. As part of the centennial celebration in 1961, local men were encouraged to grow beards. These three friends did just that. From left to right, Richard Shafto, Paul Fournier, and Jim Jackson embrace the spirit of the celebration. The men participating in this part of the centennial were called "brothers of the brush." Shafto was a World War II vet who served in B-17s. (Courtesy of Service Glass.)

CIVIL RIGHTS LEADER. Rev. Milton Henry was a prominent local attorney and citizen. A Tuskegee Airman, he was a veteran of World War II. He was known for his involvement in the community, passion for his work as an attorney, and interest in the cause of civil rights. He was deeply involved in planning many events and organizations that helped better the lives of the oppressed. He passed away on September 9, 2006. (Courtesy of Walter P. Reuther Library, WSU.)

CHRISTMAS CONCERT. This school concert, lead by Geraldine Cheal, was an annual event that was hosted at the Pontiac State Bank building. There was no legalized segregation, but schools still tended to be segregated. Ten years after this photograph, court-ordered busing would come to Pontiac. (Courtesy of Kathryn Smith.)

NEWMAN AME. Newman AME was named for George Newman, a founding member of this African Methodist Episcopal church. It was the first African American church in the county and was established in 1861. It is on the National Register of Historic Places. Services were first held in homes, a church basement, and a schoolhouse. It incorporated under this name in 1868. The congregation bought its first church building in 1872 on Auburn Avenue. This church was built in 1963. (Author's collection.)

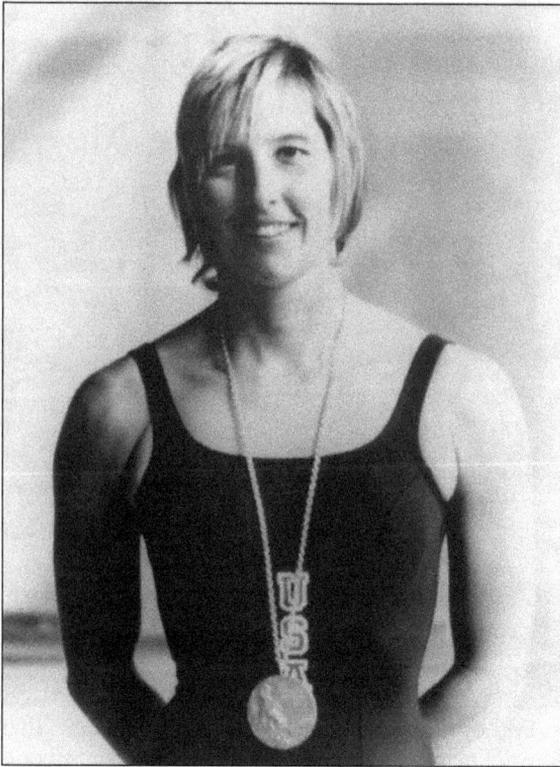

COMPETING DIVER. Micki King graduated from Pontiac Central High School in 1962. She went to the 1968 Olympics to compete in the springboard diving competition. With two dives to go and leading the competition, she hit the board on her dive and broke her arm. She went on to do her last dive, despite the agony, but didn't receive a medal. She returned to the Olympics in 1972 and brought back the gold medal. (Courtesy of Micki King.)

CIVIL UNREST. In 1971, Pontiac became the target of a federal desegregation plan. The lower-level schools were greatly segregated due to the separated neighborhoods. When the federal busing plan was implemented here, protests and violence broke out, culminating in the bombing of 10 Pontiac school buses by five men with ties to the Ku Klux Klan. (Courtesy of the *Oakland Press*.)

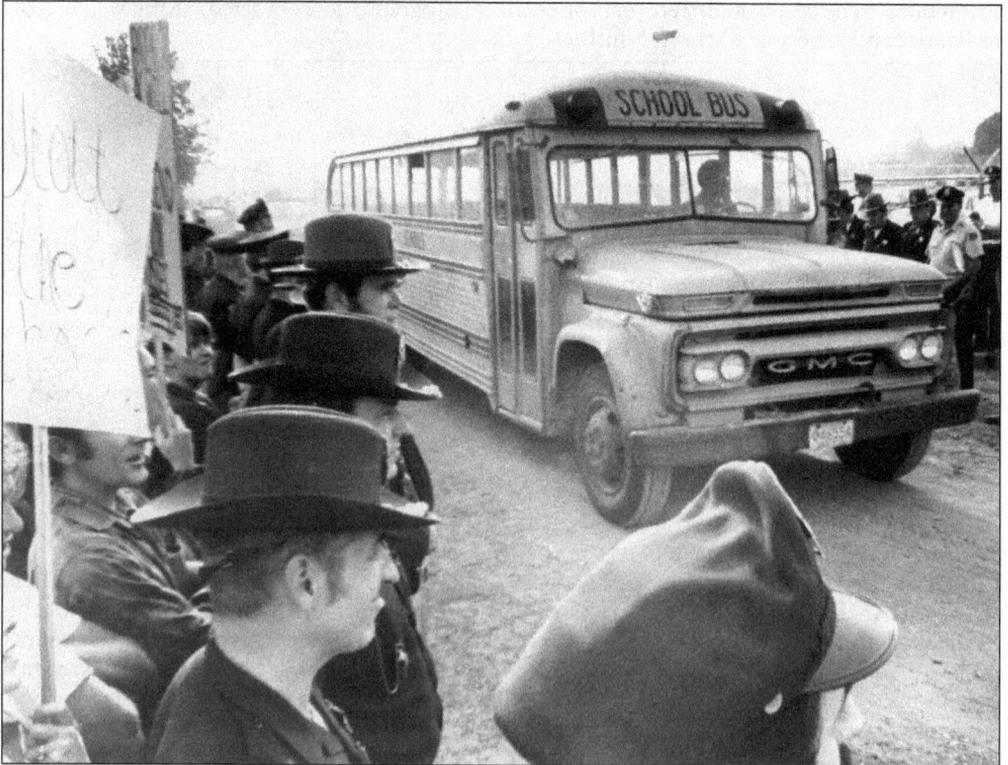

BUILDING CONVERSION. This old service station had been a carryout restaurant and car wash for several years before the mother-and-daughter team of Esther and Lisa Johnson took over. L&J Soul Food is now a full-service restaurant. Located on Woodward Avenue near Rapid Street, the building serves as an excellent example of preserving useful older buildings. (Author's collection.)

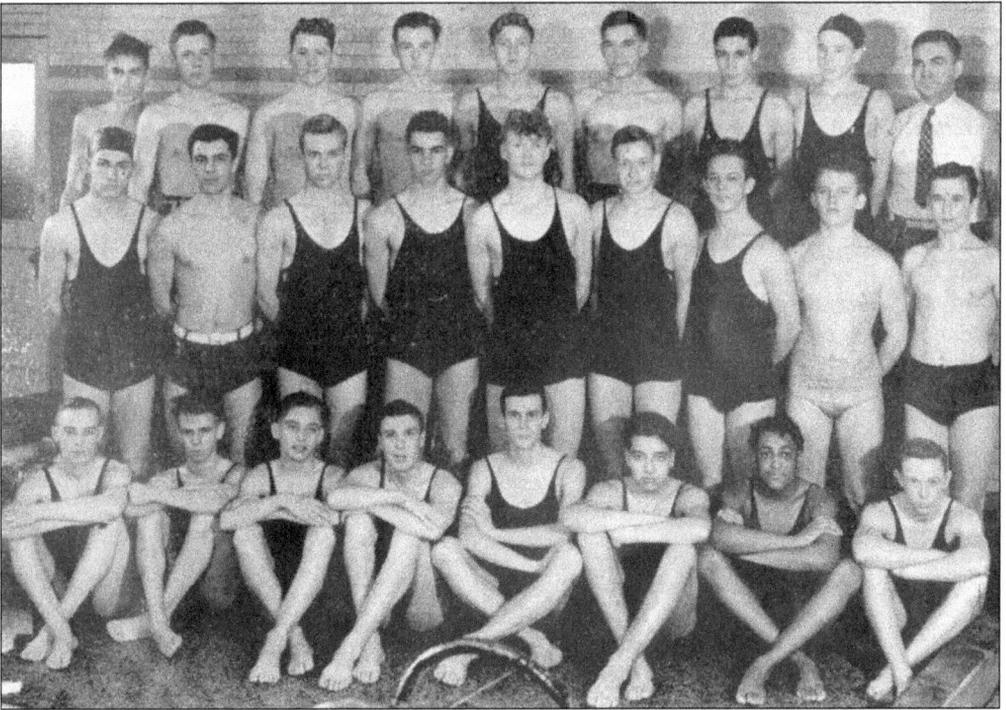

SWIM TEAM. The swimsuit fashion for the class of 1942 is definitely in transition. These boys are about to be initiated into manhood as they leave the halcyon days of Pontiac High School for the battlefields of Europe and the South Pacific. These young faces are heroes in every way. Some came home and some didn't—nothing was ever the same. (Author's collection.)

BIBLIOGRAPHY

Allerton, Gloria, and Richard Allerton. *The Re-Birth of Pontiac*. Pontiac, MI: self-published, 1986.

Annett, Bruce J. Jr. *Asylum: Pontiac's Grand Monument from the Gilded Age*. Pontiac, MI: Oakland County Pioneer and Historical Society.

Automobile Quarterly Magazine. "GM: The First 75 Years of Transportation Products." Detroit: General Motors Corporation, 1983.

Brieger, Gottfried. *Pontiac, Michigan: A Postcard Album*. Chicago: Arcadia Publishing, 2000.

Everts, L. H. and Company. *The History of Oakland County, Michigan 1817–1877*. Philadelphia: self-published, 1877.

Gavrilovich, Peter, and Bill McGraw. *The Detroit Almanac*. Detroit: *Detroit Free Press*, 2001.

Green, Mary, and Irma Johnson. *Three Feathers, The Story of Pontiac*. Chicago: Follett Publishing Company, 1960.

Gunnell, John. GMC *The First 100 Years*. Iola, WI: Krause Publications, 2002.

Hagman, Arthur A., ed. *Oakland County Book of History*. Pontiac, MI: Oakland County, 1970.

McAlester, Virginia, and Lee McAlester. *A Field Guide to American Houses*. New York: Alfred A. Knopf, 1984.

Oakland County. *Out of Small Beginnings*. Pontiac, MI: self-published, 1976.

Pontiac High School. *Quiver, 1942*. Pontiac, MI: self-published, 1942.

———. *Quiver, 1957*. Pontiac, MI: self-published, 1957.

Shcramm, Jack E., William H. Henning, and Richard R. Andrews. *When Eastern Michigan Rode the Rails*. Glendale, CA: Interurban Press, 1984.

Woods, Esmo. *Pontiac The Making of a U.S. Automobile Capital 1818–1950*. Pontiac, MI: self-published, 1991.

Various newspaper clippings from the local Pontiac newspapers, including the *Pontiac Press* with articles by Joe Haas.

ABOUT THE ORGANIZATION

The title of founder and champion of the Oakland County Pioneer and Historical Society belongs to the Honorable Thomas J. Drake. On February 22, 1860, he addressed in Pontiac an audience of pioneer families on the early history of Oakland County. Having been a member of the Michigan Territorial Council as well as serving as senator, newspaper publisher, and highly respected attorney, Drake had the credentials for the topic. Further consideration for such an organization, however, was delayed by the Civil War.

It was not until early 1874 that a group of supporters, headed by Drake, voted to resolve themselves into a body known as the Pioneer Society of Oakland County. Initial members of the society were required to be residents of the county prior to 1840. As time passed, this rule severely restricted eligibility, so membership was expanded to descendants of pioneers and other residents interested in the area's history. The organization's name was also changed to the Oakland County Pioneer and Historical Society. The society and its collections flourished. Members donated all sorts of objects or "relics," as the early settlers called them. These artifacts were stored in the old Oakland County Courthouse in downtown Pontiac as well as in the adjacent office buildings.

Storage space reached a crisis stage during World War II. Fortunately the granddaughter of Moses Wisner, the 12th governor of Michigan and a Civil War colonel, offered to sell the residue of her grandfather's estate in Pontiac to the society. Raising funds became the next order of business. This was accomplished by the creation of the Oakland County Pioneer and Veterans Historical Foundation, a nonprofit corporation. In the autumn of 1945, the society moved its collections into the Wisner mansion. In 1962, the Veterans Historical Foundation and the County Historical Society merged, keeping the Oakland County Pioneer and Historical Society name.

Today the society hosts several main attractions: the Governor Wisner mansion and its ancillaries, the Drayton Plains one-room schoolhouse, the research library and archives, and the pioneer museum. The homestead is called Pine Grove, so named by Moses Wisner. For tours or library visits call (248) 338-6732 or e-mail office@ocphs.org.

—Charles Martinez

Visit us at
arcadiapublishing.com